Melissa McQuillan
studied art history at Harvard
University, at the Institute of Fine Arts in New York
and at the Courtauld Institute of Art, University of
London. She lectures in the history of art at St Martin's
School of Art, London, and is the author
of *Impressionist Portraits*.

WORLD OF ART

This famous series
provides the widest available
range of illustrated books on art in all its aspects.
If you would like to receive a complete list
of titles in print please write to:
THAMES AND HUDSON
30 Bloomsbury Street, London WC1B 3QP
In the United States please write to:
THAMES AND HUDSON INC.
500 Fifth Avenue, New York, New York 10110

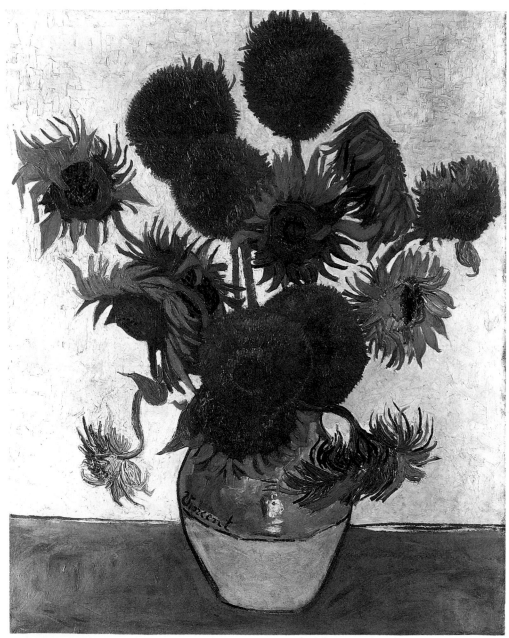

1 *Sunflowers* 1888

Melissa McQuillan

Van Gogh

168 illustrations, 25 in color

Thames and Hudson

To Graham

*I should like to thank Han van Crimpen, Curator, and
Anita Vriend, Librarian, Rijksmuseum Vincent van Gogh,
Amsterdam, for their kind assistance.*

*The abbreviations following the letters quoted in the text refer
to the three-volume edition of van Gogh's letters,* The
Complete Letters of Van Gogh, *London and New York,
1958 (reprinted 1979), where LT = Letters to Theo,
R = Letters to van Rappard, W = Letters to Wil, B = Letters
to Bernard, and T = Letters from Theo to Vincent van Gogh.*

© 1989 Thames and Hudson Ltd, London

First published in the United States in 1989 by
Thames and Hudson Inc., 500 Fifth Avenue,
New York, New York 10110

Library of Congress Catalog Card Number 88-50234

Printed and bound in Singapore

Contents

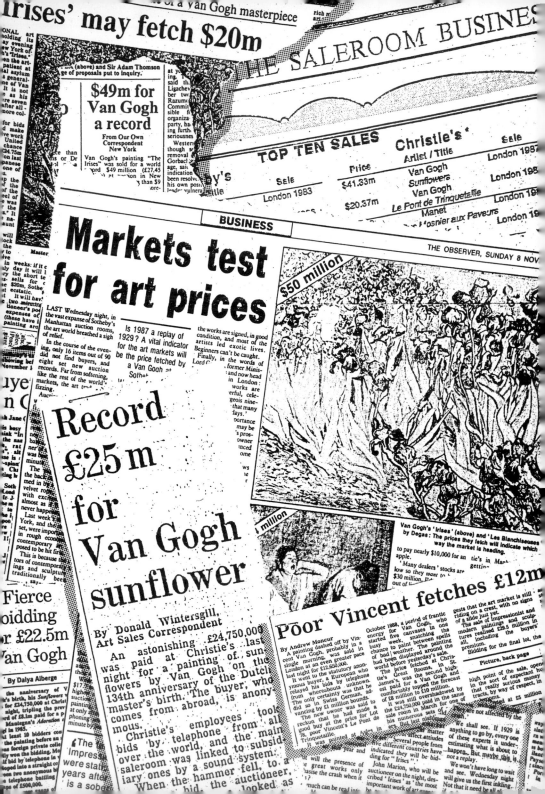

Irises' may fetch $20m

of a van Gogh masterpiece

THE SALEROOM BUSINESS

(above) and Sir Adam Thomson
ge of proposals to inquiry.

$49m for Van Gogh a record

From Our Own Correspondent
New York

Van Gogh's painting "The Irises" was sold for a world record $49 million (£27.45 ... on in New ... than $

BUSINESS

THE OBSERVER, SUNDAY 8 NOV.

Markets test for art prices

$50 million

LAST Wednesday night, in the vast expanse of Sotheby's Manhattan auction rooms, the art world breathed a sigh of relief.

In the course of the evening, only 16 items out of 90 did not find buyers, and eight set new auction records. Far from softening, like the rest of the world's markets, the art tr... fizzing.

Is 1987 a replay of 1929? A vital indicator for the art markets will be the price fetched by a Van Gogh at Sothe...

the works are signed, in good condition, and most of the artists led exotic lives. Beginners can't be caught. Finally, in the words of Lord C... former Minis... and now head in London: works are ...rful, cele- geois nine- ...that many ...lays.' ...ortance ...may be ...'s pros- ...owner ...nced ...ome

Van Gogh's 'Irises' (above) and 'Les Blanchisseuses' by Degas: The prices they fetch will indicate which way the market is heading.

to pay nearly $10,000 for an ...tie's in Man... apple.

'Many dealers' stocks are low so they want to ... $30 million, D... out of it ...

Record £25 m for Van Gogh sunflower

By Donald Wintersgill
Art Sales Correspondent

An astonishing £24,750,000 was paid at Christie's last night for a painting of sun flowers by Van Gogh on the 134th anniversary of the Dutch master's birth. The buyer, who comes from abroad, is anonymous.

Christie's employees took bids by telephone from all over the world, and the main saleroom was linked to subsidiary ones by a sound system. When the hammer fell, to a bid, the auctioneer, looked as

Fierce ...oidding ...r £22.5m an Gogh

By Dalya Alberge

...'s birth, his *Sunflowers* ... for £24,750,000 at Christ... night, tripling the prev ...rd of £8.1m paid for a p ...Mantegna's *Adoration* in 1985.

...at least 10 bidders cou ...the painting before an ...us foreign private colle ...lly won the bidding. Mo ...f bid by telephones in ...oped into a straight col ...een two anonymous bu ...telephoning battling ... of £500,000.

'The ... Impres... were stati... years afte... is a sobe...

Poor Vincent fetches £12m

By Andrew Moncur

A painting dashed off by Vincent Van Gogh, probably in a single morning, was sold in London at an even greater pace last night for £12,650,000.

It went to the statutory anonymous buyer, a European who relayed his bids by telephone from whereabouts unknown. The only certainty was that he did so in Swiss German.

The new owner was said to reckon that he had made a good buy at the price for Lot 18, poor Vincent's Le Pont de Trinquetaille.

It was painted at Arl... year and ... great works only ...asise the crash when it

October 1888, a period of frantic energy for Van Gogh, who started five canvases in one busy week, snatching the chance to paint between spells of bad weather. The painting had been displayed around the world before yesterday's sale.

The price fetched at Christie's was the second high ... est paid for a Van Gogh and comfortably topped the forecast of £8 million to £10 million.

It was still overshadowed by the £24,750,000 paid in the same sale room in March for one of his numerous sets of sunflowers. But last night...

... its ... first matter ...fect attitudes

Several people from five different countries have indicated they will be bidding for '' Irises '.

John Marion, who will be auctioneer on the night, described ' Irises ' as ' the most important work of art

...gests that the art market is still ...riding on a crest, with no signs of a slide just yet.

The sale of Impressionist and modern paintings and sculptures realised £29.5 million in all, including the buyers' premium.

Bidding for the final lot, the

Picture, back page

...high point of the sale, open... in the sort of expectant hu... that really serious money ... tracts, by way of respect, ...rooms.

...t £5 million ...

...are not affected by the

We shall see. If 1929 is anything to go by, every one of these experts is under-estimating what is about to happen. But maybe this is not a replay.

We won't have long to wait to see. Wednesday night will give us the first inkling. Not that I would be much

Images and Myths

Vincent van Gogh – in 1987 the name became an index of art market buoyancy in the face of stock market decline. At auction in March one of his paintings of sunflowers, 1889, fetched £24,750,000. *The Bridge at Trinquetaille*, 1888, a less familiar image, went for £12,650,000 in June. Publicity, speculation and international exposure preceded a new record price of $49,000,000 (£27,450,000) realized by the *Irises*, 1889, in November. Sotheby's, who handled the sale in New York, capitalized on the opportunity by issuing a catalogue devoted to just that work, itself a lavishly produced, expensive book.

2

Within days of its sale, altered images of the *Sunflowers* entered advertising vocabulary signifying the value of products as diverse as margarine and motor cars. This transposition depended not just on the astonishing price paid by an anonymous buyer but also on the familiarity of various versions of the *Sunflowers* through reproductions, posters and greetings cards. The image was immediately recognizable, and it stood for the most expensive painting of the moment. Christie's, its auctioneers, further recycled the image to promote the value of their services.

The more recent meanings negotiated by and around van Gogh's paintings join the nearly hundred-year construction of the art historical subject 'Vincent van Gogh', a subject that has become a contender for the position of the most widely known European artist. An entire museum, library and foundation is devoted to his work and its study. The Rijksmuseum Vincent van Gogh, begun in the 1960s with a commission originally awarded to the De Stijl architect and designer Gerrit Rietveld, stands on Amsterdam's Museumplein flanked by the Rijksmuseum, devoted to Old Masters, and the Stedelijk, which houses the city's modern art collection. Several major exhibitions during the 1980s ('Van Gogh in Arles', New York, 1984; 'Van Gogh in Saint-Rémy and Auvers', New York 1986–87; 'Van Gogh in Brabant', s'Hertogenbosch, 1987; 'Van Gogh à Paris', Paris, 1988) have focused microscopic analysis on one or two years of van Gogh's artistic output. Historical research and commercial exploitation have compiled many van Goghs, which collectively appeal to, reinforce and reproduce modern cultural values.

7

3 Still from the film *Lust for Life* 1956

The persona derives from an eventful, disturbing biography. A still disputed illness which manifested itself within the last two years of his life and two self-inflicted injuries (the mutilation of part of his ear and a pistol wound in his chest, the latter causing his death) occasioned the dramatic version of van Gogh. Julius Meier-Graefe's novelistic *Vincent: Der Roman eines Gottsuchers* (*Vincent: the Novel of a Seeker after God*), 1921, paved the way for Irving Stone's *Lust for Life*, 1934, whose biographical fiction inspired Vincent Minelli's Hollywood film of the same title, 1956, starring Kirk Douglas as van Gogh and Antony Quinn as his colleague Gauguin. Onto madness and public misunderstanding Don Maclean's pop song 'Vincent' grafted Christ-like self-sacrifice.

Van Gogh's decision to adopt simply his first name Vincent as his signature (on the canvases he chose to sign) has facilitated a tone of personal familiarity in the literature ('Vincent went', 'Vincent did', 'Vincent painted'). This tone also follows the practice in psychological case studies of using given names to personalize a type of behaviour while preserving the patient's anonymity (such as Freud's Dora).

Van Gogh's moments of extreme behaviour and his voluntary entry into the asylum of Saint-Paul-de-Mausole at Saint-Rémy also gave rise to a body of psychological literature. At the asylum, doctors diagnosed his illness as epilepsy. Karl Jaspers in a study of 1922 on van Gogh and Strindberg suggested schizophrenia, while others have speculated about the degenerative effects of syphilis and absinthe. Although epilepsy, possibly exacerbated by other factors, remains the currently favoured clinical specification, the less precise notion of madness has dominated the popular representation of the van Gogh persona; the incident of 'cutting off his ear' eclipses even his manner of death.

The artist 'van Gogh' has become like a site where discourses on madness and creativity converge. Madness and creative genius, both socially constructed as extreme, alienated and aberrant kinds of behaviour, are mapped onto van Gogh, rendering him the 'mad artist' and the subject of a study of creativity as a kind of abnormal psychological phenomenon. Van Gogh himself referred to 'the artist's madness' (LT 574), eliding his illness and professional identity into a cultural construction.

Albert Aurier, van Gogh's first sympathetic French critic, some six months before the artist's death formulated many of the prominent, essential characteristics of the artistic personality we know as van Gogh. In 'Les Isolés: Vincent van Gogh', published in the first issue of the Symbolist review *Mercure de France*, January 1890, Aurier couched a reading of van Gogh's œuvre in vibrantly evocative language and then proposed, 'It is then permitted for us . . . legitimately to infer from the works themselves of Vincent van Gogh his temperament as a man, or rather as an artist – an inference that it would be possible for me, if I wanted it, to corroborate with biographical facts.' Having asserted such a relationship between the products and personality of the artist, Aurier suggested that the œuvre distinguished itself through 'excess, excess in the force, excess in the nervous power, the violence in the expression.' Shifting once more back to the person, '[van Gogh] is . . . one taken by delirium . . . a terrible and maddened genius, often sublime, sometimes grotesque, always recovering almost from pathology. He is a hyperaesthete, . . . perceiving with abnormal intensity . . . the imperceptible secret characteristics of lines and forms, but even more the colours, lights, nuances invisible to healthy pupils, the magic iridescences of shadows.' Concluding his article Aurier characterized van Gogh as possessing 'the soul of a visionary, so original and so apart from the milieu of our pitiful art of today . . . He will never be fully understood except by his brothers, artists truly artists . . . and by the fortunate of the common people, of totally insignificant people, who will have escaped by chance, from the benevolent teachings of the laity.'

Aurier's article was part of his plan to articulate a theory of Symbolist painting (which he clarified in another article focusing on Paul Gauguin, published in March 1891). His strategy distinguished Symbolist artists not only from artists patronized by fashionable society (he gave the example of Jean-Louis-Ernst Meissonier) but also from other recent and current avant-gardes. Van Gogh's gratitude for such support – his first critical recognition – was mingled with unease. Admiring the article 'as a work of art in itself' (LT626a) he sensed its distance from his work and enterprise. Described as such a singular temperament, he took pains to clarify to Aurier his debt to other artists both past and present.

Although uncannily prophetic of later writing about van Gogh, Aurier's article was ignored for decades after its re-publication in the author's Œuvres posthumes, 1893; nevertheless, subsequent critics did nothing to undermine the image of the alienated individualist even as they constructed a personality evincing profound social concern and saintliness, or concentrated on the expressive or formal properties of van Gogh's art. His physical and emotional suffering, his images read as an identification with the poor, his easily recognizable individual pictorial style, especially in the later work, were co-opted in the course of twentieth-century cultural mythologizing: van Gogh was made into a paradigm of the misunderstood modern artist. Overlapping institutional, critical and cultural enterprises have secured such a paradigm. Ironically, these endeavours involving publicity, exhibitions and the machinery of art scholarship contrast with the image of the lonely isolé they project. In the decades following his death national, ideological and artistic needs formulated differently nuanced van Goghs.

In The Netherlands of the 1890s where a movement towards communal art re-incorporated the artist into society, the critics Johannes de Meester and Frederick van Eeden noted van Gogh's social involvement. De Meester suggested that he was not an artist by instinct but 'he found in painting the most appropriate opportunity to express his own conceptions of nature and of life'. By the end of the century van Gogh was transformed from the victim of a callous society into a Nietzschean. In the early years of the twentieth century his Dutch nationality became more positively advanced against French 'naturalization'. Concurrently, Johan Cohen-Gosschalk (the second husband of van Gogh's sister-in-law Johanna van Gogh-Bonger) argued for his art's transcendence of national borders. In the 1890s his work received at least one and often several showings per year. More than one hundred paintings and drawings, and selected letters, were exhibited in Amsterdam in 1892–93. This first large retrospective was organized by the Dutch Symbolist artists Jan Toorop and Roland Holst, and Holst's catalogue design featured a drooping sunflower, its neck-like stem circled by a slightly askew halo.

4

4 Roland Holst, cover design for catalogue of van Gogh exhibition, 1892

In France, selected paintings had already been seen annually at the Salon des Artistes Indépendants between 1889 and 1891, but there were fewer exhibitions in France than in Holland in the 1890s. The dealer Ambroise Vollard held shows in 1895 and 1896. Before these, van Gogh's work was on sale at the shop of Père Tanguy. Van Gogh's friend, the painter and critic, Emile Bernard arranged an exhibition in 1892 at the Galerie Le Barc de Boutteville. Bernard, like some of the Dutch artists, appropriated van Gogh for his own Symbolist enterprise. Octave Mirbeau joined Aurier as a critical supporter, pointing to his style as an affirmation of a personality, but other jockeying factions in the French art world ignored his work. His sometime friend Gauguin even attempted to dissuade Bernard from carrying out the small memorial exhibition. Only Gauguin in his 1903 memoirs *Avant et après* (published in 1918 in Germany, 1923 in France) belaboured his madness, but Gauguin had a particular interest in portraying van Gogh as mad. Reactions to Symbolism at the turn of the century separated van Gogh's art from the personality of its maker and reconstrued it as visionary, energetic and celebratory. In 1900 the critic Julian Leclercq claimed van Gogh's art for France: 'he entered into our French school of painting, of which he wished to be and truly was a member.'

Maurice Vlaminck and other artists of the Fauve generation digested the formal properties of van Gogh's brushwork and colour, assisted by a retrospective at the 1905 Indépendants. Through such association, implications of Fauve radicality and anarchism accrued retrospectively to van Gogh. While van Gogh's work had major exposure in the first decade of the 1900s (there were important exhibitions in 1901, 1905, 1908 and 1909), in the following decade it received hardly any showing. However, Théodore Duret's *Van Gogh – Vincent*, 1916, the first book-length monograph in French, contributed to his personal incarnation as the modern artist, supplanting a direct interaction with the work.

Whether regarded as Dutch or French, his painting was initially seen as alien in Germany. In 1901 and 1902 a few paintings were hung in the Berlin and Munich Secession exhibitions, and from 1905 onwards both artists' associations and dealers put his work before the public in Berlin, Munich, Bremen, Frankfurt and other German cities, culminating in a show of seventy-four works in Paul Cassirer's gallery in Berlin in 1910. The Expressionist generation identified him as a predecessor, and van Gogh's work came to be regarded as a link between Impressionism and Expressionism in later twentieth-century outlines of 'modern movements'. Expressionism sanctioned personal, emotive pictorial exaggerations of individual *angst*. By contrast, after World War I Meier-Graefe's *Vincent* focused on van Gogh's life as an idealized moral struggle.

5 Maurice Vlaminck *La Seine à Chatou* 1905

Archiving kept pace with fiction. The first edition of J. B. de la Faille's catalogue raisonné appeared in 1928. Later revised editions remain standard reference works. W. Scherjon and J. de Gruyter catalogued the paintings from Arles, Saint-Rémy and Auvers, using references in van Gogh's letters as aids to authentication, in two publications of the 1930s, while W. van Beselaere's catalogue of the Dutch period was published in 1938. Cataloguers had to confront a growing number of forgeries or problematic works – an indication of the mounting value of authentic van Goghs.

The first major American retrospective at the Museum of Modern Art, New York, in 1935 foreshadowed the post-World War II multiplication of van Gogh exhibitions in America, Europe and Japan. In 1946 more than a hundred works still in the possession of Theo van Gogh's son were displayed in Stockholm, and Paris and London both staged retrospectives in 1947. Rather than re-inserting the artist and his art into history these exhibitions elevated him into an artist-hero.

For Pablo Picasso, foremost among twentieth-century artist-heroes, van Gogh was an archetype and the originator of the modern tradition of artistic individualism. Francis Bacon's series of variations on van Gogh's self-image on the road to Tarascon (the original was destroyed in World War II) pays homage to the artist as journeyman. Van Gogh has come to signify the condition of the modern artist in the work of artists as diverse as the sculptor Ossip Zadkine and the painter Rainer Fetting.

6, 7

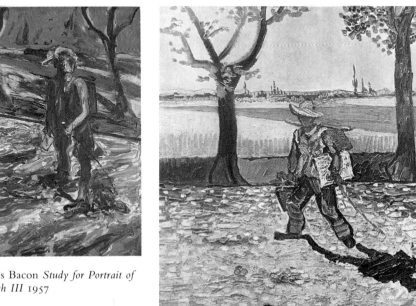

6 Francis Bacon *Study for Portrait of van Gogh III* 1957

7 *The Artist on the Road to Tarascon* 1888

The story of van Gogh forms part of the discourse of modernism. As a Dutchman naturalized into a Franco-biased mainstream of modern art, van Gogh was both alien (without modernist genealogical origins) and an example of a breakthrough into modernism. His work found few patrons during his life and began to generate artistic and critical interest only at the end of a short career, conforming to the avant-garde ideal of artist–prophet in advance of his time. His illness, generalized as madness, and the alignment of madness with supranormal creative inspiration, enabled his production to be detached from its specific historical context. The conflation of this construction of the artist–persona with his work accords meaning and value to the work by virtue of its being the product of artistic genius. The apparent individuality of the work imparts uniqueness to the artist, which in turn feeds back into the work's ineffability. Once the product of artistic labour, the paintings now signify the mythic artist van Gogh. More than merely objects of exchange in the art market, van Gogh's paintings have assumed something of the power of both icons and relics.

Exposing the accretions to the van Gogh persona and relocating his work in its historical context can enrich our understanding of its cultural significance, but it will not render an authentic or 'real' van Gogh behind the myth, however valuable this project of de-mythifying may be. The meaning of Vincent van Gogh's paintings, and their elision with the person who bore that name, is the product of representations of the paintings themselves and their painter which go back to the artist himself.

Verbally articulate and often living apart from the people with whom he felt the greatest need to communicate, van Gogh was a prolific letter writer. More than 650 letters to his brother Theo have been preserved and published. The first edition appeared in 1914 and its English translation in 1927. Another hundred-odd letters to other relatives and fellow artists were added to the complete collection issued from 1952 to 1954 (English edition 1958). Once published they in turn became the basis of numerous other versions. As passionate and moving as they often are, they offer not an unimpeded access to the artist's intentions – a key to an original meaning for the work – but yet another representation (in this case self-representation) of the artist through the medium of language.

A draft letter to Theo van Gogh was found on Vincent's body at his death. Its comparison with the letter he actually sent a few days earlier indicates just how considered his verbal representations were even in difficult emotional circumstances. Not only did he rephrase his reservations about his brother's professional plans, he depicted his own outlook in a more positive light: from the pessimistic 'Well, my own work, I am risking my life for it and my reason has half foundered because of it' (LT652), to a more confident 'As far as I'm

concerned, I apply myself to my canvases with all my mind, I am trying to do as well as certain painters whom I have greatly loved and admired.' (LT651).

Van Gogh's pictorial self-portraits also advance an elusive and sometimes contradictory self-image. Between 1885 and 1889 he painted some forty-three self-portraits, vying with his Dutch predecessor Rembrandt in the multiplication of his depicted visage. The diversity of physiognomic representation is astonishing; the entire facial structure seems to belong to different men.

Two self-portraits, painted within his last months in Paris, depict in one (winter 1887/88) a bourgeois in a felt hat and a jacket with trimmed lapels – 'He dressed quite well and in an ordinary way', wrote the Scottish painter A. S. Hartrick – in the other (early 1888) an artist with easel, palette and brushes, attired in a 'blue canvas smock, like a zinc worker', fitting a description by Lucien Pissarro. Both distinguish themselves from the rest of his self-portraits: in very few did he define his social class and in even fewer did he make allusion to his profession. Van Gogh's rapid assimilation of contemporary Parisian artistic developments may account for some of the difference in facture (how a painting is made). In *Self-portrait with Grey Hat* 9
prominent striations of paint organize the modulation of planes, spreading outwards over the face like the fur growth on an animal, contouring the upwardly curving hat-brim, and encircling the head with a background halo. *Self-portrait at the Easel* allows the canvas fabric to show through the thinner 8
paint surface, which in turn imitates a woven effect, on which more delicate strands embroider the facial modelling. This later canvas, signed and dated, makes a more calculated statement against the boldness of the smaller study.

Contrasting facture does not alone account for the longer face, fuller lips, and more skull-like forms of *Self-portrait at the Easel*. In another self-portrait, of September 1888, dedicated to and exchanged with Gauguin, sharpened features stretch tightly over the prominent skull. His avowal to Gauguin, 'I . . . exaggerate my personality, [and] I have in the first place aimed at the character of a simple bonze [Japanese monk] worshipping the Eternal Buddha' (LT544a), responded to Gauguin's description of his own contribution to the exchange. The description had moved van Gogh 'to the depths of my soul' (LT544). Other self-portraits flatten the face or undermine the chin. Shaving, loss of teeth and poor health all affected his appearance, but hardly as fundamentally as the various self-images propose. With particular reference to the *Self-portrait at the Easel* he wrote to his sister Wil, 'I want to emphasize the fact that one and the same person may furnish motifs for very different portraits. . . . A pinkish-grey face with green eyes, ash coloured hair, wrinkles on the forehead and around the mouth, stiff, wooden, a very red beard, considerably neglected and mournful, but the lips are full, a blue

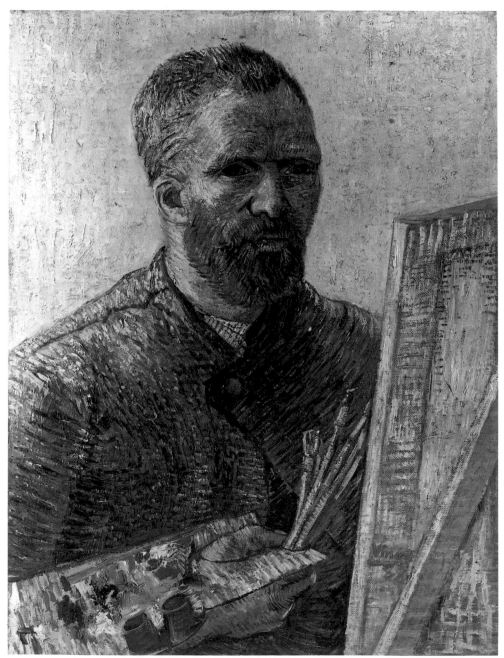

8 *Self-portrait at the Easel* 1888

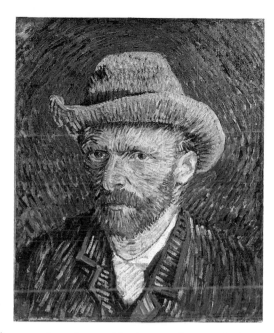

9 Self-portrait with Grey Hat
1887–88

peasant's blouse of coarse linen, and a palette with citron yellow, vermilion, malachite green, cobalt blue, in short all the colours on the palette except the orange beard, but only whole colours. The figure against a greyish–white wall . . . this resembles somewhat, for instance, the face of – Death – in Van Eeden's book . . . it isn't an easy job to paint oneself – at any rate if it is to be *different* from a photograph. And you see – this, in my opinion, is the advantage that impressionism possesses over all the other things; it is not banal, and one seeks after a deeper resemblance than the photographer's.' (W4).

As a physical likeness, an artistic personality, and the product of a historical process active long after his death, van Gogh continually evades pinning down, despite the extensive body of documentation ranging from details of diet and hygiene to artistic credo. Nor do the letters and accounts of contemporaries and portraits by other artists add up to a cohesive image. So van Gogh's paintings, though filtered through the countless posters and postcards, textured reproductions and commodity advertisements, seem unalike, inconsistent in handling and quality. His career does not belong wholly either to Dutch or to French painting and locates itself awkwardly in various accounts of modernism – little wonder that in being made into an artistic paradigm van Gogh has come to stand for the artist as socially abnormal and different. Ironically, his art, especially during the later, more popular part of his career, leaves social conventions undisturbed.

17

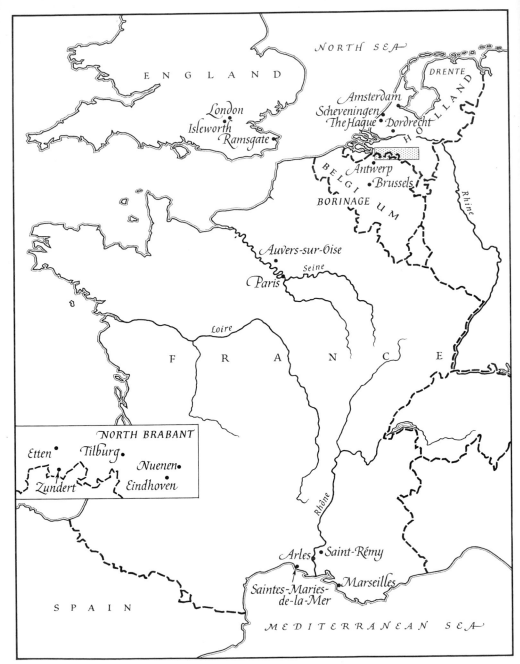

NORTH SEA

ENGLAND

London
Isleworth
Ramsgate

DRENTE

HOLLAND

Amsterdam
Scheveningen
The Hague • Dordrecht

Antwerp
• Brussels

BELGIUM

BORINAGE

Rhine

Auvers-sur-Oise

Seine

Paris

Loire

F R A N C E

NORTH BRABANT

Etten • Tilburg •
Nuenen •
• Zundert Eindhoven •

Rhône

Arles • Saint-Rémy

Saintes-Maries-
de-la-Mer

• Marseilles

SPAIN

MEDITERRANEAN SEA

10 Map of places where van Gogh lived

Biography

The predominantly biographical reading of van Gogh's œuvre derives from traditional art historical methodology encouraged by the eventful character of his life and supported by the wealth of available primary information. Van Gogh's first letter to his younger brother Theo (1857–91) is dated August 1872. Theo was still at school, and Vincent was not to turn to the practice of art for another eight years. In addition to the letters to Theo, twenty-two to his youngest sister Wilhelmina (1862–1941), starting in the middle of 1887, and a few to other members of his family, also remain. Two large groups of letters to artist colleagues – fifty-eight to his Dutch contemporary Anthon G. A. Ridder van Rappard (1858–92) between 1881 and 1885, and twenty-two to the younger Frenchman Emile Bernard (1868–1941) from summer 1887 to December 1889 – are supplemented by individual letters to the painters Paul Signac (1863–1935) and Gauguin (1848–1903) and to the critic Albert Aurier.

Sometimes the letters reflect on earlier episodes in van Gogh's life, and sometimes they include sketches, which assist the dating of paintings. Their frequency during certain periods supplies almost a daily account of events, but a hiatus covering the crucial two years that Vincent lived with Theo in Paris is left relatively poorly documented. Forty-one letters, dated between 19 October 1888 and 14 July 1890, remain from Theo van Gogh to his elder brother. Letters from Gauguin to both brothers and additional correspondence from doctors, artists and friends supply further information for the latter part of van Gogh's life. Following the death in close succession of both brothers, reminiscences were offered by or gleaned from relatives and friends.

The sheer volume of this documentation must not be allowed to obscure its partiality. Apart from problems of transcription and translation of van Gogh's letters (they were written in Dutch, French and English), their order as published is disputed, since few after 1881 are dated. They were, of course, produced for ends other than an impartial record of fact. They represent van Gogh's artistic image and his place in the world.

Vincent van Gogh's letters to Theo have a diary-like intimacy. They have even been taken as autobiography, but they were written to serve particular, immediate needs. Theo's encouragement and financial support implied belief

in Vincent's artistic potential: they made possible the artistic career. About 130 letters cover the period before October 1879. Ten months then apparently elapsed before van Gogh resumed the correspondence in July 1880. He let Theo know that he did so out of a sense of obligation – Theo had sent him fifty francs (LT 133). Initially, Theo's more regular support came as an offering 'to help you out as much as I can until you can earn your own money' (LT 169, 5 January 1882), but during the spring of 1882 Vincent wrote that he was counting on a regular 150 francs per month for at least another year (LT 195). In addition to money, Theo provided art supplies and reproductions. Vincent occasionally reciprocated with drawings for Theo, by then an art dealer, to sell. In February 1884 Vincent proposed a more regular arrangement: his work would be taken by Theo in exchange for regular monetary payments, the work thus becoming Theo's property: 'I want to consider the money I receive from you as money I have earned!' (LT 364). Hence, Theo became Vincent's employer.

The letters justify and explain the work; they give it a genealogy. They also wheedle, cajole and employ other tactics for eliciting sympathy. Theo did develop a belief in the future value of his brother's work, and he did preserve the letters.

Letters to the artist van Rappard served as a medium to forward artistic ideas, in particular van Gogh's enthusiasm for graphic illustration, and to seek corroboration from a more experienced though younger artist (he often expressed a desire for van Rappard to look at his work). When van Rappard's criticism of The Potato Eaters hurt, van Gogh became petulant: 'you . . . had no right to condemn my work in the way you did' (R52, July 1885) and self-justificatory: 'I am always doing what I can't do yet in order to learn how to do it' (R57, September 1885). From van Rappard he sought artistic communion and support for his self-confidence. From Bernard, too, he sought comradeship. The younger Bernard, at the forefront of the struggle among vanguard artists to supplant Impressionism, was also in contact with Gauguin and artists working near him at Pont–Aven. All but one of the letters to Bernard were written after van Gogh had left Paris in frustration at the rivalry and factionalism. He tried to enlist Bernard and, through Bernard, Gauguin to join his project for an artists' community in the south of France. More confident of his own direction than he had been in the Netherlands, van Gogh advised and sometimes criticized Bernard.

Theo van Gogh, having kept Vincent's letters to him, inherited most of the art works as well on his brother's death. However, he died only six months later, leaving a wife and infant son. Thus, Johanna van Gogh-Bonger, Vincent's sister-in-law, came to edit and translate many of the letters to Theo. Her memoir, written in 1913 (for the 1914 edition of the letters), of a man she

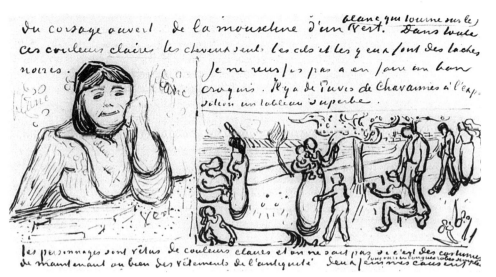

11 Letter from van Gogh to Wil (1890) with drawings of *L'Arlésienne (after Gauguin)* and Puvis de Chavannes's *Inter Artes et Naturam*

had met only a few times at the end of his life necessarily relied heavily on her memories of Theo's and other relations' confidences. She and her second husband Cohen-Gosschalk also assisted in early twentieth-century exhibitions of the pictorial œuvre. The interest and co-operation of her son, named Vincent after his uncle, enabled the success of later exhibitions, assisted research and ultimately determined the establishment of the Vincent van Gogh Foundation (1960) and Museum (opened 1973) and the Theo van Gogh Foundation (a renaming of an earlier Vincent van Gogh Foundation set up in 1950) in Amsterdam. His three children in turn sit on the board of the Foundation. Another of Vincent's siblings, his younger sister Elisabeth (1859–1936), produced an anodyne biography in 1910. Thus, the van Gogh family has maintained a vested interest in the production of van Gogh's image and reputation. More than one author has alluded, either directly or tacitly, to the family's concern to maintain proprieties.

Memoirs or reminiscences written by friends or acquaintances were inevitably inflected not only by personal feelings but also by a knowledge of van Gogh's late, aberrant behaviour and official versions of his death. The images of misfit, madman and belatedly accoladed artist were projected backwards on the memory of events.

Gauguin in *Avant et après* emphasized van Gogh's receptivity to his ideas and teaching in counteraction to suggestions of van Gogh's artistic precedence: 'at the moment when I arrived in Arles, [Vincent] was . . .

floundering considerably, . . . I undertook the task of enlightening him, which was easy for me, for I found a rich and fertile soil.' He also proposed a personality, which had become so unbalanced as to be dangerous: 'Vincent rushed towards me, an open razor in his hand,' an episode that he did not apparently relate to Bernard in his first-hand report in 1888. Such an outwardly violent image, however, justified Gauguin's precipitate departure from Arles immediately after his friend's self-mutilation.

A. S. Hartrick in 1939 remembered a van Gogh who in Paris had 'looked more than a little mad' and who, indignant over the closure of Cormon's studio where he had worked in Paris, 'went round with a pistol to shoot Cormon'. Charles Angrand referred to van Gogh's keenness to exchange paintings with fellow artists as 'an instance . . . of his mania.'

The painter Suzanne Valadon recalled a stubbornly persistent man who, despite being ignored by colleagues, continued to bring his work round to Toulouse-Lautrec's weekly gatherings. The Neo-Impressionists Lucien Pissarro and Paul Signac, painters of carefully ordered works, both emphasized a lack of self-conscious propriety in his behaviour: 'he lined up [his studies] against the wall in the street, to the great amazement of the passers-by', and his disorderly appearance: '[he] had small dots of colour painted on his sleeves . . . he shouted and gesticulated, brandishing his large, freshly painted size 30 canvas in such a way that he polychromed himself and the passers-by.'

A German critic, Max Osborn, writing in 1945 reported that the Impressionist Camille Pissarro had said, 'this man will either go mad or outpace us all. That he would do both, I did not foresee.' Bernard, a closer friend, may have believed in van Gogh's talent before his death. He certainly became one of the earliest proselytizers. In 1891 he wrote, 'van Gogh's work is more personal than that of anyone else.' In the 1911 preface to the edition of van Gogh's letters to him, Bernard stressed van Gogh's patience and determination. Even his account of an angry incident between van Gogh and his own father seems moderate when compared to the anecdotes of others.

Although the vast body of biographical information about van Gogh has been accumulated under passionate and partial conditions, biography provides one kind of chronological reference for the emergence and development of the artistic œuvre. Too restrictive a framework as an account of the meaning of van Gogh's paintings, it can yet initiate investigation towards a historical context.

Vincent Willem van Gogh was born on 30 March 1853 in the town of Groot-Zundert, province of Brabant, The Netherlands, exactly a year after a stillborn namesake. His father Theodorus van Gogh (1822–1885), the pastor

at Zundert, came from a family well established in the civic bourgeoisie of seventeenth-century Holland. In more recent generations many sons of the family had been theologians and clergymen. Vincent's father belonged to the Groningen party within the Dutch Reformed Church, an idealistic movement espousing Christian humanism. Its decline and collapse during the 1850s and 1860s contributed to Pastor Theodorus's modest career in small villages. Nor was his advancement assisted by the fact that he 'was not a gifted preacher'. A more successful uncle, Johannes, rose to the position of Vice-Admiral in the Navy. Three other uncles, Hendrik Vincent (Hein), Vincent (Cent) and Cornelis Marinus (C. M.) were in the art trade, Uncle Vincent having become a major European art dealer.

Vincent van Gogh's maternal grandfather had been bookbinder to the king. His mother Anna Cornelia Carbentus (1819–1906) and one of her sisters both married into the van Gogh family, while yet another sister became the wife of a clergyman. Like many women of her class, Anna Cornelia exhibited modest accomplishments in drawing. Following the birth of the second Vincent she had five more children. Vincent's favourite brother Theodorus, named after his father, was four years younger.

After a brief period at the local village school van Gogh was sent to a boarding school in Zevenbergen, and in 1866 to the Hogere Burgerschool in Tilburg, where he did well academically but for unknown reasons terminated his studies before the end of his second year. The drawing master at Tilburg, C. C. Huysmans, encouraged both study from nature and copying after reproductions of Old Masters. This parallel focus differed from contemporary methods in art education where copying took precedence.

There are none of those legends of childhood artistic precocity common to the mythology of artistic genius. Instead, a couple of anecdotes report van Gogh's destruction of a drawing and a modelled elephant after they elicited attention from his parents. The earliest preserved drawings, from 1862 to 1863, appear to have been copied. The next important surviving group, allocated to the early 1870s, are more awkwardly drawn and do not employ conventions of graduated modelling; however, these later drawings compositionally use the entire sheet of paper, evincing spatial concerns that were to recur repeatedly in his mature work.

Despite his early essays in drawing van Gogh came late to being a serious artist. After leaving school he entered the trade of his Uncle Vincent: in July 1869 he joined the Hague branch of the firm of Goupil & Cie as a junior clerk. Goupil had been founded in Paris in 1827 as a publishing house specializing in reproductions of works of art. Gradually, it built up a trade in originals and by 1864 had branches in Brussels, London, Berlin, New York and The Hague, where it had bought Uncle Vincent's business in 1858. Van Gogh's

uncle remained a partner but had retired from active dealing due to poor health, and the branch was managed by H. G. Tersteeg.

While van Gogh later had nothing favourable to say about art merchants, the experience set him up with a practical knowledge of the forces mediating between the artist and public, and it exposed him to a range of fine art imagery. Among more recent nineteenth-century artists, Goupil's dealt in paintings by Jean-François Millet and the French Barbizon artists and in paintings of the Dutch Hague School – artists such as Jacob Maris, Jozef Israëls and van Gogh's cousin by marriage Anton Mauve. Van Gogh broadened his acquaintance with Old Master works through visits to the Mauritshuis. Three sketchbooks of drawings, mostly of animals and plants made for Tersteeg's young daughter Elizabeth, show no evidence of a nascent ambition to emulate either these Old Masters or the 'moderns', but several landscape drawings, particularly *Driveway*, early 1873, reflect the perspectival conventions of seventeenth-century Dutch landscape.

Initially, van Gogh's good impression earned him the firm's confidence and a transfer to the London branch in June 1873. Tersteeg gave him an excellent testimonial and assured his parents of his probable future success in the profession. Van Gogh made his way to London via Paris, visiting the Louvre and Luxembourg museums, and of course Goupil's galleries.

For the first year in London he got on well, selling reproductive engravings and photographs of well-known works of art and hoping that the sale of actual pictures would become more important. He visited the National Gallery, the Victoria and Albert Museum, the Dulwich Picture Gallery and Hampton Court Palace. Much later, he still retained vivid memories of paintings by Hobbema and Constable. His taste for British painting developed slowly, but he singled out Millais and Boughton for mention to Theo as well as the more obvious Constable and Turner. On the other hand, starting with Keats he soon became an avid and lifelong enthusiast of English literature.

While much has been made of a frustrated romantic attachment to Eugénie Loyer, his landlady's daughter, whom he discovered to be already secretly engaged, he did not mention it in his letters at the time. Instead he paraphrased Jules Michelet's ideas on love from his book *L'Amour*. His enjoyment in drawing waned, but he still looked forward to a possible expansion of the London branch of Goupil's.

A series of transfers – from London to Paris in October 1874, back to London in December and once more to Paris in May 1875 – culminated in his dismissal, effective from April 1876. In Paris he had decorated his room with reproductions after Millet, Jules Breton, Charles-François Daubigny, Gabriel-Charles Gleyre and Rosa Bonheur; he continued to refer to specific

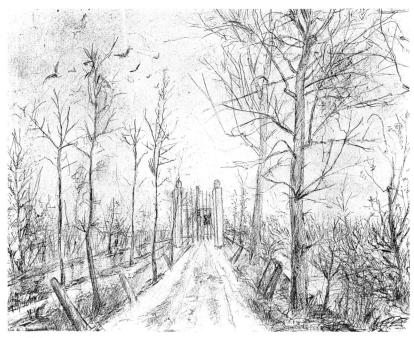

12 *Driveway* 1873

paintings by favourite artists in his letters. Yet he had lost interest in art dealing and his conduct dissatisfied his employers, as he confessed of an encounter with his superior Boussod: 'I hoped he had no serious complaints against me. But the latter was indeed the case.' (LT50, 10 January 1876).

Religious quotations had begun to pepper his letters from Paris, where he had embarked on reading the entire Bible with a new friend, Harry Gladwell, the son of a London art dealer and his eventual successor at Goupil's. Having returned to Britain in April as a teacher of French, German and arithmetic in a private school in Ramsgate, he moved in July to a position in Isleworth, which combined teaching duties (including Bible history) with parish work for the Reverend Mr Jones, a Methodist minister. He preached in Richmond, Petersham and Turnham Green, villages on the outskirts of London.

Despite feeling bound 'so strongly to the sphere that extends from schoolmaster to clergyman . . . that I cannot draw back any more' (LT70, 5 July 1876), he did not return to England after a holiday visit to his parents in December 1876. Instead he joined the Dordrecht bookselling firm Blussé and van Braam as a clerk, a post arranged by Uncle Vincent. It paid a better salary

25

than teaching, but translating the Bible into four languages and attending religious services of several denominations occupied him more than the book trade.

In May 1877, having persuaded his parents of the seriousness of his religious zeal, he went to Amsterdam to prepare for the theological entrance exams, staying with his uncle Jan, commandant of the naval dockyard. Despite serious application, he struggled with Latin and Greek and was terrified by algebra and mathematics; at least Biblical geography and history involved him in drawing maps. According to his tutor Dr Mendes da Costa, the Classics seemed irrelevant to his goals of giving 'peace to poor creatures and reconcil[ing] them to their existence here on earth.' (LT122a). Much happier were his visits to the Trippenhuis (a forerunner of the Rijksmuseum) to see the Rembrandts. While his drawings from the years in Britain mostly render views of towns in hard graphic outline, the landscape images made during 1877 and 1878 are more tonal, beginning to use the bare paper atmospherically.

He abandoned his studies in July 1878 and decided to train as an evangelical missionary in order to carry out his pious ideal of bringing consoling religious messages to the poor. For that purpose he went to Laeken, a suburb of Brussels. Verbal descriptions of pictorial imagery and graphic illustrations had long been included with his perceptions of people, his surroundings and his ideas. From Laeken he wrote a letter intimating that drawing activity itself had assumed an increased importance: 'I should like to begin making rough sketches of some of the many things that I meet on the way, but as it would probably keep me from my real work, it is better not to start.' (LT126, 15 November 1878).

At the end of the three-month probationary period he did not receive a posting, having neither complied with notions of proper submission nor shown a talent for impromptu speaking; nevertheless, in December 1878, his family once more rallying to support him, he went to the Belgian mining district of the Borinage. There he naïvely expected to minister to 'the Belgian miner [who] has a happy disposition, . . . is used to the life, and when he goes down into the shaft, wearing on his hat a little lamp to guide him in the darkness . . . entrusts himself to God, who sees his labour and protects him, his wife and his children.' (LT126).

After holding Bible meetings and visiting the sick, van Gogh secured a temporary nomination at Wasmes, but his fanatical self-sacrifice (giving away his clothes, living in a hovel and eating little) shocked his superiors and brought about his dismissal in July 1879. He persevered on his own account at Cuesmes for another year. Although he attempted to intervene with the mine bosses over the miners' conditions, he urged the workers against violent

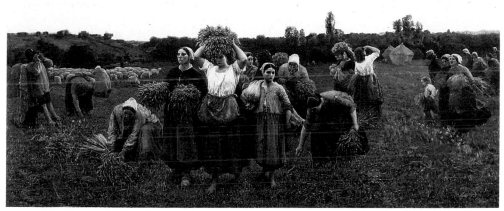

13 Jules Breton *Calling the Gleaners Home* 1859

demonstrations during a strike. By the autumn he admitted to an abatement of his evangelical ambitions. He was, however, hardly idle. Drawing 'far into the night' (LT131), he quickly filled up sketchbooks with images of miners – 'types', as he referred to them (LT131, 5 August 1879). That winter he walked to Courrières to see one of his admired painters, Jules Breton, but lost 13 courage when confronted with the discrepancy between Breton's comfortable life and the peasant subject-matter of his paintings.

A long, uncertain and defensive letter to Theo in July 1880 was followed by a short decisive message on 20 August requesting prints (reproductions after Millet's *Labours of the Field* among others) to serve as models to copy. 88 Van Gogh also asked Tersteeg to send Charles Bargue's *Exercices de fusain*, a kind of 'teach yourself to draw' book published by Goupil. He had already copied Bargue's *Cours de dessin*, a pedagogical compilation of reproductions 14, 114 of Old Masters and plaster casts. He followed this self-directed course with dedication and energy and attempted to transfer the lessons of his models to his depictions of miners.

Needing artistic friendship but hesitating to join Theo in Paris, he went to Brussels in October 1880, where he considered enrolling in the Brussels Academy, which was free, unlike the Academy in Amsterdam. By the beginning of November he had also paid a visit to van Rappard, whom Theo had known in Paris. The friendship, maintained by correspondence, lasted five years until ruptured by misunderstanding (for a time he had even shared van Rappard's studio).

Van Gogh continued to copy reproductions but he also found models in an old porter, working men and soldiers. He studied anatomy from books and borrowed a skeleton from another artist. He aimed to acquire skills in draughtsmanship which would enable him to earn a living as an illustrator – he calculated his minimum requirement as 100 francs a month. In addition to prints after Millet, Daubigny, Ruysdael and other painters, he began to collect French illustrations, singling out Honoré Daumier, Gustave Doré, Paul Gavarni and Félicien Rops. Several drawings from these months imply a supplementary narrative in their historical costume and depicted activity.

As he was forced to move somewhere less expensive and wanted an area that would offer picturesque subjects, he returned on 12 April 1881 to his parents' home in Etten, where he remained until the end of that year. He sketched landscape motifs and found local farmers and housewives to pose for a small fee, not without frustration, since 'they only want to pose in their Sunday best' while he wanted their 'characteristic bumps and dents' (LT148). These sketches from life were restricted to single figures, but he also attempted to compose drawings (which he distinguished from sketches). In these the spatially dislocated figures show the weakness of his training. He continued to copy Bargue's exercises in order to correct the flaws which were apparent to his self-critical awareness – in particular his attention to detail at the expense of the general view – and he studied books by Armand Cassagne on perspective and watercolour.

14 *Study of Two Nudes (after Bargue)* 1880

15 *Barn with Moss-grown Roof* 1881

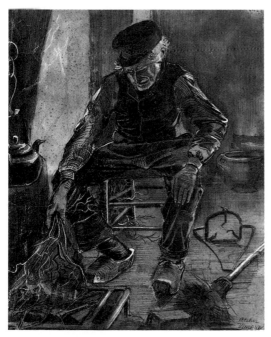

16 *Old Peasant by the Fire* 1881

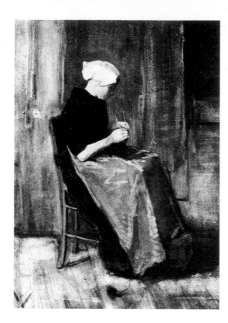

17 *Young Scheveningen Woman knitting* 1881

18 Anton Mauve *Wood Gatherers on the Heath*

Van Rappard visited him in June. Probably in September van Gogh went to The Hague, and after his return wrote to Theo about this encounter with contemporary Dutch art, including the panorama of Scheveningen by Mesdag and others 'whose only fault is that it has no fault' (LT149). He preferred Mesdag's more flawed drawings. A renewed acquaintance with his cousin Anton Mauve bolstered his confidence. Mauve evinced interest in van Gogh's 'own' drawings (as distinct from his copies), offered advice and further critical instruction, and thought he 'should start painting now' (LT149). Theo, in turn, relayed his and Tersteeg's cautious encouragement.

18

A longer period of study with Mauve in December 1881 was even more productive. His first paintings are datable to these weeks. In addition he made several watercolours of a Scheveningen girl knitting which he at last thought 'saleable in case of need' (LT163). Mauve had actually touched up one of them. Their atmospheric softening of the figure and the rather characterless features of the model are atypical of van Gogh's work, in spite of which he wanted to keep them, 'in order to remember better some things about the way in which they are done' (LT163).

17

Mauve also helped to ease van Gogh's relationship with his father, sending an encouraging progress report, but the Etten atmosphere had become strained for more than financial reasons. During the summer van Gogh had become emotionally attached to his widowed cousin Kee Vos who had come with her young son to stay in Etten. She firmly rejected his advances, but he

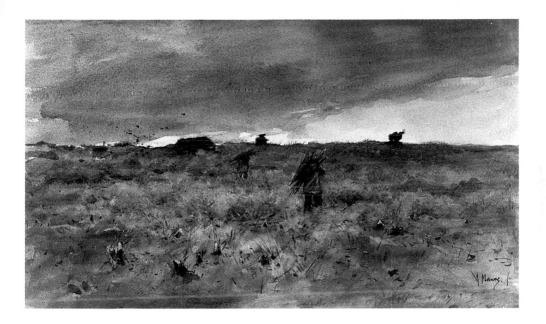

persisted, even travelling fruitlessly to Amsterdam in December to see her. Van Gogh believed this episode underlay a violent quarrel with his father on Christmas Day, the immediate cause of which had been his refusal to go to church. The Pastor told his son to leave the house.

Van Gogh went immediately to The Hague, to Mauve, who helped him set up a studio in the outskirts near the Schenkweg (the road), where he settled for the next twenty-one months. He soon met Clasina Maria Hoornik (Sien), a seamstress and charwoman who increased her income by prostitution She already had several children and was again pregnant when van Gogh met her. In an attempt to rescue her from a life that appalled him, he offered to pay her, her mother and daughter a guilder a day to model for him. In July 1882 he moved to a larger studio, and after the birth of her child Sien came to stay. They may even have lived together earlier, as van Gogh wrote to Theo in May, 'I could not pay her the full wages of a model, but that did not prevent me from paying her rent.' (LT192). The relationship did not fulfill his ideal of domesticity but it provided him with the emotional satisfaction of performing a good deed in saving a 'fallen woman', and it gave him ready models.

Van Gogh's family were not alone in disapproval of his new relationship; Theo warned him that their parents were thinking of having him locked up in an asylum. The liaison with Sien eventually interfered with his friendships with more respectable artists, but until it did so he actively involved himself

19

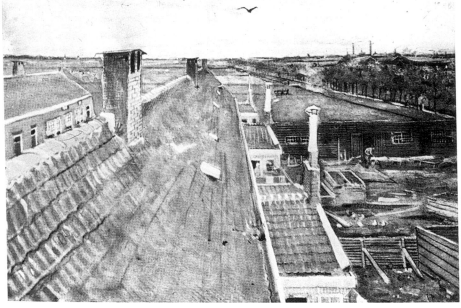

19 *Roofs seen from Artist's Attic Window* 1882

in the artistic life of The Hague. To van Rappard he wrote defensively in February 1883: 'When I first came to this city I went to all the studios I could visit in order to find intercourse and make friends. Now I have cooled off very much in this respect, being of the opinion that there is a serious drawback to it, in that the painters pretend to be friendly, but are too often inclined to trip you up.' (R20).

Mauve's interest in his 'pupil' had begun to wane after a month or so. They had an argument over the value of drawing plaster casts. Mauve developed doubts about van Gogh's abilities, and van Gogh began to suspect that Tersteeg had enlisted Mauve in an alliance against him. To Theo he reported discouraging comments from both: Tersteeg called his drawings 'unsaleable' and 'without charm' (LT195). On the other hand, Mauve's friend the artist Jan Hendrik Weissenbruch said that he drew 'confoundedly well' (LT175). George Breitner, another artist friend, accompanied him on walks to sketch in the streets and look for 'types among the people' (LT178). During the spring of 1882 he attended the Pulchri Studio, an artists' society for drawing and discussions, where he was approached to show his collection of English wood engraving illustrations. Later he associated with the younger Hague

painters Herman Johannes van der Weele, Théophile de Bock and Bernard Blommers. De Bock offered him accommodation in Scheveningen during a painting excursion. Nevertheless, van Rappard remained his closest friend, the occasional visit supplementing a sometimes plentiful flow of letters and an active exchange of duplicate wood engravings.

In The Hague van Gogh managed to purchase well over twenty volumes of the *Graphic* and *Illustrated London News* covering the decade of the 1870s. He cut out the illustrations and mounted them on grey card in order to arrange them by artist. He had sustained his project to become an illustrator, and his Hague drawings seek a directness of imagery with a sharply descriptive rendering. He learned from the graphic vocabulary: already there is a variety of marks and the rich, hatched shading makes tone rather than contoured volume. With the help of a printer he explored the medium of lithography, envisaging the production of a series of thirty related prints but finally realizing only eight. On an image of an old man with his head in his hands, he inscribed an English title, 'At Eternity's Gate', November 1882. A 164 related crouching position, signifying grief and despair, occurs in *Sorrow*, 20 November 1882, also titled in English, which reproduced an earlier nude drawing of Sien

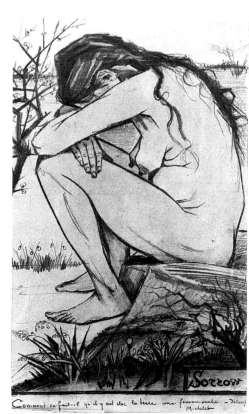

20 *Sorrow* 1882

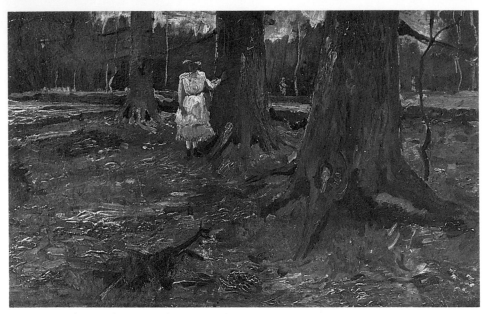

21 *Girl in a Wood* 1882

Such images of emotion recur in his Hague work but he applied himself
most frequently to a close-focus observation of elderly men, working people,
Sien and her family. In these drawings self-containment and absorption
powerfully amplify the types derived from illustration which underly them.
After only a few months in The Hague he received his first commission, an
order from his uncle C. M. for a series of twelve drawings of views of the city
at 2.50 guilders apiece. C. M. also purchased three drawings he saw in the
studio. Van Gogh put together a second series of seven drawings in May,
which met with much less approval, and he received only twenty guilders for
the lot. Most of the drawings show views on the outskirts of the expanding
city whose starkness is unmitigated by any touch of conventional charm.

He broke off a hesitant beginning in oils in January 1882, but took up the
medium again in August after a visit from Theo who had enabled him to
purchase the necessary materials. He still expressed uncertainty, mostly
because of the expense of oils, but in such terms as to elicit Theo's continued
sponsorship: 'I think it possible that if you saw the paintings, you would say
that I ought to go on with it, not just at times when I feel particularly inclined,
but regularly, as absolutely the most important thing, though it might cause
more expenses.' (LT227). Painting gave him the satisfaction of working in

118, 119
22, 121

21

34

colour. He described the ground of a woodland landscape in savoury detail: 'that ground is very dark – more red, yellow, brown ochre, black, sienna, bistre, and the result is a reddish-brown, but one that varies from bistre to deep wine-red, and even a pale blond ruddiness.' (LT228). The following summer he again produced a number of oil studies.

The Hague period set the foundations for van Gogh's later work: there he worked out his early artistic aspirations; his contact with other artists, although not totally satisfactory, helped to give direction to his efforts; despite periods of ill health brought on by stress, poor diet and disease (he was in hospital for venereal disease in June 1882), the quantity of his production, much of which has been lost, represents total application.

In 1883 his project began to shift from illustration to painting, from city motifs to country ones. He had also recognized that after several years Theo was still his sole means of support and this set him to find a cheaper place to live. Van Rappard encouraged him to go to Drenthe, an area that was attracting painters 'so that perhaps, after a time, a kind of colony of painters might spring up' (LT316). He parted from Sien: though not necessarily intending the separation to be final, he had become disillusioned by her resistance to 'salvation'. He left The Hague on 11 September 1883.

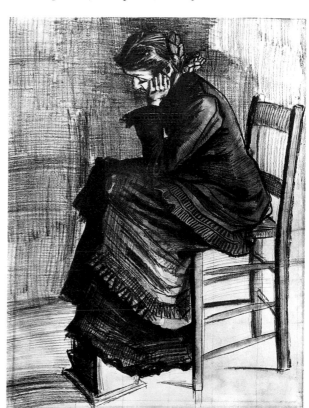

22 *Sien seated* 1882

23 *Landscape with Wheelbarrow* 1883

Van Gogh spent less than three months in Drenthe, although he had initially considered settling there permanently. From Hoogeveen, his first stop, he moved to Nieuw-Amsterdam but made frequent canal journeys back to Hoogeveen to collect his money and supplies. In his isolation from close personal contacts, he wrote prolifically to Theo, attempting to persuade his brother to give up art dealing and become an artist, going so far as to suggest that he might refuse further financial help. At the end of November he travelled to Zweeloo hoping to find the German painter Max Liebermann or a fellow painter, but there were none in the winter season.

Local residents were unwilling to pose for him, despite being paid. He thought they regarded him 'as a lunatic, a murderer, a tramp' (LT343). In studies of labourers working in the fields, the figures are set at a greater distance than the closely confronted Hague figures. The more numerous

23, 122 landscapes feature flat fields and bogs, with houses huddling low against the horizon.

Leaving work behind in Drenthe, he went to his parents' home in Nuenen in December 1883, having asked his father to advance him the fare. His

relationship with his father was no easier than before – 'keeping the peace with father is a hard job' (LT348) – but the family did offer him a small laundry-room behind the house to use as a studio. He collected his possessions from The Hague, where he briefly saw Sien and decided definitely to live apart from her.

In January 1884 his mother broke her leg while getting off a train. The accident helped to improve family relationships or at least push differences into the background; nevertheless, in May he rented his own studio of two rooms from the sexton of the Roman Catholic church, though he continued to eat and sleep at home. Ten months later, on 26 March 1885, his father collapsed and died after a walk home across the fields. Difficulties developed with his mother and sisters and to escape these, he moved the following May into an attic above the studio.

Even with Theo he nearly had a rupture. Towards the end of 1883 Vincent's persistent insistence in Drenthe that Theo become a painter had irritated the younger brother. The financial issue also loomed large, as van Gogh's frustration over not being able to earn his living grew. He accused Theo of failing him: 'You have *never sold a single one for me* – neither for much nor for little – and in fact *you have not even tried*.' (LT358, March 1884). So he devised a more regular financial agreement with Theo during the early months in Nuenen.

Depictions of weavers had developed into a dominant motif soon after his arrival in December 1883. He also executed a number of large, detailed pen and ink drawings of the wintry landscape. Some he sent to van Rappard, asking him 'to show them to people if you have the chance' (R41). He turned to van Rappard in the midst of his difficulties with Theo, writing a number of letters, which expounded his artistic beliefs, and sending him drawings. '[Rappard] liked them *all*' (LT364), Vincent retaliated to his brother. In May and October 1884 van Rappard paid visits. Theo came in June, and the brothers smoothed over their differences: Vincent wrote of it as a 'pleasant' visit (LT370).

During the summer another unfortunate romantic relationship ended in near tragedy. Van Gogh had proposed to marry Margot Begemann, a friend and neighbour, but her family opposed the match. She 'took poison in a moment of despair' (LT375) but survived and was sent to Utrecht for treatment. The attachment, stronger on her part than his, did not recommence when she later returned to Nuenen. The incident, however, had repercussions among the villagers who began to avoid the vicarage.

The same summer van Gogh formed a more positive association with a former goldsmith from Eindhoven, named Hermans. He made half a dozen compositional sketches for Hermans's dining-room based on scenes of

26

peasant life, 'at the same time symbolizing the four seasons' (LT374). Hermans himself wanted to execute the final decoration, so van Gogh retained his canvases but received twenty-five guilders (and perhaps a bit more for expenses). While he complained to Theo about Hermans's stinginess, he valued the friendship too much to object, especially as he also regarded Hermans as a pupil. In November 1884 he informed Theo, 'I now have three people in Eindhoven who want to learn to paint, and whom I am teaching to paint still-life.' (LT385). Besides Hermans this small group included Willem van de Wakker, a postal worker, and Anton Kerssemakers, a tanner. In 1912 Kerssemakers reminisced about a van Gogh who was a patient, gentle teacher, dedicated and intense about his art. Van Gogh also offered lessons to Dimmen Gestel, a young printer, from whose family's shop he purchased printers' ink and a lithographic stone.

During the winter of 1884–85 van Gogh drew and painted numerous heads of local peasants, which he explored in profile, full face, against the light and under artificial light. He studied the full figure, usually that of a woman engaged in domestic tasks. He also worked at details of hands, developing the language of modelling from strongly outlined shapes to curved hatchings describing internal contours. These studies bore fruit in an ambitious, multi-figure composition of peasants seated round their evening meal, *The Potato Eaters*, dated April 1885. He expressed a rare confidence about his achievement and even two years later from Paris told Wil that 'the picture I did at Nuenen of those peasants eating potatoes is the best one after all.' (W1). So important was this composition to him that van Rappard's criticism of a lithographic version led to a permanent rift in the summer of 1885.

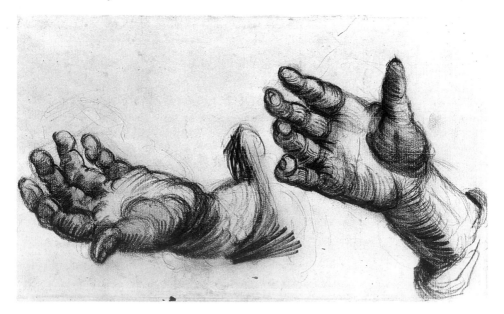

24 (opposite) *Hand Studies* 1885

25 *Head of a Peasant Woman with a White Cap, facing right* 1885

26 *Weaver facing front* 1884

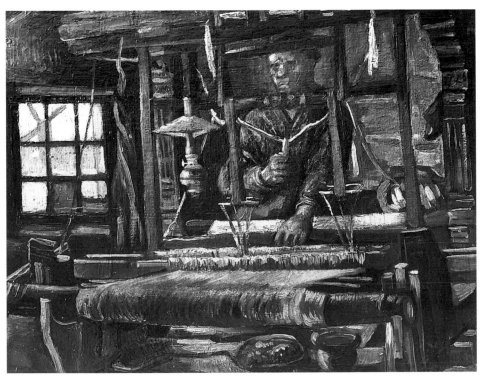

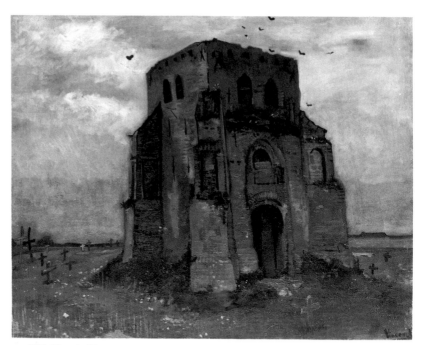

27 *Old Church Tower* 1885

 During that summer van Gogh returned to landscape painting. Nuenen's
27 old church tower in the process of demolition and peasant cottages fill the
picture space and dominate the natural environment. He also returned to the
full-length figure in a series of drawings of peasants working in the fields,
29 digging, gleaning and reaping. From different angles he repeatedly fixed on
28 figures bent double with haunches in the air, working the earth with their
hands. With experience he began to locate the figures in a more detailed,
varied landscape.

 In September once more he met problems in obtaining models. The local
clergy attempted to dissuade him from becoming too familiar with people of
a lower station, while simultaneously the priest offered the peasants money
not to pose. Van Gogh interpreted the source of the problem to have been a
model's illegitimate pregnancy, for which he had been wrongly blamed. He
turned to still-lifes worked in bituminous dark colours where the forms of
30 apples, potatoes and birds' nests appear to be worked up through the relief of
the actual paint surface.

40

30 *Birds' Nests* 1885 >

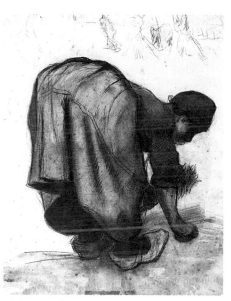

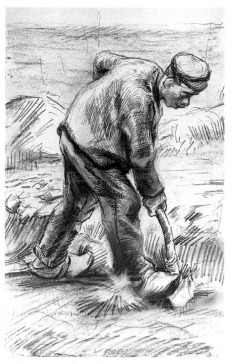

28 Peasant Woman stooping 1885 *29 Peasant turfing 1885*

With Kerssemakers he visited the museums in Amsterdam in October 1885. He was transfixed by Rembrandt's *Jewish Bride* and *The Syndics* and by Frans Hals's portraits, and he singled out works by Israëls, Meissonier, Diaz, Rubens, Cuyp and van Goyen; however, constantly 'in the museum I was thinking of Delacroix' (LT427). His reading had acquainted him with the reputation of the French Romantic painter Eugène Delacroix and, unable to refer to his paintings, he formulated an image of his colour and facture from the critical and historical literature. That autumn a more textural handling and brighter palette emerged in a group of autumnal landscapes.

Meanwhile, Theo reported the latest Parisian art of Manet and the Impressionists, to which descriptions Vincent remained resistant. Rather than Paris, he foresaw Antwerp as a market for his work. He longed for contact with painters and pictures and intended to study life drawing at the Academy and Rubens in the museums. Although he planned only a temporary stay, his departure from the Netherlands on 24 November 1885 became permanent.

Antwerp turned out to be a stopover of a mere three months on the way to Paris. Although he had barely time to settle, his decision to leave the countryside and its peasant motifs for an urban milieu made the move to Antwerp critical. 'How glad I am to see the city again,' he wrote, 'much as I like the peasants in the country. How the bringing together of contrasts gives me new ideas – the contrasts between the *absolute quiet of the country and the bustle here*. I needed it badly.' (LT443).

He decorated his room with Japanese prints, the first recorded instance of his familiarity with these non-European works. He sketched in dance halls

31

31 *Women dancing* 1885

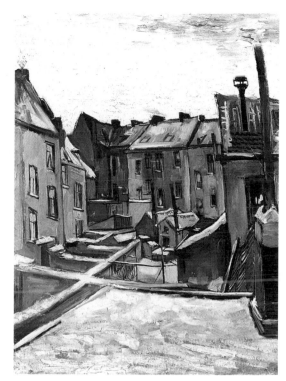

32 *Skull with Burning Cigarette* 1885

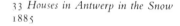
33 *Houses in Antwerp in the Snow*
1885

and *café-concerts* and made street and architectural views. He produced 33
portrait drawings and some paintings whose lighter tonality and colour
range reflected his study of Rubens; he began 'looking for a blonde model just 126
because of Rubens' (LT439).

In mid-January 1886 he enrolled at the Academy, where he had his first
opportunity to draw from the nude model (apart from a few works for
which Sien had posed, his previous nude studies had been copies after the
exercises in Bargue). He also drew ornaments and subjects after the antique. 32
In addition to classes at the Academy he drew at two evening drawing clubs
in order to study the female nude.

His blue blouse and fur cap amused his fellow students, as did his manner of
painting furiously with brushes so loaded that paint dripped to the floor. His
teachers advised him to draw plaster casts and nudes for at least a year. While
he reported their criticism to Theo as encouragement, other pupils
remembered heated arguments. As a result of the February examinations he
was put back to the beginners' class, but by the time the results were
published he had already left for Paris and may never have learned the
governing body's verdict.

43

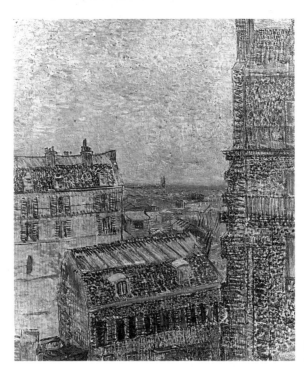

34 *View from Vincent's Room in rue Lepic* 1887

During these months he was woefully short of money and even considered working for a photographer. His health was poor and he complained of faintness – he had hardly eaten a hot meal since moving from Nuenen. It has been suggested that he was treated for syphilis; certainly he had to undergo dental work.

He equivocated about going to Paris. At first he saw it as a more distant goal, then he began to press Theo in order not to have to return to Brabant. Then, without warning he arrived in Paris in early March 1886. On a scribbled note to Theo he wrote, 'Do not be cross with me for having come all at once like this; I have thought about it so much, and I believe that in this way we shall save time. Shall be at the Louvre from midday on or sooner if you like.' (LT459).

During the next two years the brothers shared an apartment, first in the rue Laval (now rue Victor Massé) just south of the boulevard de Clichy and place Pigalle, then in larger quarters with studio space in the rue Lepic in Montmartre. This move may have been related to commercial schemes: from Antwerp van Gogh had written, 'If one wants to start a studio, one must consider well where to rent it, where one has the greatest chance of getting visitors, and making friends, and getting known.' (LT454).

34

44

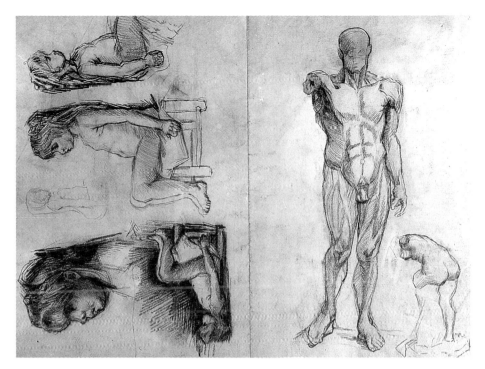

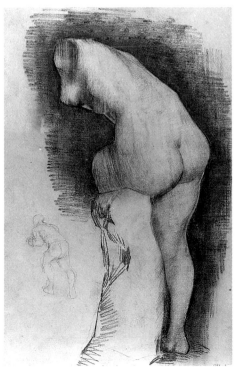

35 *Studies of a seated Nude Girl and Plaster Statuettes* 1886

36 *Studies of Plaster Statuettes* 1886 (detail of verso of 35)

Although he had stated that one reason for coming to Paris was to study at Félix Cormon's atelier, his immediate attendance there remains unconfirmed. Cormon, a popularly successful painter, had opened his studio at the request of dissatisfied students from the Ecole des Beaux-Arts. Compared with Léon Bonnat at the Ecole he was open-minded. Besides van Gogh, other notable students between 1884 and 1886 included Emile Bernard, Henri de Toulouse-Lautrec, Louis Anquetin and John Russell; however, apart from Russell van Gogh seemed not to have formed close relationships with these artists, or with others whose later reputations established them in the forefront of advanced painting, until 1887. In the late summer or early autumn of 1886 he wrote to his Antwerp friend H. M. Livens that he was not yet one of the club of Impressionists (LT459a).

35, 36 Only a few figure drawings from his Cormon days survive but numerous
99 drawings and paintings after plaster casts attest to his application. In the
37 summer he concentrated on flower still-lifes, thickly painted and colourful in the manner of Adolphe Monticelli's later work. The van Gogh brothers and their friend Alexander Reid, a Scottish painter and dealer whom Vincent had known since his time in London, admired Monticelli's work and Theo soon acquired six of his paintings. Besides still-lifes, van Gogh produced his first painted self-portraits. The more numerous urban landscapes take a panoramic view – either from a high, distant vantage point or in a horizontal spread – or, like some Hague drawings, explore the territory at the developing edge of the city. Although he had rarely painted windmills in
39, 131 Holland, he depicted the windmills of Montmartre both as a motif and as a presence on the horizon.

37 Adolphe Monticelli *Vase with Flowers c.* 1875

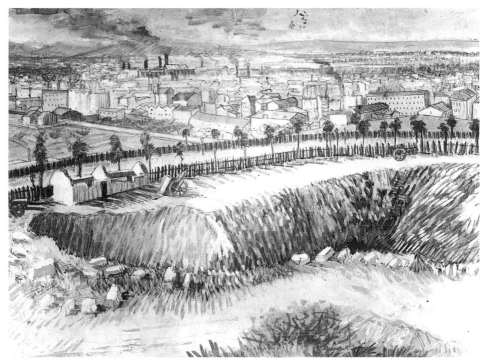

38 *Suburb of Paris seen from a Height* 1887

During his first year in Paris van Gogh cautiously proceeded to come to terms with contemporary French painting, probably with the assistance of Russell, and to seek acquaintance with less radical young artists. He proposed exchanging pictures with Antonio Cristobal and Fabian, but Angrand was the only painter associated with the emergent Neo-Impressionism whom he approached in 1886.

The situation changed in 1887. Though he had met Bernard at Cormon's in autumn 1886, their close contact developed from a meeting at Père Tanguy's shop probably late in 1886; Bernard in turn introduced van Gogh to Anquetin. Tanguy was an artists' merchant who also traded in pictures, which he often received from painters in exchange for art supplies. He was one of several smaller dealers who took on van Gogh's work. Tanguy's shop served as a meeting place for artists and here, probably in January or February 1887, van Gogh also made the acquaintance of Signac.

Van Gogh painted alongside Signac at Asnières, one of the suburbs of expanding Paris, during the spring of 1887. In the summer and autumn he

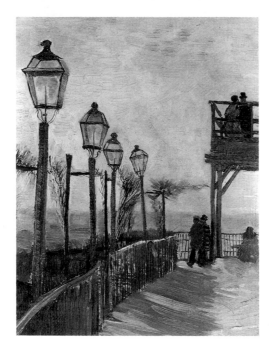

39 *Montmartre near the Upper Mill* 1886

visited Bernard, who lived with his father in the same village. Bernard reminisced, 'Vincent often came to see me at the wooden atelier built in my parents' garden in Asnières. It was there that we both set out to do portraits of Tanguy. He even started a portrait of me, but having quarrelled with my father, who refused to go along with his advice concerning my future, he grew so angry that he abandoned my portrait and carried off, unfinished, that of Tanguy, flinging it still wet under his arm.' The three artists never worked in tandem, Bernard and Signac being theoretical opponents.

Van Gogh also associated with Camille Pissarro and his son Lucien, although he did not see much of the elder Pissarro before the end of 1887. Theo's role as a dealer – he now managed one of the branches of Boussod and Valadon, who had taken over from Goupil – assisted contact with the Pissarros and he was the first to handle Camille Pissarro's pointillist works. He also introduced his brother to Degas and Monet (two others with whom he had a commercial relationship), although neither of these older painters became close friends. Of this generation, other than Pissarro, only Armand Guillaumin became more than a casual acquaintance. Bernard also recorded a meeting between van Gogh and Cézanne at Tanguy's. Then in the early part of 1887 van Gogh sometimes attended Toulouse-Lautrec's weekly open house. He admired Seurat's work but met him (then the leader of the Neo-

Impressionists) only in the late autumn or winter of 1887–88 and paid a sole visit to Seurat's studio on the eve of his own departure for Arles. It is possible that he met Gauguin in the early months of 1887, before Gauguin's trip to Martinique. If so they did not become well acquainted until Gauguin's return in late November, when Theo also became commercially interested in Gauguin's work.

While Theo van Gogh was able to introduce his brother to other artists, he was not in a position to promote his work at the Boussod and Valadon gallery on the boulevard Montmartre. His enthusiasm for the Impressionists was not supported by the firm's directors, and he had to exhibit their works upstairs. He did, however, take his brother's work to some of the smaller dealers. One of these, Arsène Portier, had shown an interest before van Gogh moved to Paris, but it is not known whether he actually had any dealings with him. Julien François Tanguy (Père Tanguy) was the first to exhibit van Gogh's 85 works in his shop, followed by George Thomas (Père Thomas) and Pierre Firmin Martin. While several other art merchants are named in the letters, Tanguy remained the most loyal and reliable. Van Gogh portrayed Tanguy three times, initially in a naturalistic format (presumably the work painted at Bernard's studio) and later two versions in a more emblematic manner, seated before a background of paintings and Japanese prints.

Since it was difficult for younger, less conventional artists to get a public showing, Vincent van Gogh himself, with his previous experience in dealing, organized an exhibition of 'Impressionists of the Petit Boulevard', as he referred to the younger generation (he distinguished his group by Parisian geography from the first-generation Impressionists of the 'Grands Boulevards'). The exhibition took place in November and December 1887 at the Grand Bouillon, Restaurant du Chalet on the avenue de Clichy. Bernard estimated that van Gogh displayed about a hundred of his own paintings. Anquetin, Bernard himself, Koning (a Dutchman) and Toulouse-Lautrec also exhibited in a hall where more than a thousand canvases could be hung. Van Gogh had wanted to include Seurat and Signac, but the hostility of others towards the Neo-Impressionists made this impossible. According to the memory of Cristobal, Pissarro, Gauguin and Guillaumin were persuaded by van Gogh to display works once the exhibition had opened. Visitors included several art dealers and Pissarro, Gauguin, Guillaumin and Seurat. A dispute with the restaurant owner led to van Gogh's abrupt removal of his work, but later he recalled few regrets since both Bernard and Anquetin had sold works and he had made an exchange with Gauguin (LT510).

The Du Chalet exhibition was the second entrepreneurial venture of this type undertaken by van Gogh. In March he had organized an exhibition of Japanese prints at the Café du Tambourin, where he took his meals and

exchanged canvases for food. Bernard has suggested not only a business relationship but a personal one with the café's proprietor, the Italian Agostina Segatori, a former artists' model. Segatori may have been the model in two of van Gogh's paintings: *Woman at a Table in the Café du Tambourin*, 84 February/March 1887, and *The Italian Woman*, late 1887. An unpleasant incident, only fragmentarily described in a letter to Theo, broke their relations in July 1887.

Van Gogh did not align himself exclusively with any one of the several artistic camps. Association with Gauguin, Bernard and Anquetin did not hinder him from admiring Neo-Impressionism, and in the late autumn of 1887 van Gogh participated with Seurat and Signac in an exhibition in the *Salle de répétition* of André Antoine's Théâtre Libre.

Thus van Gogh's work found public showing as much as any of his colleagues. Nor did he completely fail to sell his work (despite popular mythology). Gauguin recorded the purchase of a still-life of shrimps by one of the small dealers.

During his second year in Paris van Gogh's painting came to take account of and interact with the work of his acquaintances and the new art he saw around him. The earlier coherence of his development dispersed as his facture, composition and motif took on board the competing ideas he encountered.

His palette brightened, at first cautiously diluting the hue, thinly spread on the light canvas ground. His brushwork delicately embroidered the canvas with fine strands and dots of contrasting colours. Later a vocabulary of brushstrokes, in which marks functioned simultaneously as descriptive texture, as modelling and as indication of spatial depth, borrowed from and supplanted drawing *per se*.

Many earlier motifs appear with subtle differences. Some still-lifes focus on particular kinds of objects – for example, old boots. Others explore a greater range of objects: plants, books, café items, food and flowers. Compositionally, they range from single objects closely observed to a simple grouping of several items, to a radiating sprawl across the canvas. Landscapes continue to depict Montmartre and the Parisian *banlieus*, to which is added 133, 167 the more suburban Asnières. Varying perspective constructions open or foreclose the picture space. He continued to paint self-portraits and portraits. While he tended to focus on his own head, the portraits of others often took in 40 more of the sitter's environment. In addition, there were female nudes and 129 some restaurant interiors.

In the late summer and early autumn of 1887 he painted three motifs after 81 Japanese prints, perhaps attempting to learn from these works, which he so admired, as he had learned through his exercises from Bargue. He undertook

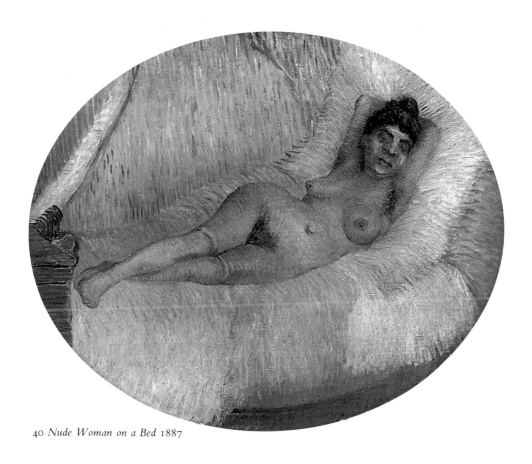

40 *Nude Woman on a Bed* 1887

this task at a moment of great personal stress: relations with Theo had become especially strained again, and he had recently broken with Segatori.

While some paintings concentrate on specifically urban motifs (the boulevards and the outskirts along the *barrières*, some café scenes), and while a few of the scenes of Asnières depict the industrialization of the suburbs, a great part of his work relegates the modern world to the background or displaces it onto less overt motifs. The nudes appear to represent prostitutes. The depicted Japanese prints and novels allude to modernity but in the paintings of such objects formal issues of pictorial representation come more to the foreground. By autumn 1887, the landscapes and still-lifes, even the portraits and self-portraits, relinquish some of their presence as motifs to the assertive colour and facture which construct the images.

38, 166

Despite their common cultural interests and projects for the amelioration of the financial and material problems of modern artists, the van Gogh brothers found life together quite difficult. Andries Bonger, a friend of Theo and his future brother-in-law, remarked several times about Vincent's awkward personality and the trouble it caused Theo. Vincent had difficulty in coping with Paris. His first letter after his departure explained: 'It seems to me almost impossible to work in Paris unless one has some place of retreat where one can recuperate and get one's tranquillity and poise back. Without that, one would get hopelessly stultified.' (LT463). Later, to Gauguin he confessed, 'when I left Paris, [I was] seriously sick at heart and in body, and nearly an alcoholic because of my rising fury at my strength failing me.' (LT544a).

In February 1888 van Gogh left Paris for the south of France. It was a considered move, although the date of departure may have been a sudden decision if Bernard is to be believed: 'One evening Vincent said to me, "I'm leaving tomorrow; let's arrange the atelier in such a way that my brother will feel that I'm still here."'

Van Gogh arrived in Arles on 20 February. The unusually heavy snowfall which he encountered contradicted his expectations of sun (W1). Van Gogh's idea of 'the South' encompassed the exotic North Africa visited by Delacroix, the home of Monticelli, who came from Marseilles, and an ideal 'Japanese' world of sun, limpid skies, and happiness. The tales of *Tartarin de Tarascon* by the Provençal Alphonse Daudet filled out his image of the south.

When he arrived he first stayed at the Hôtel–Restaurant Carrel on the rue Cavalerie, but in May he rented the rooms of a small house at 2 place Lamartine, not far from the railway. He was unable immediately to afford furnishings for this 'yellow house' and left his first lodgings in a dispute over the bill and moved until the middle of September to the Café de la Gare, also in the place Lamartine. Months before the house was ready for occupation, indeed almost immediately after he rented it, he wrote of his wish 'to share the new studio with someone', mentioning both Gauguin and Dodge MacKnight (an American painter and friend of John Russell), who was staying at nearby Fontvieille (LT480). Later he repeatedly invited Bernard and Gauguin to join him and enlisted Theo's more persuasive financial incentive to work on Gauguin: 'Now the fact is that my brother cannot send you money in Brittany and at the same time send me money in Provence. But are you willing to share with me here? If we combine, there may be enough for both of us, I am sure of it, in fact', van Gogh wrote to Gauguin at the end of May (LT494a).

Although van Gogh was away from the Paris art scene he kept abreast of the news by correspondence with his friends there. Nor was he completely

41

41 Photograph of the Yellow House at Arles

isolated from personal contact with artists in Arles: a few local amateur artists visited him. He struck up a friendship with the Danish artist Christian Mourier-Petersen in early March and gave him letters of introduction to Theo and friends in Paris. At the end of April he met Dodge MacKnight, and in June he met a friend of MacKnight, the Belgian artist Eugène Boch, whose portrait he painted in September as 'The Poet'. He began giving drawing lessons to Milliet, a second lieutenant in the Zouaves, in June. Yet, about 5 July he complained to Theo of loneliness and of disappointment in not making connections with art lovers in Arles (LT508). His most loyal friend turned out to be Joseph Roulin, a postal worker. He painted the first portrait of Roulin in late July, eventually producing several more, as well as paintings of the entire Roulin family.

52

50

47

Gauguin finally arrived in Arles on 23 October 1888. In the preceding months van Gogh had produced a large body of work, in which he clarified what he had learned about colour in Paris under the sun and light of Arles. He transformed the experience of brushwork and mark-making he had encountered in contemporary painting and fused it with his knowledge of Japanese prints and the developing cloisonnist style of friends like Anquetin, Bernard, Gauguin and Toulouse-Lautrec. Once away from the constant exposure to new artistic ideas, his Dutch vision had reasserted itself in fresh terms.

104, 105

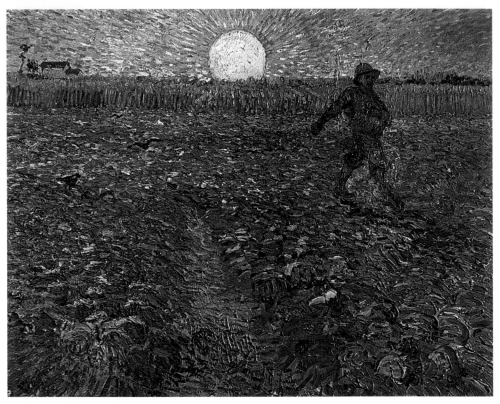

42 *Sower with setting Sun* 1888

43 *Peasants working in a Field* 1888

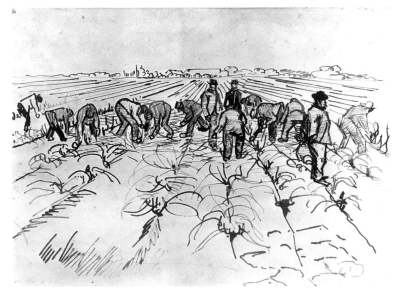

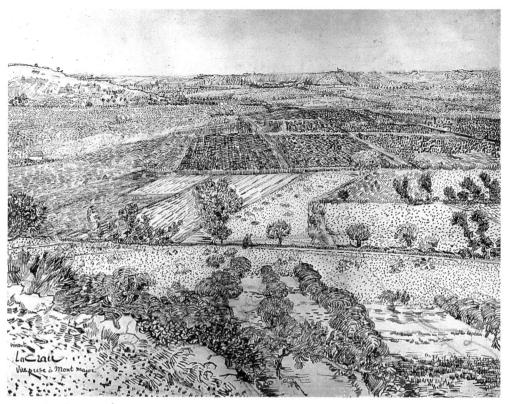

44 *La Crau seen from Montmajour* 1888

Like his earlier departure from The Hague, his move from Paris was a retreat from the city. Not surprisingly, landscape motifs dominated his production. The snow melted and flowering fruit trees came into bloom. In March and April he painted the blossoming orchards and individual trees. One of these, *Pink Peach Trees*, April/May 1888, he dedicated to the memory 48 of Mauve on learning of his former teacher's death on 8 February.

At the end of April, when he heard of Theo's difficulties with his 43 employers over promoting the Impressionists, Vincent turned mainly to drawing as an economy measure. In May he made a series of large pen and ink drawings of the Crau plain and Montmajour, the site of a ruined abbey, in 44 response to Theo's suggestion that he send some drawings to the second exhibition of the Dutch etching society in Amsterdam. Ultimately, he submitted none of these panoramic vistas, but in July he produced a second series of drawings from the same site. These, too, had a specific motivation –

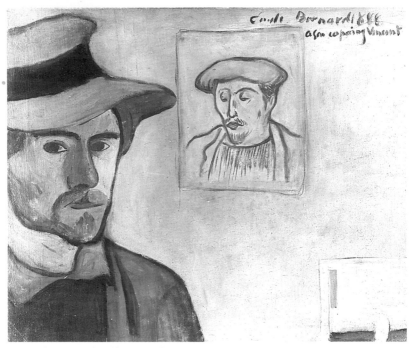

45 Emile Bernard *Self-portrait 'à son copaing Vincent'* 1888

to raise money for Gauguin's visit; however, the dealer Thomas, for whom they were intended, refused to buy them. These five large drawings, to which van Gogh accorded an importance equal to painting, explored both looming close-ups and bird's-eye views – vantage points taken less frequently in his contemporaneous landscape paintings, which tend to construct a more continuous spatial recession from a near foreground towards a distant incident on the horizon.

He visited the fishing village of Saintes-Maries-de-la-Mer for several days at the end of May, just after the annual religious pilgrimage. There he painted and drew several seascapes, local cottages and fishing boats pulled up on the beach.

In July van Gogh began to make drawings for Bernard and Russell after paintings that he was preparing to send to Theo. As he explained to his brother, 'Today I sent six drawings after painted studies to Bernard. I have promised him six more, and I have asked for some sketches after his painted studies in exchange.' (LT511). He wanted the exchange not only to serve as a means of communication, but also to keep Theo informed of Bernard's latest

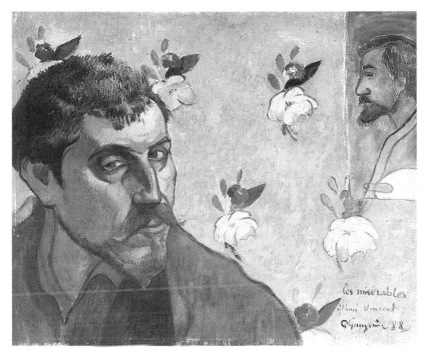

46 Paul Gauguin *'Les Misérables' (Self-portrait with Portrait of Bernard)* 1888

work in the hopes that his brother would buy one of Bernard's finished paintings. With Russell he hoped that this generosity would encourage Russell to purchase a Gauguin painting from Theo. He soon promised Theo a set of sketches after nearly the same works: 'You will then see better what there is in the painted studies in the way of drawing.' (LT518).

He proposed another sort of exchange to Gauguin and Bernard in September. As he reported to Theo, 'I would very much like to have here the portrait of Bernard by Gauguin and that of Gauguin by Bernard.' (LT535). Gauguin's contribution turned out to be a self-portrait, *'Les Misérables'*, 46 which depicted a smaller portrait of Bernard almost on, rather than in, the background. The arrival of the portrait was preceded by a letter in which Gauguin described his painting in symbolic terms: 'The mask of a badly dressed bandit, and with the power of a Jean Valjean, with his nobility and inner gentleness. . . . And this Jean Valjean, oppressed and outlawed by society, with his love and his strength, is this not also the image of the present-day Impressionist? And by painting him with my own features you have both my personal likeness and our portrait of all the poor victims of society.'

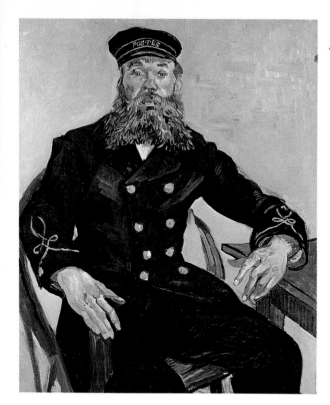

47 *Postman Roulin* 1888

48 *Pink Peach Trees*
(Souvenir de Mauve) 1888 >

45 Van Gogh preferred Bernard's self-portrait with its sketch of Gauguin in the centre background: 'The Gauguin is of course remarkable, but I very much like Bernard's picture. It is just the inner vision of a painter, . . .' (LT545). He also confidently felt that his self-portrait held its own against Gauguin's. In December Charles Laval, another painter working at Pont-Aven, also sent his own self-portrait.

After seeing his colleagues' self-portraits he wrote to Theo in early October that he had at last a more general confidence in his work (LT545). The paintings of the summer had become bolder in their juxtaposition of saturated colour, bolder too in their compositional clarity and frequent 50, 47, 51 simplicity. Portraits of Milliet, of Roulin, of a peasant named Patience Escalier 49 and a young girl he titled 'La Mousmé' (after reading a Japoniste novel by Pierre Loti) make deliberate shapes against simple or plain backgrounds. In 1 August he had begun a series of still-lifes of sunflowers in a vase, intending them as a decorative project for the walls of the yellow house. He later earmarked them for Gauguin's room. They share with the portraits a close presentation, strong individuality of outline and monochrome backgrounds.

49 *La Mousmé* 1888

50 *Lieutenant Milliet* 1888

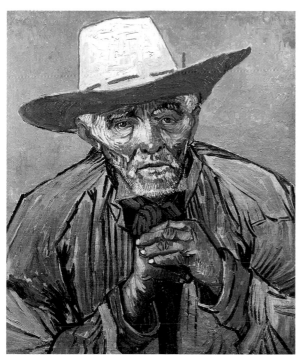

51 *Old Provençal Peasant
(Patience Escalier)* 1888

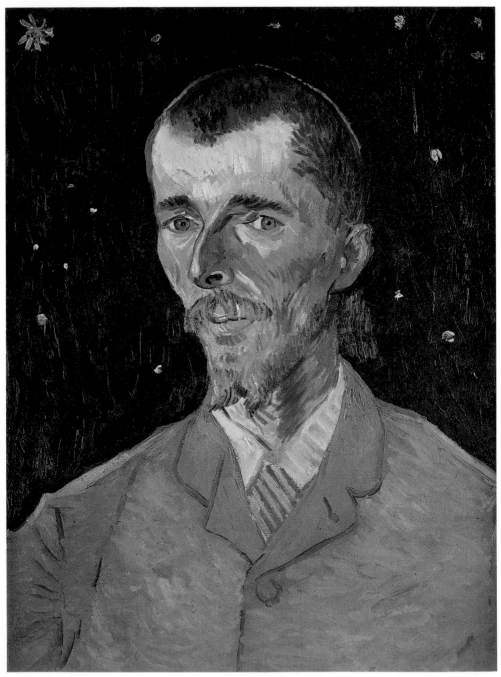

52 *Eugène Boch (The Poet)* 1888

53 *Park at Arles* 1888 >

New motifs appeared: interiors of a restaurant, a night café, his bedroom. He applied his attention to the town of Arles with *Café Terrace at Night*, September 1888; *The Yellow House*, September 1888; *Railroad Bridge*, October 1888, and *The Bridge at Trinquetaille*, October 1888.

Some of the portraits and the *Sunflowers* appear charged with an additional presence. Their flatness and the textured *matière* of the background likens them to icons. In the portrait of Boch he added stars to the background. Not simply a portrait, it was a study for *The Poet against a Starry Sky*, whose final version he destroyed along with *Christ with the Angel in Gethsemane*, 'because the form had not been studied beforehand from the model, which is necessary in such cases', so he explained to Bernard (B19, October 1888). Although he was not ready to paint without reference to reality, he invested certain works with symbolic significance, intensifying colours and exaggerating shapes and spatial construction. Even if his particular significance cannot be read from the paintings without the aid of the letters, their unnaturalness begs extra-visual associations. *The Night Café*, September 1888, *Café Terrace at Night* and *Starry Night over the Rhône*, September, all support van Gogh's association with Symbolism.

145

144

52

54, 55
146

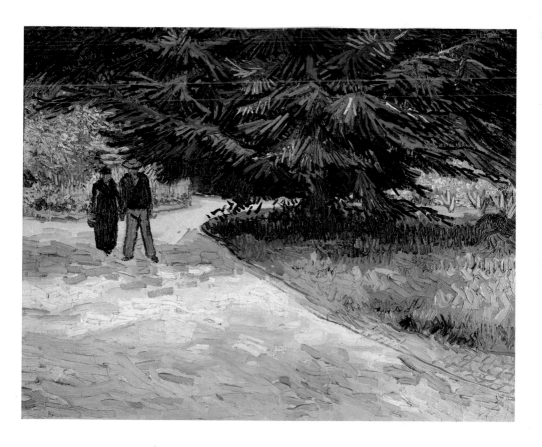

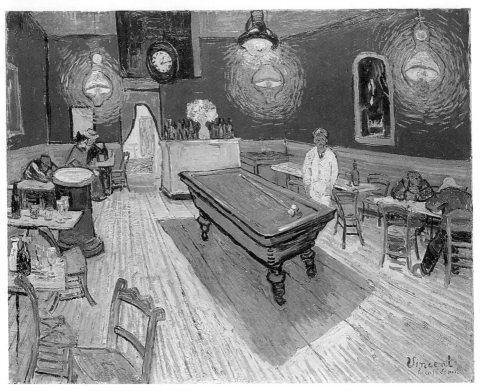

54 *The Night Café* 1888

53 Less obviously symbolic was a group of paintings of a public garden begun in September. The *Poets' Garden* was destined as a decorative group for Gauguin's bedroom. The poets in van Gogh's mind were the earlier residents in the south of France, Petrarch and Boccaccio, to whom he added a new poet, Gauguin.

Van Gogh had built up impossible expectations of Gauguin and the dream of a 'studio of the south'. After several delays and postponements Gauguin finally arrived in Arles on 23 October 1888. About two days before, van Gogh had complained of the effect tiredness and inadequate diet were having on his nerves (LT556). Gauguin reported to Theo that he had found Vincent a little agitated and that he hoped to calm him bit by bit.

Because of bad weather in the late autumn they were often cooped up in the house for days on end. Both men were difficult and selfish in their own ways. Their strong convictions about art often conflicted, although Gauguin

55 *Café Terrace at Night (place du Forum)* 1888

56 Paul Gauguin *Van Gogh painting Sunflowers* 1888

was the more persuasive: in mid-November van Gogh wrote to Theo, 'Gauguin, in spite of himself and in spite of me, has more or less proved to me that it is time I was varying my work a little. I'm beginning to compose from memory, . . .' (LT563). Then in mid-December Gauguin wrote to Theo that he and Vincent were too incompatible to live side by side, although he held Vincent in high esteem and would leave him with regret. In his next letter he

56 retracted his intention to depart for Paris, and described a portrait, *Van Gogh painting Sunflowers*, November, that he had just finished. In the meantime the two painters had made an excursion to Montpellier to see the Alfred Bruyas collection in the Musée Fabre. Again their tastes clashed and van Gogh reported, 'Gauguin and I talked a lot about Delacroix, Rembrandt, etc. Our arguments are terribly *electric*, sometimes we come out of them with our heads as exhausted as a used electric battery. We were in the midst of magic, for as [Eugène] Fromentin says so well: Rembrandt is above all a magician.' (LT564).

Gauguin later wrote of several instances of threatening behaviour from van Gogh. Whether or not these were fabrications, he and van Gogh did have a violent quarrel on the night of 23 December 1888. Gauguin decided to

57 Paul Gauguin *Garden at Arles* 1888

58 *Memory of the Garden at Etten* 1888

spend the night in a hotel and returned the next morning to be confronted by the police. Late at night van Gogh had severed part of his ear and presented it to a prostitute called Rachel at the local brothel and then returned to bed. The police had found him nearly lifeless and had had him sent to hospital. Gauguin summoned Theo by telegram but both he and Theo left Arles on 26 December, although Vincent's condition was still considered critical.

However, during the first weeks of Gauguin's residence in Arles the two painters worked in close association, sharing the coarse canvas that Gauguin had brought with him, a model (Mme Ginoux, the *patronne* at the Café de la Gare) and landscape motifs such as Les Alyschamps, a tomb-lined Roman way.

In the latter part of November, despite his previously stated dependence on nature, van Gogh did yield to Gauguin's urgings to 'vary [his] work a little' (LT563). He wrote, 'Gauguin gives me the courage to imagine things, and certainly things from the imagination take on a more mysterious character.' (LT562). *Memory of the Garden at Etten*, November, was his most Gauguinesque work, yet the decorative pointillism applied as surface texture is totally unlike Gauguin's own *Garden at Arles*, also of November. Van Gogh wrote to Wil that the painting rendered the poetic character of the garden and that the two figures might be Wil and their mother. Although the resemblance was lacking, the colour 'suggests Mother's personality to me' (W9). He also painted *Woman reading a Novel*, December, in response to Gauguin. As respite from the imaginative effort at the end of November, he worked on at least six portraits of members of the Roulin family – two more of the postman, two of the eldest son Armand, one of the younger son Camille, one of Madame Roulin on her own and one of Madame Roulin with the baby Marcelle. He began another portrait of Madame Roulin entitled *La Berceuse* (The Cradle Rocker) in December and returned to it in January 1889. A pair of paintings of chairs, *Gauguin's Chair*, November, and his own (*Van Gogh's Chair*, November 1888–January 1889), empty of occupants but with still-life items on the seats, contrast with each other as emblematic portraits and as colour and light studies.

After a week of attacks of his illness at the end of December van Gogh's condition rapidly improved. He hoped to get back to his painting soon and wrote to Gauguin, demoting his illness over the last few days to 'fever and comparative weakness' (LT566). On 4 January 1889 he visited the yellow house and returned home on the 7th. He worked through January, completing paintings in progress before the 23 December attack and copies of previous paintings like *La Berceuse* and *Sunflowers*.

A second attack in early February had him in hospital until the 17th; however, his release alarmed the neighbours who presented a petition to the

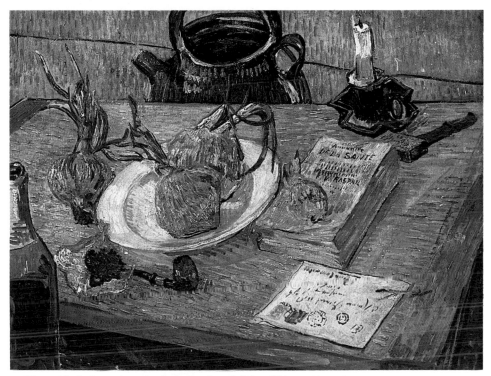

59 *Plate with Onions, Annuaire de la Santé, and Other Objects* 1889

mayor demanding that he return to his family or be locked up. As a result the superintendent of police had him re-admitted on 25 February. The Reverend Frédérik Salles, a Protestant pastor, followed these events, visited Vincent and kept Theo abreast of developments. At the end of March 1889 Signac came to visit and together they walked to the yellow house. Van Gogh gave his friend a still-life, *Plate with Herrings*, from January. During these months he also received visits from Roulin, who had been transferred to Marseilles.

The attacks disrupted van Gogh's work during the winter and spring. Nevertheless, as soon as he felt well enough and was allowed to by Dr Rey, he picked up his painting again. In late March he wrote to Theo, 'You will see that the canvases I have done in the intervals are steady and not inferior to the others. I *miss* the work more than it tires me.' (LT580). Besides two self-portraits frankly showing his bandaged ear, he painted a portrait of Dr Rey 110 and copies of portraits of Roulin and of *La Berceuse*. He depicted the asylum garden and a ward. With the onset of spring he planned a new series of 61 blossoming orchards.

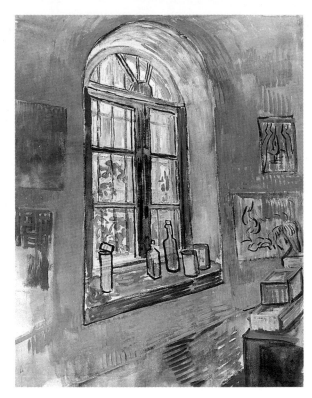

60 *Window of
Studio at St Paul's
Hospital* 1889

61 *Dormitory in
Hospital* 1889

While he matter of factly described his illness and his acceptance of it and
outlined measures for improving his physical health, he found he could not
face the responsibilities of a studio and living alone. He proposed entering an
60 asylum for three months as a trial period. Thus on 8 May 1889 he left for the
asylum of Saint-Paul-de-Mausole in Saint-Rémy de Provence, accompanied
by the Rev. Salles.

Periodic recurrences of his illness punctuated van Gogh's stay at Saint-
Rémy. Theo had arranged for him to have two rooms, a bedroom and a
room for a studio. In the longer lucid intervals he painted as he was permitted
– outdoors or in his room, after nature or from reproductive images.

In early June he received a shipment of materials from Theo and was
allowed to paint outside the walls of the asylum, accompanied by an
attendant, Jean-François Poulet. A month later he went to Arles with the
head attendant in order to collect his paintings. The first attack at Saint-Rémy
followed in mid-July as he was painting in the fields. He managed to finish
the picture but was reported to have eaten his paints during the spell. He was

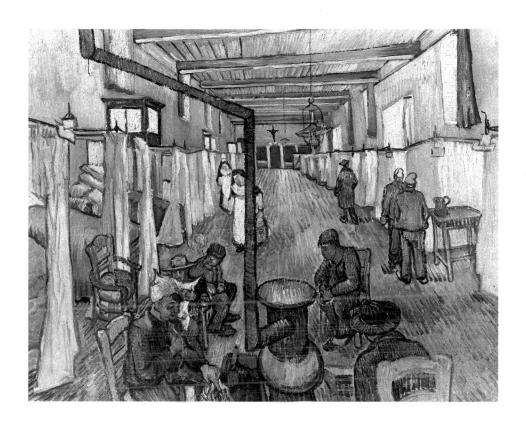

ill for five weeks, and he later described his mind as having wandered for days. Dr Peyron, the director of the asylum, noted that he suffered from disturbing dreams. As van Gogh recuperated he began to get irritated with the asylum, complaining about the food, the other patients, the expense and the ever present nuns. He first broached the idea of returning north in early September, but it took him until the end of that month before he felt brave enough even to venture outdoors. In November he once more visited Arles, this time with no after-effects on his mental stability.

Exactly a year after the first manifestation of his illness he suffered another crisis from which he recovered fairly rapidly. He broke down again, however, for a week in late January 1890, shortly after another trip to Arles, and at the end of February he collapsed in Arles, managing to lose a portrait he had brought to give Mme Ginoux. This time recovery took him two months.

Once able to write he pressed his urgent desire to go north. The previous September Theo had sounded out Camille Pissarro over the possibility of

Vincent's living with the Pissarros at Eragny. Subsequently, he followed up Pissarro's recommendation of Dr Paul Gachet, a heart specialist in Auvers-sur-Oise, who was an art collector and amateur artist as well. Finally, on 16 May 1890 van Gogh left Saint-Rémy, travelling on his own by train to Paris.

Although van Gogh had no immediate contact with fellow artists during his year at Saint-Rémy (the longest phase in his artistic career of such physical isolation), he kept abreast of events in Paris through Theo's letters, and he corresponded with Gauguin, Bernard and Russell. Two critics, the Dutchman J. J. Isaäcson and Albert Aurier, wrote articles about his work and these Theo forwarded. The attention, or rather the terms in which it was phrased, bothered van Gogh and he replied to the authors with a mixture of gratitude and reservation.

His work also found wider public exposure. He showed *Irises*, May 1888, and *Starry Night over the Rhône* at the exhibition of the Société des Indépendants in September 1889 and ten paintings at the Indépendants in the spring of 1890 (he had also exhibited with them in spring 1888). Octave Maus invited him to send paintings to Les XX in Brussels and he submitted six works to that exhibition which opened in January 1890. Anna Boch, a painter and sister of Eugène Boch, bought one of these, usually identified as *The Red Vineyard*, November 1888, for 400 francs.

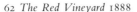

146

62

62 *The Red Vineyard* 1888

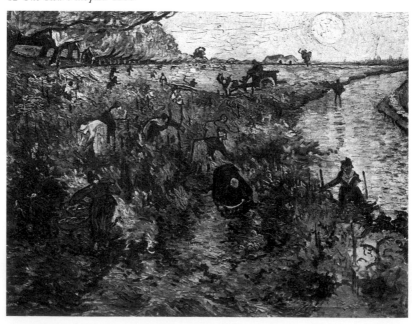

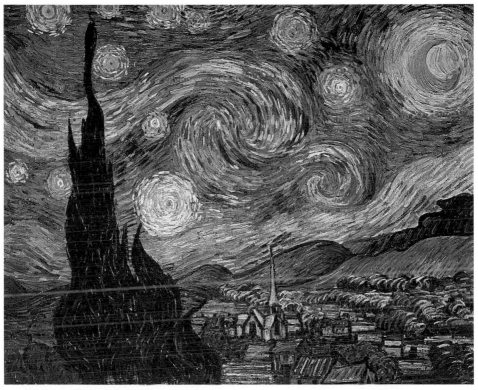

63 *Starry Night* 1889

64 *Undergrowth* 1889

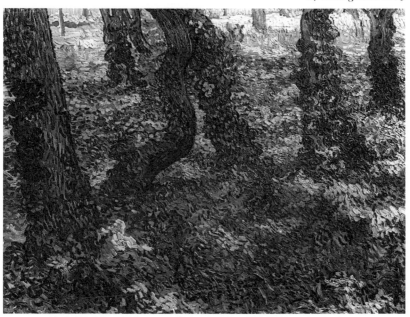

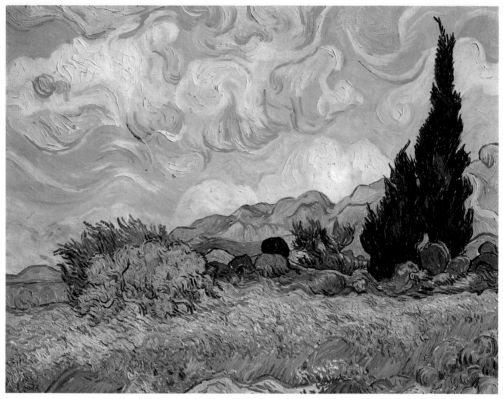

65 *Cornfield with Cypresses* 1889

64 Although illness interrupted his painting, he produced a variety of motifs, developing different rhythms in the application of painted marks and altering the range of hues in his palette. Soon after he came to Saint-Rémy, his 162, 156 canvases of irises and other plants in the asylum gardens adopted a close, horizon-less vantage point looking down on the motif. A view out of an 151 upper-storey window overlooking fenced off fields recurred with seemingly 155 infinite nuances during the summer. Olive orchards became another 65 recurrent theme. In some of the fields and even more assertively in the orchards, both surfaces and shapes bulge and double on themselves in plastic convolutions. More rhythmic swirls and undulations activate the large 63 expanse of sky in *Starry Night*, June 1889.

70 After the July attack portraiture and self-portraiture reappeared, their 100, 101 surfaces also structured out of striations. Prints after Delacroix's *Pietà* (by C. 88 Nanteuil) and Millet's *Labours of the Field* provided motifs during the months

74

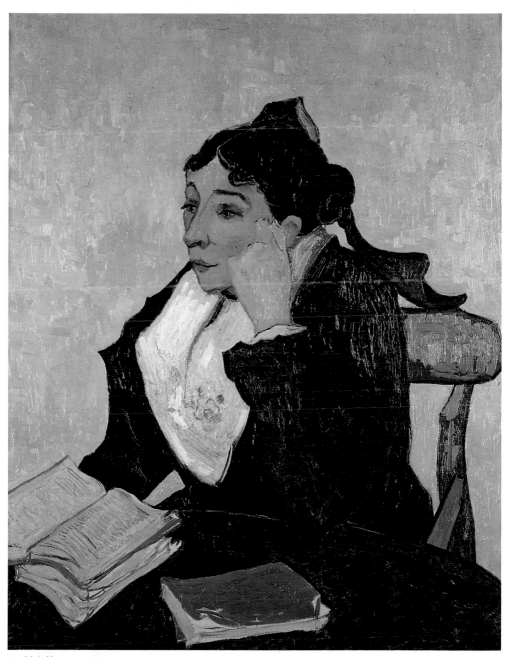

66 *L'Arlésienne* 1888

67 *Pine Woods* 1889

68 *Road with Cypresses and Star* 1890

69 *Entrance to a Quarry* 1889

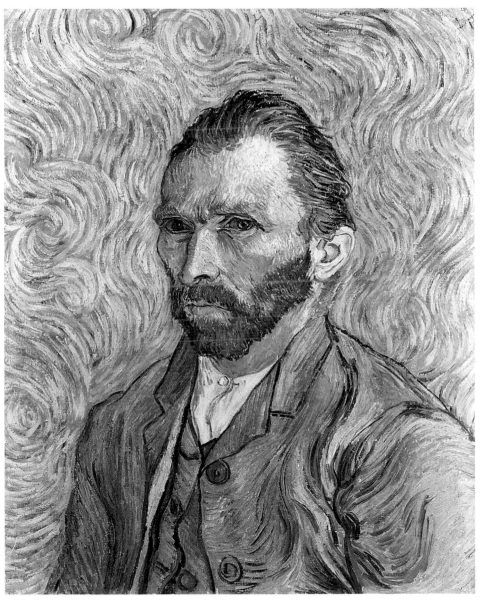

70 *Self-portrait* 1889

71 *Cottages with Thatched Roofs at Auvers-sur-Oise* 1890

when he could not face going out of doors and when models were
unavailable. His interpretations of the black and white sources favoured a
blue/yellow colour chord, but in contrast with earlier works the hues were
69 muted, and putty greys and olive drabs moderated the tonal range. Repeats of
his own works retained the higher-keyed chromatics of the original versions.
When he again ventured out, earth colours (ochres, siennas, umbers) more
prominently featured in his landscapes, as if in thinking of the north he re-
67, 68 acquired a kind of Dutch palette. A more angular drawing and flecked
brushwork appear in some of the autumn works, though these shifts in
facture did not necessarily develop in tandem.

Some flower paintings in the new year re-introduce the intense
colouration and monochrome backgrounds more common in his Arles
159 paintings. *Branches of an Almond Tree in Blossom*, February 1890, made for the

birth of his nephew, view the branches against a blue sky; Theo had married Johanna Bonger in April 1889 and Vincent's namesake was born on 31 January 1890. The long period of illness in the spring had not been completely unproductive. To Theo and to his mother and sister he wrote of paintings composed from memory, 'a memory of Brabant, hovels with moss-covered roofs and beech hedges on an autumn evening with a stormy sky, the sun setting amid ruddy clouds' (LT629a). Drawings from these months resume motifs of diggers and gleaners and domestic interiors reminiscent of earlier motifs from Nuenen.

Van Gogh spent three days in Paris with Theo, Jo and the baby. He looked over the pictures stored at the apartment, many of which he had not seen for several years. With Theo he visited Tanguy's shop, and the Salon du Champ de Mars, a secessionist group from the Salon. On 19 May, finding 'all the noise [in Paris] was not for me' (LT635), he left for Auvers-sur-Oise.

Dr Gachet had found van Gogh accommodation in an inn, which van Gogh considered too expensive, so on the day of his arrival he took an attic room in another inn belonging to Arthur-Gustave Ravoux. Over the next few weeks he wrote to Theo about familiar topics: his current work, the condition of his paintings stored at Tanguy's, problems with money and anxieties about Theo and Theo's family. He also began to urge Theo to spend his holidays in Auvers rather than The Netherlands and even suggested

68

73, 74

72 *Landscape in the Rain* 1890

73 *Sower in the Rain* 1890

74 *Interior of a Farm with Figures by a Fire* 1890

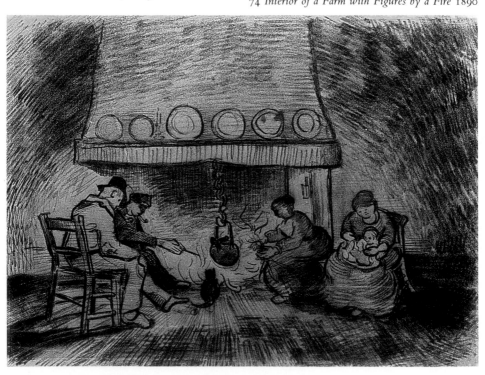

renting a pied-à-terre for Theo and his family in Auvers. He visited Dr Gachet, lunched with him and painted in his garden. He perceived Gachet 'as ill and distraught as you [Theo] or me . . .' (LT638).

Theo, Jo and the baby came for a visit on 8 June. Nearly a month later, on 6 July, van Gogh spent a day in Paris. Aurier and Toulouse-Lautrec came by Theo's apartment; so did Guillaumin, but by his arrival van Gogh had already found the excitement too much and hurried back to Auvers. Vincent had not met the most settled domestic environment – the baby was recovering from a serious illness, Jo was tired and Theo was considering leaving Boussod and Valadon.

In Auvers van Gogh had the enthusiastic companionship of Gachet. 163 Gachet owned an etching press and van Gogh hoped to make some etchings of 'southern subjects' (LT642). More ambitiously, he planned the publication of reproductive prints after his and Gauguin's paintings (to be printed by Gachet and published by Theo). Eventually, one etching, a portrait of Gachet, materialized from his schemes.

Auvers had appealed to many painters in the nineteenth century. The Barbizon painter Charles-François Daubigny had lived there and attracted 75

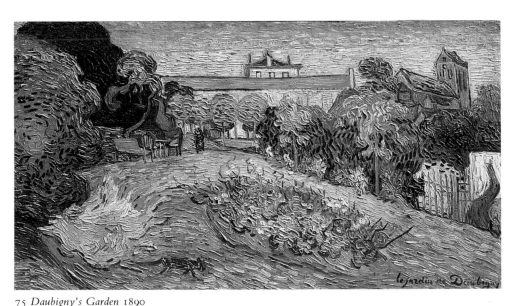

75 *Daubigny's Garden* 1890

Corot and Daumier. Van Gogh paid homage to Daubigny in several
paintings of his house and garden. In the 1870s came Pissarro and Paul
Cézanne. During van Gogh's two months' residence another Dutch painter,
Anton Hirschig, arrived in the middle of June and took rooms in the same
inn.

Van Gogh painted numerous depictions of the village as well as the
surrounding fields in these prolific weeks. His production averaged a
painting per day. There were also a number of floral still-lifes. Besides
portraits of the doctor and his daughter Marguerite, he painted the Ravouxs'
daughter Adeline, several children and young girls. To Wil he indicated a
renewal of enthusiasm for portraiture: 'What impassions me most – much
more than all the rest of my métier – is the portrait, the modern portrait.'
(W22).

In the Auvers paintings he furthered the looser handling and more angular
drawing which had emerged at Saint-Rémy. Foliage is spiky and skies look
like mosaic tesserae. He also took up a new canvas format, a double square,
mostly used horizontally for landscapes. Three of these, with a motif of
wheatfields, he described to Theo as 'express[ing] sadness and extreme
loneliness' but also signalling the more positive 'health and restorative forces
that I see in the country' (LT649).

Theo and his family did go on holiday in the middle of July, to Leiden,
Theo returning alone on the 19th while Jo visited her family in Amsterdam.
He had a meeting with Boussod and Valadon, as a result of which he decided
to stay on at the gallery. On 25 July he wrote to Jo: 'I have a letter from
Vincent which seems quite incomprehensible; when will there come a happy
time for him?' (Letters lii); but in that letter Vincent had ordered more paint
for himself and Hirschig, an indication that he planned future work. On
Monday 28 July Theo went to Auvers having been called by a letter from Dr
Gachet. Vincent van Gogh had shot and critically wounded himself in the
chest the day before; however, he had managed to walk back to the inn and
upstairs to bed. When Theo arrived his brother was conscious enough to talk.
Theo wrote a hopeful letter to Jo: 'Don't get too anxious; his condition has
been just as hopeless before, but his strong constitution deceived the doctors.'
(Letters lii–liii). Theo's optimism was premature: his brother died in the early
morning of 29 July 1890.

Theo van Gogh himself died on 21 January 1891, outliving his brother by
not quite six months. With Bernard's help he had organized a small
exhibition of Vincent's work in his apartment. His physical health, more
precarious even than his brother's, had already caused him concern during
the past few years. It broke down completely in October and stress finally
rendered him completely apathetic.

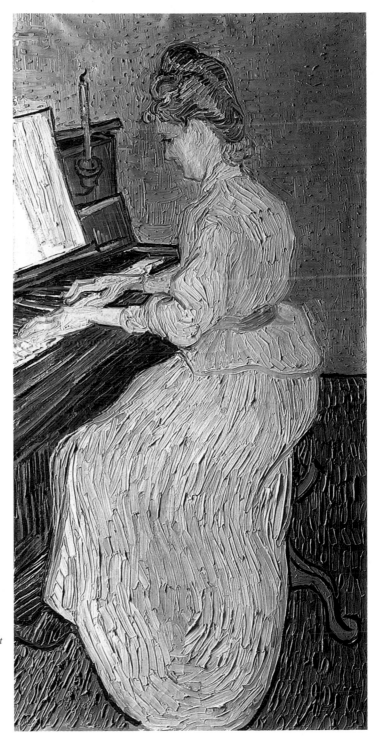

76 *Marguerite Gachet at the Piano* 1890

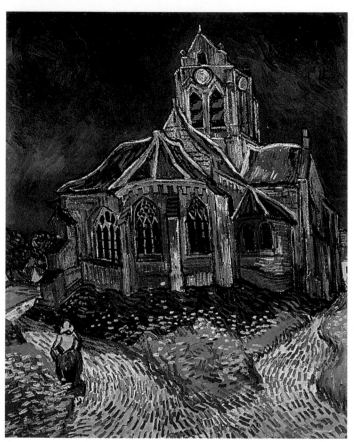

77 *Church at Auvers-sur-Oise* 1890

79 *Two Pear Trees with Château* 1890

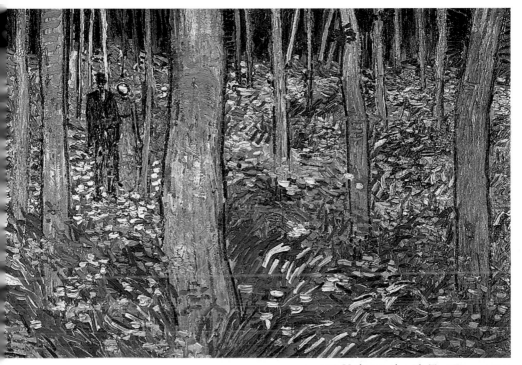

78 *Undergrowth with Two Figures* 1890

Theo van Gogh fills a secondary role in histories of art, his chief importance being characterized as that of the object of Vincent's letters. He was, however, important in supporting and marketing the Impressionists and later artists. In 1878 he had been taken on by the Brussels firm of Goupil's and transferred to The Hague branch in the autumn of that year, thus following in his elder brother's footsteps. He went to Paris in 1878, at first temporarily to represent Goupil at the Exposition Universelle, then permanently. The Paris firm had been taken over by Boussod and Valadon in 1875, Boussod having married Goupil's grand-daughter. In 1882 Theo van Gogh was given the administration of one of the three Paris establishments, not the most important gallery in the place de l'Opéra but a more modest one at 19 boulevard Montmartre.

Theo bought his first Impressionist painting, a Pissarro landscape, in 1884, followed by Sisley, Monet and Renoir in 1885. In 1887 he became Degas's dealer and in 1888, after receiving an inheritance from Uncle Vincent, he signed a contract with Gauguin. His gallery also had a short-lived contract with Monet. He gave exhibitions to Pissarro and Raffaelli in 1887 and to Monet in 1888. Thus, for a while the gallery became one of the few serious dealers of Impressionist painting. Theo, along with his brother, also assembled a modest private collection mostly of works by artist-friends. His superiors disapproved of his contemporary tastes, but thought enough of his work to consider sending him to their new New York branch in the summer of 1888.

Descriptions of him indicate that he was not a pressurizing salesman. The critic Gustave Kahn remembered: 'His profound conviction of the value of the new art was stated without vigour and thus without great success. . . . But this salesman was an excellent critic and engaged in discussions with painters and writers as the discriminating art lover he was.' On the other hand, Theo managed to sell what his superiors deemed an unsaleable Corot to the Dutch painter and collector Mesdag. The gallery stock at Theo's death included works by these painters and Guillaumin, Daumier, Jongkind, Redon, Toulouse-Lautrec and the sculptor Barye. Had he lived a full lifespan or had the gallery trusted his choice, they would have reaped the financial rewards of his perspicacity, but they sold off the stock soon after his death.

Although hundreds of letters from Vincent to Theo survive, only a fraction from Theo to his older brother have been preserved. Yet Vincent's letters give substantial support for a two-sided dialogue. He even referred to the work as a joint enterprise, employing on occasion the pronoun we: 'What we have to do is to go quietly on, but that period of drawing cannot be avoided, and it is most pressing', he wrote from Antwerp (LT456). He did not depend just on the money and emotional support, but worked out his

80 Photograph of Theo van Gogh

ideas on art through this medium with Theo. More than once he tried to persuade Theo to leave dealing for painting, while other schemes counted on Theo's business sense.

Vincent had been in Paris in the middle of the 1870s but there is no evidence that he encountered the Impressionists at that time. During his years in Holland it was Theo who was more *au fait* with advanced ideas about art in Paris. He introduced Vincent to Impressionist ideas before 1886 and then assisted his introduction to the paintings and the painters. He chose photographs and prints to send to his brother, obviously responding to direct requests but also reflecting his own enthusiasms. He shared his aesthetic judgments. How important must that have been for Vincent who suffered such frequent spells of low confidence? Theo singled out certain paintings for praise and spoke less favourably of others: 'I understand quite well what it is which preoccupies you in your new canvases, like the village in the moonlight [*Starry Night*], or the mountains, but I think that the search for some style is prejudicial to the true sentiment of things.' (T19).

While Vincent van Gogh actually applied paint to canvas, Theo van Gogh contributed vitally to the œuvre. Lacking other patronage Vincent came to paint *for* Theo. Vincent may be the name allocated to the paintings, but in a sense they are a joint product.

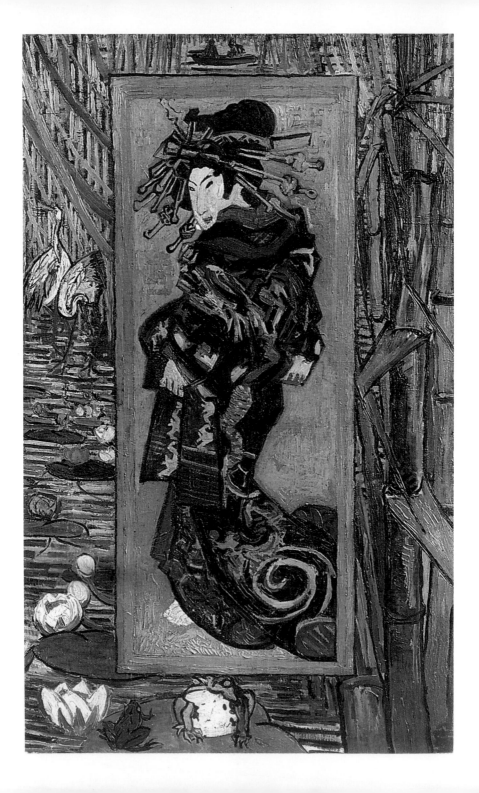

Encounters with Art

Van Gogh's letters contain ample evidence of his engagement with the art of others and with the conditions of art's production. He did more than look. He read art magazines and monographs and he discussed the ideas obtained from these encounters. His drawings and paintings maintain an active dialogue with the work he admired and with his perceptions of the needs and functions of art. The circumstances of his life acquainted him in turn with different types of art worlds into which he negotiated his way and found a position.

His earliest experiences taught him the commodity function of art. Work at Goupil's made him aware of the art market's mediation between artist and public. It established his ideas about public taste and his visits to other galleries presented him with past art that had been accorded public value.

The Maison Goupil, having expanded beyond trade in reproductions, specialized in nineteenth-century French art and promoted the Hague School (they carried Israëls, Mauve, the Maris brothers, Blommers, Roelofs and Gabriel). Van Gogh's uncle Vincent (who had sold out to Goupil in 1869) brought the Barbizon painters to Holland just before their wide public popularity, and Uncle C. M. dealt in Hague and Barbizon painters in his Amsterdam galleries.

Van Gogh's handful of letters from The Hague mention few artists by name, and of those only the Belgian Alfred Stevens retained an enduring reputation. In London van Gogh compared the Barbizon painters Daubigny and Narcisse Virgille Diaz de la Peña to Constable. To Theo at the Goupil branch in Brussels he listed 'the painters I am very fond of, and whose work you will probably see something of': Lagye, De Braekeleer, Wauters, Maris, Tissot, Georg Saal, Jundt, Ziem and Mauve (LT10, 20 July 1873). In January 1874 he sent a much fuller list to Theo, who was then working in The Hague: 'The following are some of the painters whom I like especially: Scheffer, Delaroche, Hébert, Hamon, Leys, Tissot, Lagye, Boughton, Millais, Thijs Maris, De Groux, De Braekeleer, jr., Millet, Jules Breton, Feyen-Perrin, Eugène Feyen, Brion, Jundt, Georg Saal. Israëls, Anker, Knaus, Vautier, Jourdan, Compte-Calix, Rochussen, Meissonier, Madrazo, Ziem, Boudin, Gérôme, Fromentin, Decamps, Bonington, Diaz, Th. Rousseau, Troyon,

< 81 *Japonaiserie: the Courtesan after Keisai Eisen* 1887

Dupré, Corot, Paul Huet, Jacque, Otto Weber, Daubigny, Bernier, Emile Breton, Chenu, César de Cock, Mlle. Collart, Badmer, Koekkoek, Schelfhout, Weissenbruch, and last but not least, Maris and Mauve. But I might go on like that for I don't know how long. Then there are the old masters, and I am sure I have forgotten some of the best modern ones.' (LT13).

The list indicates van Gogh's eclectic tastes spanning the spectrum of Goupil's clientele. The range of academic, *juste milieu* (art that attempted a compromise between academic and innovatory styles) and 'independent' French artists includes virtually all the French Barbizon landscapists, later romantic French painters like Delaroche, Decamps, the artist and writer Fromentin, the academicians Gérôme (noted for his flawlessly smooth orientalist paintings and scenes from antiquity and history) and Meissonier (a painter of minutely detailed, anecdotal genre scenes). The Hague School is well represented, some Belgians, Tissot – a Frenchman resident in England since the Commune – a few British artists, among them the sometime Pre-Raphaelite Millais (but none of the rest of the Pre-Raphaelite Brotherhood.)

It is clear from the final sentence of this passage that van Gogh considered these artists 'modern'. Obviously, modernity meant something more like 'contemporary' or 'recent' to him in 1874. The term 'modern' was not part of the polemical apparatus that became linked to the avant-garde. He paired modern in a binary opposition with 'Old Master' rather than with 'old-fashioned'. His language was that of a dealer in known, saleable mid-nineteenth century artists. One of the mainstays of the Goupil business in London was the sale of graphic and photographic reproductions. Van Gogh noted that prints after J.-A.-D. Ingres's *Venus Anadyomene* sold very well. Later, in The Hague, refining a more particular notion of modern art – 'think how old *modern art* already is' (LT241) – one that implied a turning point into a modern age, he located the origins of modernity with Ingres, Delacroix and Géricault. The very different values of modernist hindsight might single out only Boudin, often regarded as a plein-air forerunner of Impressionism, and possibly Tissot, an artist whom Degas invited to participate in the first Impressionist exhibition, as qualifying for the appellation 'modern' in 1874. In that year the artists who were to become known as the Impressionists organized their first exhibition, having been frustrated in efforts to attain public exposure through the established channel of the Salon.

After van Gogh was transferred to Paris he wrote in 1875 for the first time of his own collection of reproductive prints: the French Corot, Millet, Jules Dupré, Daubigny, Troyon, Bonington, Charlet, Edmond Frère, the Dutchmen Maris and Bosboom and an early indication of his admiration for Old Masters – Rembrandt, Ruysdael, Nicholas Maes and Philippe de Champaigne (LT30 and 33, July/August 1875). While showing his friend

Gladwell his favourite pictures in the Luxembourg (the modern collection in Paris), he pointed out many of the same artists, with the addition of religious paintings by Brion, *Lost Illusions* by Gleyre, a landscape by Cabat (van Gogh thought this artist's works resembled Ruysdael's) and a ploughing scene by Rosa Bonheur (LT42, October 1875).

During his time in the art trade van Gogh frequented museums and art exhibitions. It has even been suggested that he was a more regular museum goer before he became an artist than subsequently. He mentioned an exhibition of Belgian art and one of 'old art' in letters from London, singling out Rembrandt, Ruysdael, Hals, Van Dyck, Rubens, Titian, Tintoretto, Reynolds, Romney and Old Crome.

Dutch seventeenth-century artists remained a touchstone through his last years as a painter. His period of religious dedication reinforced his fondness for Rembrandt; indeed, while studying for the ministry in Amsterdam he frequently visited the Trippenhuis and wrote incessantly about Rembrandt, virtually to the exclusion of other artists.

In addition to his core of favourite artists there were others admired for their subjects and sentiments, often read in terms of literary images. Thus, George Henry Boughton's historicizing narrative *Pilgrims Setting out for Canterbury* (based on Chaucer), reinterpreted by van Gogh in 1876, became a 'Pilgrim's Progress': 'A sandy path leads over the hills to a mountain, on the top of which is the Holy City, lit by the red sun setting behind the grey evening clouds. On the road is a pilgrim who wants to go to the city; he is already tired and asks a woman in black, who is standing by the road and whose name is "Sorrowful yet always rejoicing" [here follows an inaccurately quoted passage from Christina Rossetti] . . . Truly, it is not a picture but an inspiration.' (LT74, 26 August 1876). Although he slipped into error not only in his quotation but also in his identification of the subject of the picture, van Gogh obviously read such pictures in the language of their address to their middle-class, art loving audiences.

In contrast with his avid gallery attendance before 1878, during his first years as a painter van Gogh hardly entered a museum, although he did directly experience the work of artist-friends and acquaintances. He carried with him vivid visual memories and his collection of prints. The artistic preferences established by his early experiences inclined towards the Barbizon painters of rural and peasant imagery, their Dutch counterparts of the Hague School, and seventeenth-century Dutch painters. The French writers Charles Blanc, Fromentin and Théophile Thoré-Bürger had promoted seventeenth-century Dutch painting as a forerunner of mid-nineteenth century French realism; in turn contemporary Dutch artists of the Hague School looked towards the Barbizon artists; consequently, van

Gogh's objects of admiration had a coherence already established in critical literature and current practice.

When van Gogh committed himself to the profession of making art he encountered various situations as he tried to articulate a place for his own art. Before he went to Paris, the Hague School offered the strongest immediate role-model. He was well acquainted with the Hague School both through his work at Goupil's and his kinship with Anton Mauve. Not only was Mauve married to van Gogh's cousin Jet Carbentus, he had been Goupil's most heavily stocked Hague artist in the early 1870s. The opportunity of studying with Mauve attracted van Gogh to The Hague.

The Hague School enjoyed a substantial reputation outside The Netherlands at the end of the nineteenth century. In the 1870s a number of painters from throughout The Netherlands, who had been educated even further afield in Antwerp, Brussels and Paris, had come together in The Hague. In addition to Mauve they included Jacob Maris and his younger brothers Matthijs and Willem, Johannes Bosboom, Jan Hendrik Weissenbruch, Bernard Blommers, Willem Roelofs, Gerard Bilders, Hendrik Mesdag, Jozef Israëls and Paul Gabriël. In age they spanned two generations, but their paintings had a common interest in landscape motifs and in depictions of peasants and fishing people. The Hague was slow to become industrialized so such motifs were readily accessible from the city. Thus, their paintings signalled modernity in their apparently naturalistic observation without confronting the urban industrialization, just beginning to have an impact in The Netherlands.

A collaborative work supervised by Mesdag, and employing among others the younger artist George Hendrik Breitner, was the panorama of Scheveningen, a commercial enterprise sponsored by Belgian entrepreneurs. Mesdag sited his vantage point so that he recorded a view of the fishing town that was actually rapidly disappearing due to tourist development.

In handling, the work of most of the Hague School painters produced atmospheric effects through a light, often grey tonality. Painterliness softened the forms and gave a lively texture to the canvas surface. The dominant horizons, whether low or raised, the static compositions, the stillness and monumentality of the figures suggest a kind of eternal and natural relationship between the land and the traces or presence of the people whose lives depended on it. In their reference to the conventions and formats of seventeenth-century Dutch forebears they asserted the value of tradition. Nevertheless, the Hague School represented the new painting in The Netherlands. It aspired to a renewal of Dutch art, although it lacked the powerful institutions against which to rebel that were provided in France by the Academy and the Salon.

The artists of the Hague School joined the already established Pulchri Studio, founded in 1847. It gave them an opportunity to socialize, look at each other's work and discuss artistic issues with artists of different persuasions. They set up the Dutch Drawing Society in 1876 to provide more opportunities to exhibit watercolours, a medium of great importance to Weissenbruch, Mauve, Israëls and Maris. Although watercolours broadened their market, printmaking, which would have reached a far wider public, was not taken seriously.

As industrialization became unavoidable the Hague School artists moved further, often to Drenthe and Brabant, in search of their unspoilt pastoral ideal. Younger artists such as Breitner and Isaac Israëls moved to Amsterdam in the 1880s, culturally a more radical city.

The Barbizon painters had provided a precedent, encouragement and model for the Hague School. They shared a historical foundation: Dutch seventeenth-century landscape had been a referent for the apparently informal compositions of the Barbizon landscapists, exerting a strong impact on the work of Troyon in particular. The French landscapists Théodore Rousseau, Daubigny, Dupré, Diaz de la Peña, Troyon and the painter of peasant images, Millet, became known as the Barbizon School after the town in the Forest of Fontainebleau where they often painted and where many lived. Their romantic naturalism matured in the 1840s and achieved a wider following in the next decade. Although the Barbizon School had coalesced several decades earlier than the Hague School, its impact in the Dutch art market was roughly contemporary. Popular acceptance of such work in France had been hindered by its non-adherence to academic values and thus its poor representation at the Salons before 1848.

Millet's peasants, less naturalistic but monumentally *naturalized* as 'the peasant', intervene more obviously than the landscape paintings in the formation of an imagery that acknowledged the major social upheavals in the middle of the century. They are not prettified or made hygienic in the manner of an earlier peasant tradition, but their relation to their work is rendered as an eternal condition (even if the message is one of eternal suffering). Yet, in the 1850s and 60s in France this way of life was fast disappearing as the peasants moved to the city to enter an urban workforce.

Barbizon landscape painting has often been taken as a *plein air* forerunner of Impressionism. Some of the paintings indeed exhibit an apparently casual composition, a concern with light, and a painterly facture which was admired by Impressionists, but its construction of a rural imagery in contrast with the daily experience of its public, and its processed lighting effects (sunsets, a glowing, filtered daylight), tie it to romanticism. Although Barbizon painting, both landscape and Millet's peasants, was made out to be a

89

82 Luke Fildes *Houseless and Hungry* 1869

rebellion against official and academic values in contemporary accounts, it did not propose radical social revision, but reformulated rural myths.

A more direct representation of modern experience was offered not by painting but by graphic illustration in popular magazines, such as the British *Graphic* and *Illustrated London News* and the French *L'Illustration*. Van Gogh had noted these images when working in England in the 1870s; he began collecting them in the early 1880s in Brussels; in 1882 in The Hague he bought up back issues of the magazines, favouring imagery of the previous decade. While his collecting coincided with his plans to support himself as an illustrator, his interest was shared by other painters. Much of the correspondence with van Rappard concerns exchanges of these illustrations. He was also invited to show some of his collection at the Pulchri Studio, although this exhibition did not take place due to other members' low opinions of the artistic merit of such work.

The largest portion of van Gogh's collection came from the *Graphic*, with his favourite illustrators Luke Fildes, Frank Holl and Hubert von Herkomer. The *Graphic* had been founded in 1869 with the intention of using artists

82, 83

rather than hack illustrators to draw the images for their wood engravings (the actual engraving was accomplished by craftsmen). It depicted a wide social spectrum ranging from royalty and fancy balls to subjects of the urban and rural poor, from members of the establishment to working-class immigrants, and from the illustrious to criminals. Its representations of the working classes were relatively new and the freshness of observation lends them a sense of candid objectivity; nevertheless, the position or attitude of the spectator is constructed into them. The demarcation between the deserving and undeserving poor sets up a moral standpoint, one of sympathy or disapproval. Van Gogh thought less highly of English painting than its graphics: paintings even by the same artists appear less immediate, their space more recessive and their lighting a suffused chiaroscuro.

The British tradition in the clarity and apparent matter-of-factness of its images differed from the more ambiguous and shifting readings prompted by prints in the French tradition of Daumier, Gavarni and Doré, whom van Gogh also collected. Daumier's and Gavarni's caricatural drawing deflated bourgeois values. In comparison with illustrations in the *Graphic*, Doré's London scenes render the urban poor as a more threatening presence. Establishment figures within the images aggravate the social tensions. Grotesqueness accentuates the otherness of people living on social margins. Although the British graphics vastly outnumber the French in van Gogh's collection, later at Saint-Rémy he chose to copy prints by Doré and Daumier.

The literature of art supplied van Gogh with another source of knowledge about current and recent art theory and practice. From London in 1873 he

83 Hubert von Herkomer
*Sunday at the Chelsea
Hospital* 1871

advised Theo, 'If you have the chance, read about art, especially the art magazines, *Gazette des Beaux-Arts*, etc. As soon as I have the opportunity, I will send you a book by Burger [Thoré–Bürger] about the museums at The Hague and Amsterdam.' (LT12). While in Etten and Nuenen publications on art (and letters from Theo) served as his main source of information on the art world.

In the nineteenth century newspapers and periodicals carried art reviews. An important event like the annual Parisian Salon could occasion extensive serialized reviews. A more specific art press developed later in the century with the birth of periodicals exclusively devoted to art. Many were short-lived but van Gogh was acquainted with some of the most enduring: the English *The Artist* and the French *L'Artiste* and *Gazette des Beaux-Arts*. The periodicals played a role in the development of the discipline of art history as well as art criticism. The *Gazette des Beaux-Arts* played a major part in bringing to the fore seventeenth-century Dutch and French realism, thus providing historical authority for nineteenth-century realist and naturalist painters. Connoisseurship was another of their functions, as was the improvement of national taste.

The art book became a major adjunct of the market. It also was instrumental in the formation of national cultural identities. Two important areas were the identification and construction of national schools (sometimes based on guidebook studies of museums, as was the case of the book by 'Burger' mentioned in van Gogh's letter) and the monograph, which established an œuvre, and a value, for individual painters. Besides Thoré-Bürger's *Musées de la Hollande* (1858, 1860), van Gogh read Fromentin's *Les Maîtres d'autrefois* (1876), Théophile Silvestre's *Eugène Delacroix: documents nouveau* (1864), and the Goncourt brothers' *L'Art du dixhuitième siècle* (1859–75) while he was in Nuenen. He also knew various books by Charles Blanc, editor of the *Gazette des Beaux-Arts*: *Les Artistes de mon temps* (1876), *Grammaire des arts du dessin, architecture, sculpture, peinture* (1867) and *Histoire des peintres de toutes les écoles* (1863–68). Blanc's writings shaped van Gogh's notion of Delacroix's colour theories at a time when he had no access to the actual paintings.

Novels of artistic life by the Goncourts and Zola's *L'Œuvre* (1886) represented the nineteenth-century artist as an outsider. Although van Gogh may not have read Henri Mürger's collection of stories *Scènes de la vie bohème*, it was known to him and Theo. These fictional portrayals contributed to van Gogh's own formulation of artistic behaviour. On reading a fragment of *L'Œuvre*'s serialization in *Le Gil Blas*, he wrote: 'I think that this novel if it penetrates the art world somewhat, may do some good. The fragment I read was very striking.' (LT444, January 1886). Even before reading *L'Œuvre* he

knew the character of its protagonist Claude Lantier from other Zola novels: 'Lantier . . . seems to be drawn from life after somebody who certainly was not the worst representative of that school, which I think is called impressionistic.' (LT247).

In October 1885, after several years of relative isolation from artistic contact, van Gogh once again felt the need to see the art of museums and he abruptly made a short visit to Amsterdam. The journey marked the beginning of a project to establish a new direction for his enterprise made decisive by his move to Antwerp. Van Gogh's letters from Antwerp were filled with discussions of Rubens and Jordaens, 'the museums of old pictures and the Musée Moderne' (LT436), and the later, colouristic paintings of Henri de Braekeleer. Mention of teachers and contemporaries in descriptions of his experience evinces little interest in their work. Before long his preoccupation with a future in Paris drove out reflections on the present.

Van Gogh knew *about* the Impressionists well in advance of his move to Paris, although as his reference to Zola's Claude Lantier indicates his idea of their work was initially very rough. From Nuenen he mentioned, 'There is a school – I believe – of impressionists. But I know very little about it.' (LT402). Towards the end of his residence in Nuenen his lengthy exposition of his own developing colour theories countered his second-hand knowledge of Impressionism. Although in this instance he did not refer to Impressionism by name, he reacted against 'following nature mechanically and servilely' (LT429).

He arrived in Paris not long before the final Impressionist group exhibition opened in May 1886. The exhibitors had never subscribed to a cohesive group style. Already by 1880 the artists who had shown together in 1874 and subsequently – Degas, Monet, Renoir, Pissarro, Sisley, Morisot, Caillebotte, Marie and Félix Braquemond, and others – no longer overlooked personal and professional differences for the sake of mutual support. Several had begun to realize financial success through the efforts of dealers like Durand-Ruel and patrons like the Charpentiers. They no longer needed or wanted to set themselves apart under the Impressionist label. Of the four exhibitions held between 1880 and 1886 Monet, Renoir and Sisley each exhibited only once. The work of the landscapists, sometimes regarded as stylistically unified, had shifted away from *plein air* scenes painted in broken touches of pigment. New artists with rather divergent aims, such as Gauguin, Odilon Redon, Lucien Pissarro, Seurat and Signac, appeared in later Impressionist exhibitions.

While Impressionism was being rejected, superseded or opposed by a younger generation of artists, the term Impressionism still signified even for this younger generation an anti-academic, official or *juste milieu* stance. Both

van Gogh and Gauguin referred to themselves as Impressionists in the later 1880s.

Another group formed itself in 1884. Like the Impressionists it reacted to the narrow admission criteria of the Salons, but it admitted anyone who wished to submit. The Groupe des Artistes Indépendants' first exhibition included Redon, Signac, Guillaumin (a founder member of the Impressionists) and Seurat among numerous artists whose only common experience was rejection from or refusal to submit to the Salon. Arguments and even fisticuffs accompanied its birth, and within a few weeks after the opening of its exhibition in May the self-appointed administrators had been removed and a newly founded Société des Artistes Indépendants supplanted the first group. They held their first exhibition in December and thereafter roughly annually. Van Gogh exhibited at three Indépendants shows during his life. Anquetin and Toulouse-Lautrec also participated but not Gauguin.

In the mid-1880s the Neo-Impressionists made a strong showing at the Indépendants. Seurat followed by Signac, Camille and Lucien Pissarro, Angrand, Luce, Cross and others, reacting to their perception of Impressionism's lack of rigour, began applying their pigments in small pointillist touches. Their divisionist use of complementary colours had the support of critical theories expounded by Félix Fénéon that claimed to be based on scientific writings.

Bernard and Toulouse-Lautrec both passed through this Neo-Impressionism but, along with Anquetin, by 1887 they began to bring clear, continuous outlines and flat shapes of colour into decorative and expressive conjunction. Bernard stated his intention to 'allow Ideas to dominate the technique of painting'. In Brittany in the summer of 1888 Bernard found Gauguin an interested and then dominant adaptor of his ideas. Cloisonnism, as this style of bounded colour shapes became known, was just one of several stylistic formulations for painting that evoked extra-visual meanings, a kind of painting that paralleled Symbolist poetry.

While the restless Gauguin did not stay long in Paris, between his trips to Martinique, Brittany and Arles his presence was felt in exhibitions and through his admirers. Cézanne had a much lower profile and held to a more independent course. Although he secluded himself in Aix-en-Provence, his work could be seen at Père Tanguy's.

If the more radical art in the aftermath of Impressionism was hardly cohesive in style, it faced a less monolithically defined opponent. The Salon had been newly re-organized in 1881 under the control of the artists rather than the academicians, and it split into two bodies in 1890. Renoir and Monet both had works accepted by the Salon during the decade, and more middle-of-the-road exhibitors like Bastien-Lepage had taken note of Impressionist

tonality and brushwork. Pierre Puvis de Chavannes, an artist who exhibited at the Salons and who produced large-scale mural decorations of classicizing simplicity, began both to receive more favourable criticism and to be regarded as a predecessor by the burgeoning Symbolist group. 86

Retrospectively, for all its stylistic diversity, that decade has come to be characterized as one of consolidation for modernist painting – an art turned self-critically on its own practice. This modernism, however, had not yet completely disengaged its attentions from the modern world. Although Gauguin and Cézanne retreated from the city, Seurat and Toulouse-Lautrec constructed an imagery based on contemporary behaviour and acknowledged the shifting boundaries between city and outskirts, and between classes and genders within the city population. Modern life remained an issue for modernism. Many of the Neo-Impressionists did not find art and political engagement mutually exclusive; indeed, the Pissarros, Seurat, Signac and others expressed sympathy with the anarchist movement.

Van Gogh's acquaintance with this effervescent and polemical art world developed erratically. Theo and John Russell facilitated his knowledge of Impressionism, and the dealer Portier, whose shop lay below Theo's apartment on the rue Lepic, initiated contact with Guillaumin. Before van Gogh's art registered a response to the various vanguard groups, he underwent an apprenticeship to the later work of Adolphe Monticelli, which he probably first saw at Delarebeyette's gallery on the advice of Alexander Reid.

Rather than encountering Impressionism, its aftermath and reaction in the sequence of its chronological emergence, van Gogh took on board developing Neo-Impressionism and its Impressionist predecessor as variants of one and the same thing. Among his avant-garde acquaintances, only Toulouse-Lautrec can be located with sureness among his fellow students at Cormon's, but the earliest documentation of their friendship is at the beginning of 1887. He knew Angrand in 1886, though at that time Angrand, still working in an Impressionist and naturalist idiom, had not yet espoused the more systematic Neo-Impressionism of Seurat. Van Gogh allied himself with Signac and then Bernard in the spring and summer of 1887 and by the autumn his work had become an important factor in the construction of vanguard strategies.

Van Gogh first referred to Japanese prints and Japonisme in letters from Antwerp but he consciously began to work out his own orientalism only in the second half of 1887, for example in *The Italian Woman, Portrait of Père Tanguy* and *Japonaiserie: the Courtesan after Keisai Eisen*. John Russell, who had been to Japan, probably encouraged his interest in collecting *ukiyo-e* prints ('pictures of the floating world'), and he furthered his familiarity while 84

85, 81

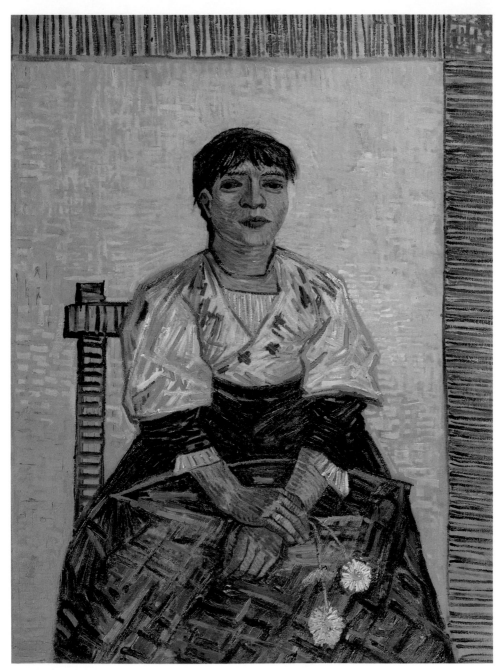

84 *The Italian Woman* 1887–88

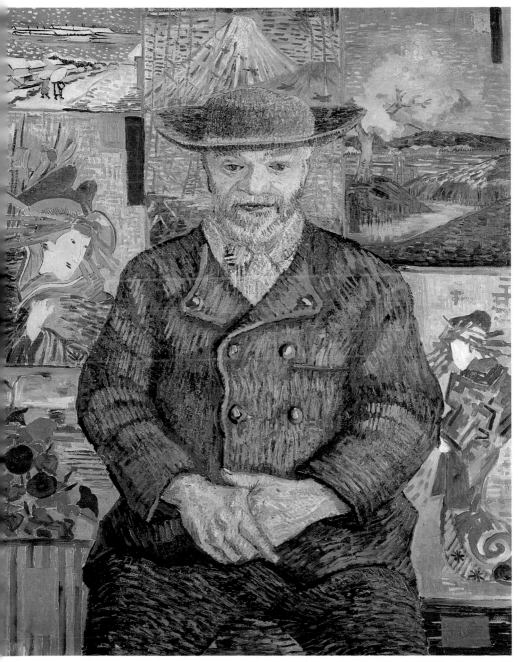

85 *Portrait of Père Tanguy* 1887–88

86 Pierre Puvis de Chavannes
Inter Artes et Naturam 1888–90
(central panel)

browsing at Siegfried (Samuel) Bing's shop (the principal Parisian merchant of Far Eastern art). Although Degas, Manet and Braquemond provided him with Japoniste precedents, he went directly to the prints rather than through already formulated European models.

After two years in Paris van Gogh fled the urban capital, worn in health by the life he had adopted and discouraged by the factionalism, particularly between the Neo-Impressionists and the Cloisonnists. In Arles, though, he continued to keep abreast of what his friends were producing and thinking. As ever he had Theo's letters, which now resonated with his own experience of art in Paris. He corresponded with Russell and with the Neo-Impressionist Signac and the Cloisonnists Bernard and Gauguin. Through the medium of sketches in letters and the exchange of works he maintained an immediate knowledge of what his friends selected to send him. For two months he had Gauguin, the self-styled leader of the Pont-Aven group, alongside him.

Gauguin had first visited Pont-Aven in 1886 in search of a primitive simplicity and somewhere cheaper to live. Bernard joined him there late in the summer of 1888. Charles Laval, who had accompanied Gauguin the previous year to Martinique, and Emile Schuffenecker, another painter friend of Gauguin, were also at Pont-Aven, as were a number of other artists not part of Gauguin's circle. These included Paul Sérusier who ultimately made himself known to Gauguin, was tutored by him and in turn conveyed his instruction to his own friends.

Squabbles over priority and innovation retrospectively affected later accounts of what went on at Pont-Aven that summer. Bernard's arrival, the

younger artist full of theories, catalyzed Gauguin. The two pursued a simplification of forms, an intensification of colour and images drawn from imagination – a synthetic composition standing as a metaphor for a more profound experience of the world than the representation of visual sensations. During these months van Gogh corresponded with both artists and attempted to win them over to his 'studio of the south'.

After Gauguin's visit and his first crisis in 1888, van Gogh carried on his correspondence with Bernard and Gauguin, but he became more critical of the direction taken by their synthetism. He received a brief visit from Signac, but his picture library, established before his residence in Paris, took on renewed importance as his illness deprived him of direct artistic contact.

On his way through Paris en route to Auvers and on a sole visit from his new residence, he saw old friends and a recent exhibition (the Salon des Artistes Français) at which Puvis de Chavannes's *Inter Artes et Naturam*, 1888– 90, made a memorable impression. In Auvers Dr Gachet, who was also an amateur artist under the pseudonym van Ryssel and a friend and collector of Pissarro, Cézanne, Gauillaumin and other Impressionists, supplied van Gogh with conversation about art and an environment of pictorial images.

Such art worlds, which van Gogh knew and in which he moved, were various in their public and their productions. They covered national diversities and several generations of artists. He engaged selectively with them, as he positioned and repositioned his own enterprise. He continued to show avid curiosity in new developments but he returned to his oldest touchstones.

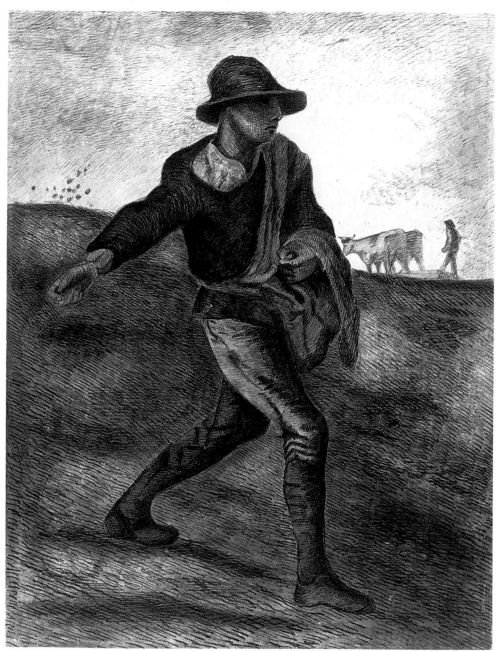

87 *The Sower (after Millet)* 1881

Van Gogh's Practice

Van Gogh was twenty-seven by the time he decided to practise art seriously. He had not shown more than an amateur interest in sketching until his experience in the Borinage had left him disillusioned with religion. His early drawings, ill-proportioned and awkward, give no sign of conventional skill or talent. Through dogged determination and self-criticism he trained his eye and his hand, while through looking, reading and discussion he worked out his concept of an artistic practice.

Except for brief associations with particular artists or educational institutions van Gogh taught himself. His work at Goupil's not only had shown him art that had been accorded market value, but had also acquainted him with a course of self-instruction. In 1868 Goupil began publishing Charles Bargue and Léon Gérôme's *Cours de dessin*, a text and two volumes of lithographed plates after casts and Old Master drawings. Bargue's *Exercices au fusain pour préparer à l'étude de l'académie d'après nature*, consisting of sixty linear models of the male nude for figure drawing, appeared in 1870. Copying was an intrinsic part of art education in the nineteenth century, and van Gogh followed approved practice. He first copied Bargue's *Cours* in 1877 114 while in Amsterdam and repeated it several times. He borrowed the *Exercices* from Tersteeg in 1880, and even in 1890 was 'terribly anxious to copy once more the charcoal studies by Bargue . . . the nude figures' (LT638). Bargue gave him a system with which to make sense of what he saw, a simplicity and geometry with which to order nature. The Bargue nudes stressed outline and 14 angularity, a way of articulating vision which he retained throughout his artistic career. Bargue's poses also remained part of his vocabulary; his figure drawings 'after nature' often adapted one of the tested formulae.

He also used Armand Cassagne's *Traité d'aquarelle* (1875), the *A B C D du dessin (Guide de l'alphabet du dessin, c. 1881), Le Dessin pour tous* (1862), and either *Traité pratique de perspective appliquée au dessin artistique et industriel* (1866) or *Eléments de perspective* (1882). He first read the *A B C D* in The Hague and still wanted it for reference in Arles, requesting Theo to send him a copy. Cassagne supplied him instruction on perspective. He had a perspective frame made when he was in Etten, a device like a stretcher frame with crossed threads used as an aid in drawing. Sketches illustrating the

construction of such an instrument made both in The Hague and years later in Auvers attest to the frame's continued usefulness.

Although van Gogh never painted copies of Old Masters in galleries and museums, he did use prints after paintings. Reproductions of Millet outnumbered all others. In Cuesmes he sketched large drawings after Millet's series *Four Hours of the Day*, his *Sower* and ten plates of *Labours of the Field*.

87–89

88 Print after Jean-François Millet's *Labours of the Field*

89 Jean-François Millet *The Sower* 1850

Much more than the plates in Bargue, these works appealed for their subject-matter: the peasant rooted in nature, frequently glossed with religious overtones. Magazine illustrations after works by Félicien Rops and Jules Dalou also served as early models. He copied such prints as an aid to figure drawing (thus expanding on Bargue's repertoire of figure types) and composition.

90 Emile Bernard *Breton Women and Children* 1888

92 *Night: the Watch (after Millet)* 1889

From 1882 he rarely made copies as a learning device, although variants on the typology of Millet, Breton and Dupré often appeared in his imagery. In Paris he painted close renderings of Japanese prints, and later in Arles he made a watercolour copy of Bernard's *Breton Women in a Meadow*, 1888. The early 90, 91 exercises had impressed their value on him as a means of study and absorption of pictorial ideas. In January and February 1890 five canvases were based on Gauguin's November 1888 drawing *L'Arlésienne* (a portrait of Mme Ginoux 95, 96 made for his *Night Café*, also of November 1888). At Saint-Rémy van Gogh returned to Millet in painted improvisations after prints, also producing 92, 93 paintings after reproductions of Delacroix, Rembrandt, Doré, Daumier and 100–103 Demont-Breton. These he considered interpretative translations, even collaborative exercises.

At the outset of his artistic career, having worked on his own for more than a year, he sought help in 1881 from the most obvious quarter, his cousin by marriage Anton Mauve. He wanted to learn to make 'saleable drawings', and

< 91 *Breton Women (after Bernard)* 1888–89

Mauve was successful at making work that appealed to buyers. He was part of the family and could hardly charge for tuition. Mauve did not teach as a rule, but he did take van Gogh in hand for a brief period. He advised on ways to observe the model and on the use of colour. He initiated van Gogh into the use of watercolour – a saleable medium in The Hague – and he gave him his first instruction in oil painting. His method of instruction included retouching his pupil's work, a standard practise; van Gogh sent Theo a watercolour of a Scheveningen girl that 'Mauve has brushed a little' (LT163, December 1882). The watercolours in particular reveal van Gogh striving to assimilate not only technical facility, but a more acceptable style and subject. The delicacy of the watercolours contrasts with the much more forceful, awkward drawings in chalk, pencil and pen. He did not, however, unquestioningly accept all tuition and rebelled against Mauve's insistence that he draw from casts.

As well as encouragement his cousin provided materials (his first palette and paints), introductions to fellow artists and the Pulchri Studio, and money. But after Mauve's friendliness cooled, van Gogh did not seek another teacher for several years. Indeed, in Nuenen it was he who offered tuition to local pupils.

Van Gogh seems to have considered enrolling at the Academy in Brussels but there is no record of his attendance. The Antwerp Academy instead became his first formal art education. He had initially decided to go to Antwerp to find a public and renew contact with art and artists; as for the Academy, 'they would not want me . . . nor would I want to go there', he wrote from Nuenen (LT433). Yet he also thought he needed to work from the nude model and to draw from antique casts in order to master the human figure. Thus, in January 1886, he enrolled in a figure painting class taught by Verlat and an evening drawing class led by Vinck. A few weeks later he joined Eugène Siberdt's daytime drawing class. He found more life models, especially female models, who were rarely employed at the Academy, by joining drawing clubs. While he made an effort to comply with academic teaching by making a figure of Germanicus for the drawing class competition, he refused to compromise completely. He was convinced that he would be placed last in the competition 'because all the drawings of the others are exactly alike, and mine is absolutely different' (LT452). He resisted academic idealization. Correct academic drawing was 'dead'. When given a cast of the Venus de Milo to draw, he accentuated her hips and rebutted his teacher's criticism by pointing out the biological function of female proportions.

Dissatisfied as he was with the Antwerp Academy he envisaged another year of life and cast drawing in Paris, the aim being to acquire the ability to

draw a figure from memory: 'One who can draw a figure from memory is much more productive than one who cannot.' (LT449). He expected little more from Cormon's instruction than from Verlat's; rather the opportunity to have models at a feasible cost drew him to the Academy and atelier. Study at Cormon's may have been a rationalization of motives to overcome Theo's seeming reluctance to have his brother descend on him in Paris. Once there he may not, indeed, have rushed to Cormon's as has commonly been supposed. A. S. Hartrick remembered Cormon as being an 'admirable teacher' and 'more sympathetic to novelties than most of his kind'. Van Gogh tested his open-mindedness: François Gauzi, another student, recalled that van Gogh did not produce the strictly copied drawing studies expected of a willing pupil. On one occasion he painted the nude as a study in strong colour contrasts. Bernard attributed van Gogh's departure from Cormon's to a realization that the calm perfection of classicism was not in his Dutch nature.

Surviving life and cast drawings show a development from gauche, lumpy bodies accentuating knotted muscles to more smoothly contoured and gradually modelled studies. In Paris he drew several casts repeatedly. Three of these casts, a female nude, a male écorché, and a male nude after Michelangelo's *Dying Slave* are now in the collection of the van Gogh Museum in Amsterdam. The fact that he owned casts suggests that much if not all of these studies were done at home rather than at Cormon's. 35, 36

Cormon's studio was van Gogh's last period of formal study, but he remained a perpetual student even after he had gained greater confidence in his work. In Paris he discovered the work of Monticelli and assiduously absorbed his manner in tactilely painted floral still-lifes of darkly glowing colour. Later, in Saint-Rémy he returned to his earlier masters Millet, Delacroix and Rembrandt to plumb fresh insights. 37, 99

Gauguin claimed something of a master–pupil relationship with van Gogh in Arles and attributed van Gogh's mature style to his own guidance. He wrote in *Avant et après*, 'Van Gogh, without losing an inch of his originality, gained a fruitful lesson from me. And each day he would thank me for it. . . . When I arrived in Arles, Vincent was trying to find his way, whereas I, much older, was a mature man. I do owe something to Vincent; namely the awareness of having been useful to him, the *affirmation* of my earlier ideas about painting.' Although the work of the two artists does not bear out this arrogant statement, van Gogh seemed to concur. He wrote to the critic Aurier that he owed much to Paul Gauguin and allotted himself a secondary position. His *L'Arlésienne* paintings after Gauguin's drawing render his sometime companion a homage consistent with his variations on works of Millet and Delacroix. 94, 95

95, 96

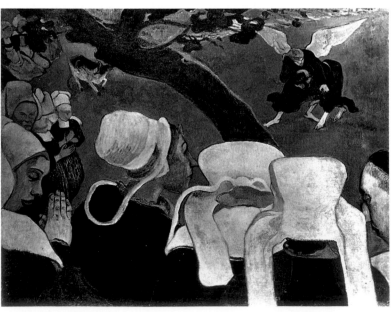

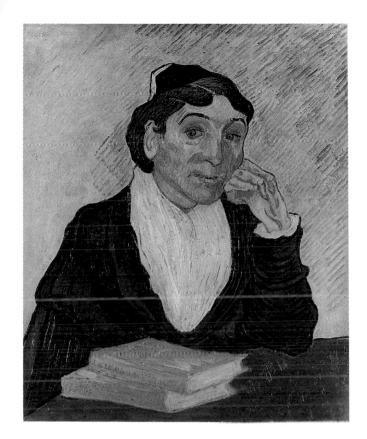

< 93 *The Sower* 1888

< 94 Paul Gauguin *Vision after the Sermon* 1888

95 *L'Arlésienne (after Gauguin)* 1890

96 Paul Gauguin *L'Arlésienne: Mme Ginoux* 1888

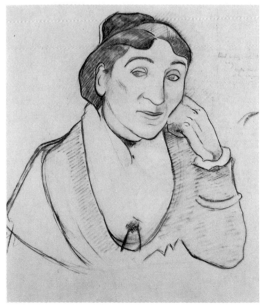

Van Gogh has been regarded as among the least theoretical of the Symbolists; nevertheless, while he may have contributed little to the theoretical strategies of Symbolism, he did not simply paint from instinct or emotion. Van Gogh thought about art and its purpose before he ever attempted to become a professional. His ideas and his practice were mutually revised and re-articulated during his decade as a painter.

Theoretical support for his practice was derived from voracious reading as well as from conversation and accepted conventions, but van Gogh absorbed and reformulated these ideas into statements of his own beliefs in his letters. In these he discussed technical details of his paintings, he revealed premises underlying his working methods and he put forth his convictions about the social role of painting.

Colour preoccupied him even during his Dutch years when earthy tones dominated his paintings. Discussion of his palette and the effect desired from particular ways of handling colour recur throughout his letters to Theo. Colour is a more regularly insistent theme than drawing or composition. Early paintings concentrate on rendering the appearance of local colour. By the late spring of 1884 his approach to colour had been imbued with theories about Delacroix's colour as expounded by Théophile Silvestre and Charles Blanc. Blanc based his ideas of simultaneous contrast on the colour science of M. E. Chevreul. Henceforth, van Gogh's writing about colour adopted a more technical language: 'green and red are complementary colours. . . . pink is the broken colour, got by mixing the above-mentioned red and the above-mentioned green. That's why there is harmony between the colours. . . . the background forms a contrast to the foreground, the one is a neutral colour, got by mixing blue with orange; the other, the same neutral colour simply by adding some yellow . . . The reason why this dull yellow stands out so is because it is put in a wide field of, be it neutral, violet.' The letter concludes, 'If you come across some good book on colour theories, mind you send it to me, for I too am far from knowing everything about it, and am searching for more every day.' (LT428, October 1885). It is extraordinary that this letter

30 was written while he was painting still-lifes striking for their resinous, tar-like appearance. In 1885 simultaneous contrast had meant not optical mixture but the avoidance of local colour and the production of chiaroscuro through the mixing of complementaries. Subsequently van Gogh's theories while at Nuenen altered in application but not in substance. Blanc's theories could sustain multiple readings; indeed, they were fundamental to Neo-Impressionism.

97 In Paris van Gogh encountered the divisionist colour first rigorously applied by Seurat and espoused by their common friends Signac and Fénéon. He did not, however, adopt divisionism's luminously vibrating colour, and

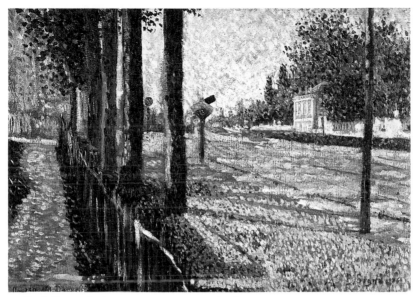

97 Paul Signac *Railway Junction at Bois-Colombes* 1886

he did not become directly acquainted with the scientific ideas of Charles Henry until informed in a letter from Signac in April 1889. Japanese prints finally precipitated his developing cloisonnist separation of vivid hues. It was a desire for stronger colour sensations that led him to the south of France. The Arles paintings intensify and exaggerate local colour in an effort to evoke spiritual states of mind. Gauguin, elaborating his own symbolic use of colour, and engaged in one-upmanship, wrote to van Gogh in September 1888, 'You are right to want painting with a colouration suggestive of poetic ideas, and in this sense I am in agreement with you with a difference: I do not know *poetic ideas*, it is probably a sense that fails me. I find *everything* poetic and it is in the corners of my heart that sometimes mysteriously I catch a glimpse of poetry. Forms and colours conducted in harmony produce from themselves a poetry.' At the end of his life van Gogh saw colour 'as a means of arriving at the expression and the intensification of the character' in portraiture, in contrast with 'photographic resemblance' (W22, June 1890).

In Paris Vincent and Theo went to several concerts to hear Wagner's music, and in June 1888 he read a book on the musician. Wagner fed his earlier interest in analogies between colour and music, one that had developed from observation and had been reinforced by Blanc: 'in Nuenen . . . I made a vain attempt to learn music, so much did I already feel the relation between our colour and Wagner's music.' (LT539, September 1888). The

French permutation of Wagner's ideas inspired many poets and other painters of the Symbolist generation as well.

Convention supported his assumptions about the value of copying, perspective systems and life drawing, but he objected to the ends to which these skills were put in academic teaching. Rather than aspiring towards an academically defined success, he modestly set his sights on learning a 'handicraft' (LT142), an 'artisanly' defined goal concomitant with policies of reform in French art and design education since the middle of the century. Academic traditions had been challenged by Romanticism and questioned not only by vanguard artists but also by official institutions. By the 1880s van Gogh's was hardly a radical position. Thus, his acceptance not just in his early work of the academic division between studies and finished pictures is all the more remarkable. 'So studies belong more to the studio than among the public, and must not be considered from the same point of view as the pictures.' (LT233, autumn 1882). Later, although he was willing to have his studies seen, he accorded relatively few paintings the status of 'finished pictures' with his signature.

Alongside his abundant discussions of the practical and narrowly professional aspects of his art he articulated his vision of the function and purpose of art in terms no less interactive with the arguments of his time. Van Gogh's conception of the role of nature modified during his career, although he rarely relinquished reference to a model. He invoked nature in a letter of July 1882 (LT221) in active resistance to Tersteeg's call for a more saleable kind of watercolour composed from memory. Nature stood for the directly observed model against the cosmetic softening brought about by memory. In the autumn of 1885 nature's central role made way for the expressiveness of the painter's materials. '*Colour expresses something in itself*, one cannot do without this, one must use it; . . . the result is more beautiful than the exact imitation of the things themselves. . . . To study from nature, to wrestle with reality – I don't want to do away with it, for years and years I myself have done just that, almost fruitlessly and with all kinds of sad results. . . . One starts with a hopeless struggle to follow nature, and everything goes wrong; one ends by calmly creating from one's palette, and nature agrees with it, and follows. . . . Though I believe that the best pictures are more or less freely painted by heart, I *can't* help adding that one can never study nature too much and too hard.' (LT429). Here, van Gogh appears to have been defining his art in response to Theo's information about Manet and possibly the Impressionists. In Arles, even at the prodding of Gauguin, he found work from the imagination extremely difficult and the results often dissatisfying. He destroyed a religious painting, *Christ with the Angel in Gethsemane* (B19, October 1888) and later, when Bernard sent photographs of his recent

religious paintings, he protested at the 'mystification' and admonished his friend, 'you can do better than that, and you know you must seek after the possible, the logical, the true.' (B21, November 1889). To Theo he disparaged Bernard's and Gauguin's direction and responded, 'What I have done is a rather hard and coarse reality beside their abstractions, but it will have a rustic quality, and will smell of the earth ' (LT615, November 1889) A realist in contrast to his friends' 'abstractions', but no realist in the sense of Courbet or naturalist in the sense of early Impressionism, van Gogh used intensified colours and exaggerated drawing not to reject nature but to bring out its experience more vividly, to express himself more forcibly. Gauguin nominated him a romantic in contrast with his own primitivism.

In July 1882 van Gogh had positioned the artist (himself) as romantically detached from the public: 'Sooner or later feeling and love for nature meet a response from people who are interested in art. It is the painter's duty to be entirely absorbed by nature and to use all his intelligence to express sentiment in his work so that it becomes intelligible to other people. In my opinion working for the market is not exactly the right way; on the contrary, it means fooling art lovers. The true painters have not done this; the sympathy they eventually received was the result of their sincerity.' (LT221, July 1882). Despite claims that he wanted to earn his living by his work and to make saleable paintings, van Gogh subscribed to the divisibility of art and economic realities and to the necessity of this division for artistic integrity. As the years wore on and he came no nearer to earning his living through his art and as the anxiety of his dependence on Theo weighed on him, he barely modified his basic stance: 'But have I set my heart on my work being a success? A thousand times no. . . . I only want my pictures to be of such quality that you [Theo] will not be too dissatisfied with *your* work [i.e. Theo's financial support].' Rather than actively resisting the institutions of the art market he advocated passive acceptance: 'it is not our duty to alter what exists, and to beat our heads against a stone wall. Anyway, we must get our place in the sun without upsetting anyone.' (LT550, October 1888).

Van Gogh's devotion to peasant imagery has been identified with socialist politics or with anarchism, since he knew of the ideas of the Dutch anarchist author Multatuli, a critic of Dutch colonial policy in his novel *Max Havelaar*. Having previously depicted a range of urban and agricultural workers, in Drenthe he identified his enterprise with peasant imagery. Letters written from Nuenen in 1884 frequently refer to the barricades and to revolutionary principles, but the barricades are those of 1848 and the revolution is one in art likened to political events of three decades earlier. Indeed, his peasant painting constructs a reactionary imagery, in naturalizing and eternalizing the role of the peasant rather than advocating change: in 1884 he wrote, 'If I

have some luck with that shepherd, it will become a figure in which there will be something of the *very old Brabant*' (LT382); and in 1888, 'in the portrait of the peasant I worked this way . . . I imagine the man I have to paint, terrible in the furnace of the height of harvest-time, as surrounded by the whole Midi.' (LT520).

His friends Père Tanguy and the postman Roulin came from a lower social class but despite the subject-matter of his painting, he formed few friendships outside his own class. In describing Roulin to Theo he likened the postman to Tanguy, characterizing both as revolutionaries, detesting the Third Republic and disillusioned with the republican principle. Yet the revolution is that of 1789: 'I once watched [Roulin] sing the "Marseillaise," and I thought I was watching '89, not the next year, but the one 99 years ago. It was a Delacroix, a Daumier, straight from the old Dutchmen [the Dutch Old Masters].' (LT520). Roulin the revolutionary becomes picturesque.

The writings of Jules Michelet and Thomas Carlyle contributed substantially to the formation of van Gogh's social and political framework. Michelet was a liberal romantic republican, nostalgic for the first French revolution. Van Gogh became acquainted with his writings in 1873, and although he disavowed Michelet during his religious phase, he again drew support from the French writer's ideas on women and the family while in The Hague. In 1883 he began reading Carlyle. Carlyle sanctioned his distaste for social realities, reinforced a withdrawal into abstract thought rather than political action, and offered a universal, ideal notion of 'Man'. Carlyle's formulation of the poet (or artist) as prophet, a revealer of sacred mystery, supported van Gogh's assumption of a posture of romantic alienation and the role of religious martyrdom for the sake of his art.

Thus van Gogh's relation to theory throws up ambiguities and contradictions. His approach was eclectic and empirical. While he constantly attempted to 'explain' himself and his work he did not consciously theorize his position.

So, too, his tastes in art were astonishingly eclectic. His early favourites are listed in Chapter III, and his later admirations continued to be generously inclusive. He defended Meissonier against Gauguin's contempt and Aurier's dismissive remarks in 1890 (in 'Les Isolés' he referred to 'the small infamies of M. Meissonier'). Repeated viewings of Meissonier's workmanship provided something new each time; Cabanel, too, could offer truth and keen observation (LT602), but Gérôme, an academic associate of Meissonier and Cabanel, he branded a 'delusive photographer' (LT527).

Originality was a frequent term of praise for the art of his contemporaries and colleagues. Of Seurat he wrote, 'I often think of his method, though I do not follow it at all; but he is an original colourist, and Signac too, though to a

different degree, their stippling is a new discovery.' (LT539). While he and Gauguin lived together, he rarely wrote analytically or critically about his friend's painting, but he approved its originality: 'Gauguin is working on a very original nude woman in the hay with some pigs. It promises to be very fine and of great distinction.' (LT562). Later, disappointed with Gauguin's and Bernard's departure from nature, he noted to Theo that 'it gives me a painful feeling of collapse instead of progress.' (LT615). In his own relentless self-criticism he aimed for sincerity and emotional commitment. 'Is it not emotion, the sincerity of one's feeling for nature, that draws us, and if the emotions are sometimes so strong that one works without knowing one works, when sometimes the strokes come with a continuity and a coherence like words in a speech or a letter, then one must remember that it has not always been so, and that in time to come there will again be hard days, empty of inspiration.' (LT504).

Thus, van Gogh evinced a refusal to set stylistic or technical standards of judgment. He appealed to something like an integrity of individual perception or experience. He implied that this experience of truth, sincerity, originality might be a common experience and did not regard it as problematic. His eclecticism, in contrast with the frequent exclusivity of his friends (cloisonnists and pointillists refusing to have anything to do with each other), assumes more the distance of historian, dealer or arts administrator than the partiality of a producer intent on forming a personal and original art. It was an attitude already prevalent in official educational and cultural circles in the 1880s – the encouragement of diversity and individuality – although officialdom expected commitment rather than impartiality from each artist.

Van Gogh's multifarious experience granted him familiarity with a wide range of the past and present art that could be experienced in Western Europe at the time. It also directed the choice of the art with which to engage his own work, and the significance of that art to his work.

His admiration for artists of the Romantic and Romantic-realist generations – Millet, Delacroix, the Barbizon painters – may appear anomalous in a painter committed to originality. Similarly, while the Realist generation sanctioned his passion for seventeenth-century Dutch painting, such touchstones were at least an artistic generation out of date with his French contemporaries.

As van Gogh deliberately set his own course of education and worked out his practice so he constructed his own artistic genealogy. During his Dutch years the dialogue of his art with the Hague School, seventeenth-century Dutch painting and the Barbizon school might be seen as part of the conventional baggage for a young ambitious painter in that country and at that time. Most obviously, his involvement with convention manifested

98

itself in his choice of motifs. Images of the beach at Scheveningen and of workers in the fields bear comparison with those of Mauve. His peasant interiors relate to the work of Jozef Israëls, whom he regarded equal to Millet. Landscapes done in Drenthe especially seem to recollect Weissenbruch in the relationship of earth, human-made objects and sky. Although he later found fault with the grey tonality that had become a mannerism with younger Hague School painters, he continued to respect Mauve's work.

While his work moved away from the Hague School, it continued to refer to Millet, the Barbizon painters and the older Dutch masters. From The Hague he wrote that he considered Millet's and Jules Breton's work unsurpassable and 'since Millet we have greatly deteriorated.' (LT241).

His Dutch peasant images from The Hague have a superficial resemblance to the peasants of his Dutch contemporaries, although his early copies after specific Millet images had become part of his vocabulary of poses. In Drenthe and Nuenen, however, with the shift in his enterprise, Millet's work became significant to his strategy. He constructed an equivalent of Millet's monumentalized peasant together with the plain, sometimes brutal ugliness of feature evident in Millet's depictions of male peasants. The poses of labour and the relation of the figure to the horizon repeatedly recall Millet. The decorative programme of designs made for Hermans suggests an emulation of Millet's *Seasons*, which depicted peasants in unity with the cycles of nature. Millet, and to a certain extent Breton and other Barbizon painters, offered an apparently sympathetic and truthful image of the peasant – truthful in the sense of rejecting the cosmetic, picturesque veneer of a Léopold Robert. Yet

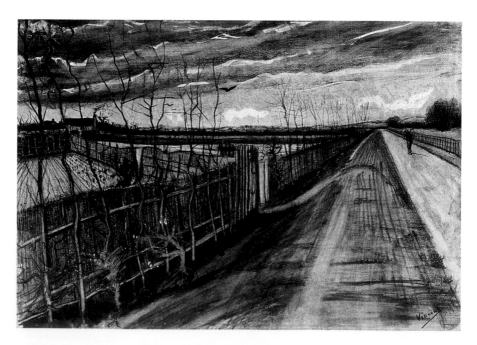

the naturalization of peasant life located an eternal peasant as an opposite to modern urban instability. Van Gogh's own life also alternated several times between city and country, and the country served as a refuge from the city.

Van Gogh's rephrasing of Millet at Saint-Rémy came as a reassertion of natural order at a time when his own 'natural' biology seemed less secure. Millet-like peasant images inhabit many Arles and Saint-Rémy paintings but, concurrent with his insistence on returning north, the drawing of his peasant figures assumes a generalized, rounded form, a softly inflated appearance which can be related to Millet's figures.

His initial response to Delacroix developed in Nuenen away from any direct contact with the artist's works, although van Gogh had admired Delacroix long before he became an artist. References to him proliferate in the later letters from Nuenen. Delacroix promised theoretical guidance, albeit received at second hand, at a time of struggle to stretch his own handling of colour.

His first extended reference to Delacroix, a quote from Charles Blanc's *Les artistes de mon temps* (LT370), followed a visit from Theo in the summer of 1884. Its context suggests that his interest in Delacroix increased through the stimulus of conversations with his brother. Once in Paris van Gogh turned to the work of another Romantic colourist, Monticelli. Delacroix's Romantic imaginative subjects did not correspond to van Gogh's need to refer to nature, but Delacroix the colourist undoubtedly prepared his receptivity to Monticelli's still-lifes. Floral still-lifes in Monticellian impastoed, jewel-like colour became a major motif in 1886.

37, 99

98 (opposite) *Road at Loosduinen near The Hague* 1882

99 *Vases with Asters and Phlox* 1886

121

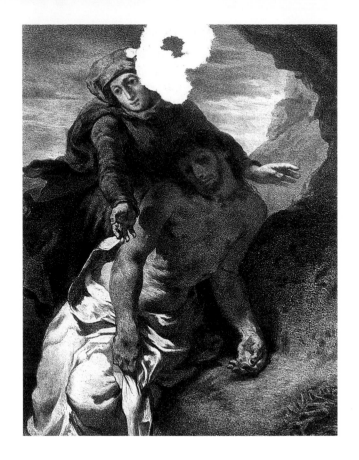

Delacroix and Monticelli also served as models for the move to Arles. Delacroix had gone to North Africa, but to van Gogh this meant that he had gone south, and the experience of southern light had been a catalyst for his colour. Monticelli had come from Marseilles, not far from Arles. Indeed, van Gogh hoped to make the journey from Arles to find paintings by Monticelli. Delacroix's example also maintained his perseverance through difficulties: 'I am always thinking of that saying of Delacroix's . . . namely that he discovered painting when he no longer had any breath or teeth left.' (LT605, September 1889).

Delacroix's subjects finally became available through reproductive prints as objects for van Gogh's interpretations. Delacroix's *Pietà* and *Good Samaritan* were both Biblical subjects, a kind of imagery that van Gogh had been unable to realize in earlier efforts and one whose realization he found objectionable in the work of Bernard. Whereas the imaginative effort of

100

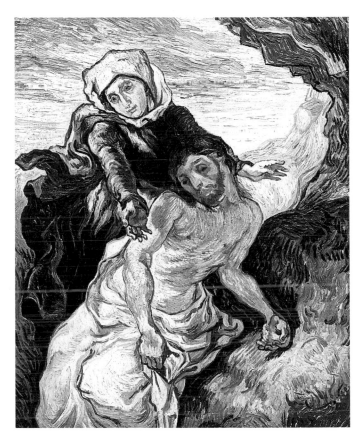

100 (opposite) Eugène Delacroix *Pietà* (print by Céléstin Nanteuil)

101 *Pietà after Delacroix* 1889

producing his own 'Christ in the Garden of Olives' proved impossible, prints after Delacroix served him in a manner akin to nature, an object for the projection of emotional empathy. He even validated Delacroix's religious imagery on rather spurious bases: that his travels had acquainted him with people who were descendants of the early inhabitants of the Holy Land.

Ironically, reproductive prints did not provide colouring, the very thing which had been Delacroix's initial attraction for van Gogh. Rather, colour became a signal aspect of van Gogh's translation of or improvisation on Delacroix, only distantly related to memories of originals by Delacroix. At the time that van Gogh painted the *Pietà*, in September 1889, he had been suffering from disturbing religious hallucinations and Nanteuil's reproduction is damaged as the result of an attack. Possibly the choice of motif responded to or attempted to exorcise what he described as 'an absurd religious turn' (LT605, September 1889).

101

123

102 Rembrandt *The Raising of Lazarus*

103 *The Raising of Lazarus (after Rembrandt)* 1890

A Rembrandt print of a religious motif, *The Raising of Lazarus*, became another model for interpretation. Freely adapted, van Gogh's version of *The Raising of Lazarus*, May 1890, used only a detail from the Rembrandt, cutting out the figure of Christ and substituting a glowing sun, his own evocation of supernatural power.

Van Gogh's reverence for Rembrandt remained the most constant and profound of all his attachments to the Dutch Old Masters. Rembrandt's characterization as both realist and romantic by mid-nineteenth-century critics especially appealed to van Gogh. After several years of isolation from the art world in Nuenen he longed for the museums of Amsterdam, particularly to see Rembrandt and Hals. The visit to Amsterdam became a kind of epiphany. Rembrandt, both 'true to nature' and (when 'free to idealize') soaring to the 'infinite', revealed himself as poet, or 'Creator'. Hals 'remains on earth' (LT426), but his colour and range of greys occasioned enthusiastic description. The colour of both Hals and Rembrandt was filtered through eyes tinted by his reading of Delacroix's theory.

While Rembrandt and Hals sanctioned his devotion to portraiture, Vermeer, Ruysdael, Koninck and other Dutch painters offered landscape formats – panoramas and bird's-eye views, buildings intimately attached to the land, receding perspectives and spatial deflections. For all his admiration of the Old Masters, however, he regarded his favourite 'modern masters' quite as reverentially.

Puvis de Chavannes, born in 1824, but still active and just beginning to attract attention from the generation of the 1880s, became a late final enthusiasm of the moderns. Puvis's simplified, classicizing, yet suggestively evocative decorations found supporters among the painters of the Symbolist generation. By 1889 van Gogh had come to equate Puvis with Delacroix in importance; to the critic Isaäcson he wrote, 'His canvases of the last few years are vaguer, more prophetic if possible than even Delacroix, before them one feels an emotion as if one were present at the continuation of all kinds of things, a benevolent renaissance ordained by fate.' (LT614a, November 1889). His reaction to the recent direction taken by Gauguin and Bernard focused his attention on Puvis. It is tempting to associate the muted palette of the late autumn of 1889, often employing chalky earth colours, to a memory of Puvis's serene work. The Puvis that he admired in the Salon of 1890 had a long frieze-like format. Soon after, on 17 June, he first tackled this format as a double square hung horizontally (with one exception), which he used for his most ambitious late paintings. The idealism, transcendence and timelessness of Puvis appealed to van Gogh.

Although van Gogh verbally expressed admiration for the achievements of his contemporaries, his pictorial practice was more critical. He had friendships among younger members of the Hague School, but he oriented his work towards a dialogue with the more established Hague painters and he decidedly rejected the neutral tonality of his younger Hague peers.

Van Gogh's pantheon of masters whether old or modern was a touchstone for inspiration. As examples of what could be attained they served to define his goals for modern painting. He also took refuge in them for spiritual consolation. The making of art supplanted religion in his life, and the art of others came to bear his devotion. He questioned only the painters of the Hague School, so nearly his contemporaries.

Van Rappard became his closest associate until 1886. Although van Rappard was younger in age, he was ahead in artistic training. Van Gogh at first expressed uncertainty about pursuing a friendship because of van Rappard's prosperity and a reservation about young artists 'who do not always reflect on what they do or say' (LT139, January 1881). By May 1882 van Rappard's approval of van Gogh's drawings was worth reporting to Theo (LT202). In turn van Gogh imparted his enthusiasm for English

graphics to his friend. During visits they seem to have worked side by side on similar though not necessarily identical motifs. Although van Gogh often self-effacingly credited the dominant artistic contribution to those with whom he interacted, he came to regard the relationship with van Rappard as one of equals who could 'profit more from each other's experience' (LT271, March 1883). Disagreements eventually arose over technique and over van Gogh's most heartfelt enterprise of his Dutch years – his approach to peasant painting, which culminated in *The Potato Eaters*, 1885. 125

In Paris van Gogh first formed friendships with artists whose practice cautiously steered through naturalism towards Impressionism. John Russell and the Englishman Frank Boggs both were working from a palette and brushwork derived from Realism and Manet. Only Fabian had begun to absorb the palette and facture of Impressionism.

By the autumn of 1886 van Gogh was definitely familiar with work by the Impressionists. He probably saw their final group exhibition in May and June and individual works either at Durand-Ruel's and Georges Petit's galleries or at Tanguy's and Portier's shops. To Livens, a friend from Antwerp, he wrote of his qualified response: 'though not being one of the club yet I have much admired certain impressionists' pictures – *Degas* nude figure – *Claude Monet* landscape.' (LT459a, August/October 1887); his descriptions of his current enterprise and his paintings attest to his difficulty in coming to terms with Impressionism. The still-lifes refer to Monticelli; the landscapes tentatively adopt a *plein air* palette and broken brush-stroke (as distinguished from a juicier painterly application).

His paintings reached their closest resemblance to the Impressionist work of Monet in the summer of 1887, following a brief adoption of a more regular 133, 135 application of contrasting hues derived from Neo-Impressionism.

While he knew Seurat's work – *Sunday Afternoon on the Island of Grande Jatte*, 1884–86, had been exhibited twice – he was not to meet this foremost Neo-Impressionist until February 1888. He was close to Signac in the spring 97 of 1887, but however much he adopted details of Neo-Impressionist facture he handled them decoratively rather than with the scientific rigour of a dedicated proponent. Van Gogh's response to Neo-Impressionism briefly resembles Toulouse-Lautrec's, which during the same months had adopted a scintillating surface made up of fine, thread-like pigment application. 130

Even superficial reference to Neo-Impressionism, being the only coherent stylistic critique of Impressionism in the mid-1880s, served as a means of breaking away from the generation of the 1870s. Bernard, who later minimized his contact and destroyed most of the work, and Toulouse-Lautrec both soon moved towards flattened patches of colour bounded by a cursive outline, which came to be known as cloisonnism. So did van Gogh,

104 Louis Anquetin *The Mower at Noon: Summer* 1887

105 *Arles, View from the Wheatfields* 1888

but his course was distinguished by its apparent devolution from a rather hesitant exploration of Neo-Impressionism to a bolder, more intuitive Impressionist-like landscape style. By the autumn of 1887 his work and his entrepreneurial abilities contributed to the formation of cloisonnism, but both in the Du Chalet exhibition and in his work van Gogh did not discard his previous alliances. He wanted to include Neo-Impressionists in the exhibition, and he transposed the insistent pointillist touch into drawn marks, which constituted an all-over surface.

Among the Du Chalet artists both Anquetin's and Bernard's work provoked later response from van Gogh. In Arles he clarified his drawing and composition, strengthening his draughtsman-like painterliness and organizing colour into compartments of intense hues. A memory of Anquetin's 104, 105 *Mower at Noon: Summer*, 1887, emerged in *Arles: View from the Wheatfields*,

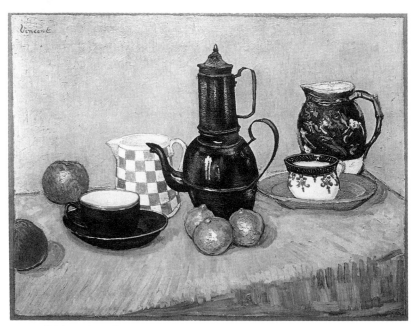

106 *Still-life with Coffee-pot* 1888

106 June 1888, and *Still-life with Coffee-pot*, May 1888, arrives at a surface pattern and composition similar to Bernard's contemporary still-lifes.

 In Arles he maintained contact with Bernard and the painters at Pont-Aven both directly and through Theo, exchanging written ideas and painted works. His involvements with other artists were relatively uncomplicated compared to his relationship with Gauguin. While he engineered Gauguin's close presence, he resisted a wholesale adoption of Gauguin's practice, for by the end of the 1880s he had achieved a degree of conviction in his own work. Competition stimulated creative production and he did yield to Gauguin's

58 insistence on working from imagination: *Memory of the Garden at Etten* came
57 closest to his friend's co-eval work *Garden at Arles* but, as if in defiance of Gauguin's distaste for Neo-Impressionism, he sprinkled the surface with a simulacrum of pointillist dots. After the first manifestation of his illness and Gauguin's precipitate departure he continued to follow developments at Pont-Aven, but his belief in his own direction was secure enough for him to voice some of his strongest artistic criticisms against their religious and mystical idealism.

 Van Gogh's dialogue with his contemporaries took various forms. From some he sought friendship and artistic companionship, stimulus and criticism

(provided that the criticism did not wound). Others guided the formulation of his direction, their work offering challenges and insights. The personal investment which van Gogh made in the relationship with Gauguin, however, conflicted with the reality of mutual artistic abrasion.

Van Gogh drew on elements not only from the European fine art tradition but also from outside it. Graphic illustration offered a contemporary imagery not broached in painting, although French Realist painters had referred to popular prints and other forms of popular imagery in establishing the authenticity of their own. Van Gogh's early enthusiasm for illustration, particularly in the British press of the 1870s, was related to its subject-matter: scenes of work both urban and rural, human 'types' generally drawn from the working class. It served as a reference for his own undertaking to become an illustrator. The illustrations of Fildes, Herkomer and Holl, among others, 82, 83 offered power and virility, stimulation and invigoration (R23, February 1883). He read in them a nobility and seriousness of sentiment (LT240, November 1882). He identified the biographies of these artists with his own economic struggles.

Drawing predominated in van Gogh's work in The Netherlands. Until he went to Drenthe his output was almost entirely in black and white, and even in Nuenen drawing served as a medium for finished compositions as well as for studies. In The Hague lithographic crayon and black chalk gave rich 107

107 *Public Soup Kitchen* 1883

density to his images. The vocabulary of wood engraving (a contribution of the craftsman who carved the block rather than the illustrator) may have encouraged his development of a pictorial language consisting of specific marks for texture, colour and space. Graphic illustration encouraged legible shapes and striking images that read two-dimensionally. His favourite illustrations fixed images of social types that were simultaneously readable as individuals – a feature of his own portraiture. In his later painting he extended and adapted these early graphic practices, refining his draughtsmanship and constructing arresting images.

European artists had appropriated Japanese cultural artefacts since the end of the 1850s. In the 1860s and 1870s Manet, Whistler, Degas and the Impressionists were attracted to Japanese *ukiyo-e* woodcut prints. Van Gogh may even have encountered Japanese prints before 1870 and in Nuenen he read Edmond de Goncourt, a *japoniste* enthusiast. A letter from Antwerp gives the first evidence that he owned prints, and he described his first impressions of Antwerp as 'Japonaiserie' (LT437, late 1885). Although he organized an exhibition of Japanese prints at the Café du Tambourin in the spring of 1887, not until that summer did he actually attempt to come to terms artistically with the images from his own collection and those he poured over at Bing's shop. He then translated into paint two prints after Hiroshige and synthesized another painting from several sources including a cover of *Paris illustré* which reproduced a print by Keisai Eisen. These works were his most faithful copies since Etten, although he also improvised in each case: the borders of the 'Hiroshige' paintings include nonsensical combinations of real Japanese characters, while the colour and border of the 'Eisen' work are more freely imagined. He did not immediately follow up the flat colour patterns, but Hartrick later suggested that van Gogh's striated paint texture in late 1887 attempted to imitate the crêpe paper surfaces of some Japanese prints. He next overtly acknowledged Japanese prints in the background of the seated portraits of Père Tanguy, winter 1887–88. The decorative background competes with the figure of Tanguy himself as a striking surface pattern. A less demonstrable relationship between his painting and Japanese prints (so far undocumented and not discussed) may be suggested in the development of his palette during 1887. Although his move towards more saturated, unmixed hues shows his interaction with advanced Parisian painting, his adoption of searing colours and acid combinations is not shared by his colleagues' work; however, certain reds, yellows, blues and greens are juxtaposed in the coloured inks of late Edo period Japanese prints.

Van Gogh's mental image of the Japanese projected a primitive, religious, natural people. Japan stood in his mind for an ideal world, a world he sought in the south. He thought the light in Arles would render nature closer to the

108 'Le Japon', cover of *Paris illustré* May 1866

109 Van Gogh's tracing of the *Paris illustré* cover, 1887

Japanese colouring, and soon after his arrival wanted 'to make some drawings in the manner of Japanese prints' (LT474, April 1888). Although he referred to the Japanese aspect of his Arles work more than once, his Japonisme is less specifically identifiable than in the work of many of his immediate predecessors and contemporaries. By the late 1880s certain 'Japanese' qualities – a high vantage point and cropping of forms at the edges – had been widely adopted, yet van Gogh did not exploit such stylistic traits. A painting such as *L'Arlésienne*, November 1888, with its flat shapes, broken contour and use of black as a positive colour, may belatedly resume a direction proposed in his Paris adaptations of Japanese prints. It may, on the other hand, be responding to Bernard's and Gauguin's cloisonnism. It may also be a response to discussions with Gauguin, which considered the imposition of abstract decoration on nature found in Japanese prints. Van Gogh's final quotation of Japanese imagery was a depiction of Toyokuni's *Geishas in a Landscape* at the right in *Self-portrait with a Bandaged Ear*, January 1889 (the version in the Courtauld Institute Galleries, London). Disillusioned with the failure of his

111

66

110

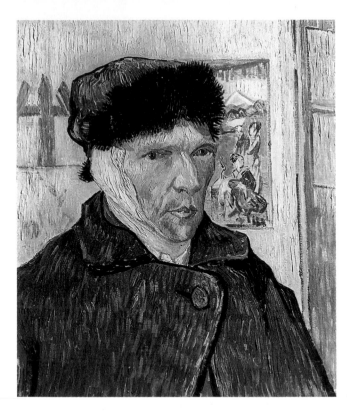

110 *Self-portrait with Bandaged Ear* 1889

southern dream, he painted a disjunctive juxtaposition of sunny Japan and his bundled up figure.

Both graphic illustration and Japanese prints had connotations of 'modernity'. Although a key to his development as a painter, neither kind of work held for him the same richness as the work of his favourite painters. In aspiring to become an illustrator van Gogh visualized a mass public and means of access to that public. The audience for illustrated magazines was far larger than the audience for paintings and comprised economic and social classes for whom the visual vocabulary of painting was an unaccustomed (and possibly illegible) experience. While he had in mind the ultimate aim of producing a graphic imagery largely observant of the working class, the *déclassé* and those who had fallen on hard times (the 'honest' poor), he also attempted to reach a fine-art audience.

In The Hague, besides working briefly for his uncle C. M. making topographical scenes, he attempted to produce work that would interest Tersteeg, but managed to sell him only one for ten guilders. The work he did

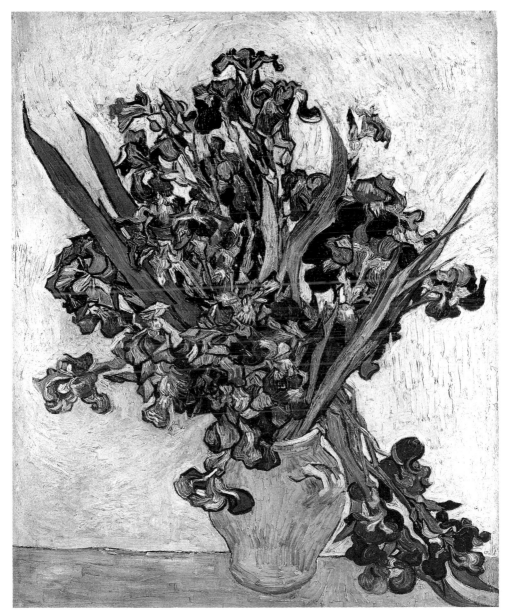

111 *Vase with Violet Irises against a Yellow Background* 1890

produce, however, was either too specific or too unconventional in subject-matter – the raw topography of the emerging urban outskirts rather than more picturesque views of the old city or rural countryside – to find a place in the middle-class market for drawings and watercolours. He never did approach the editorial offices of the magazines he admired. He never professed himself ready for the move to London which that would have entailed. Although he came to identify himself as a painter, even in Nuenen he planned to make drawings for the *Illustrated London News* (LT380, autumn 1884).

As a painter he had a less specific market in mind. In The Netherlands he painted peasant pictures for city dwellers, hoping to find patrons in Belgium, Antwerp or Paris. His experience of art dealing and dealers left him with disdain for the taste of the middle-class patron who acquired art as a commodity and as a sign of social status: 'I shrug my shoulders at the banalities which most connoisseurs seem to indulge more and more.' (LT366, spring 1885). He visualized a small, appreciative élite who would understand his work. He hopefully projected onto an audience his own aspirations. From Nuenen he wrote, 'the realism *not wanted* then [in the time of Charles de Groux, 1825–70] is *in demand* now' (LT390, early 1885) and, 'I personally have the firm conviction that there are a few people who, having been drawn into the city and kept bound up there, yet retain unfading impressions of the country, and remain all their lives homesick for the fields and the peasants. Such art lovers are sometimes struck by the sincerity in a picture, and what repulses others does not trouble them.' (LT398, spring 1885). Even the Parisians, now the dupes of convention, would one day appreciate peasant painting (LT410, June 1885).

He was practical enough to realize that access had to be through established institutions, principally the art dealers, but these institutions needed revamping. From Antwerp he complained, 'The prices, the public, everything needs renovation, and the future is to work cheaply for the people, because the ordinary art lovers seem to get more and more tight-fisted.' (LT441). During the winter of 1885–86 in Antwerp he optimistically predicted probable major changes in the art trade (LT444).

Contempt for the galleries underlay his inconsistent, ambivalent admonishments to Theo. He accused Theo of not doing enough to try to sell his work. He urged Theo to become more assertive as a dealer, to sever ties with his employers and set up independently, at times to get out of art dealing completely and become a painter, and then worried about his own source of income from Theo's patronage, which increased from a basic 150 francs a month arranged in the spring of 1884 to 50 francs a week in Arles in 1888 and 1889.

The experience of Paris shifted his perspective. Schemes for an artists' association and for the 'studio of the south' incorporated an ill-defined and ideal role for Theo as a channel to the public. The more he counted on Theo the less overt concern he evinced for a wider audience. From Arles he wrote, 'out of the thirty studies I shall send you, you will not be able to sell one in Paris. . . . what I do is not *saleable* like the Brocharts for instance, but it can be sold to people who buy things because there is *nature* in them.' (LT513, July 1888). Those who liked his kind of painting would be too poor to buy it; he likened *La Berceuse* to chromolithographs and *images d'Epinal* (popular prints 168 from Epinal in the Voges), which decorated the homes of peasants. He also began to express a fear of success, as if success would bring a decline of artistic powers in its wake. Yet he did exhibit with the Indépendants and Les XX. He sold a self-portrait to the London dealers Sulley and Lori in 1888 and in 1890 a painting to Anna Boch for four hundred Belgian francs. Against the growing interest in his work, he painted for a smaller public: for Theo, whom he characterized as a half-creator or creative dealer, and who believed in the ultimate value of his work, for a small circle of other painters, and for himself.

Production of an Œuvre

Van Gogh's journeying from one residence to another has commonly served as a framework for the development of his œuvre; such a structure acknowledges the different character of his work in The Hague, Drenthe, Nuenen, Paris, Arles, Saint-Rémy and Auvers. He changed his working environment in order to immerse himself in particular subjects and visual conditions, or to identify himself more closely with certain professional aspirations. While variations in his work relate to the geography and to his acquisition of skill, they do not simply reflect his private experience. They were produced by interacting with various cultural formations, which presented him with artistic options and stimulated his vision of his own direction.

Van Gogh's imagery and facture did not develop smoothly and even his technical control wavered between security and gaucheness. Shifts in motifs did not necessarily synchronize with new essays in facture. Constantly studying and aware of his limitations in conventional skills, he sought to realize strength from clumsiness and to re-present whatever imagery he identified as central to his enterprise at any moment.

More than two thousand surviving paintings, drawings and prints comprise van Gogh's artistic production. He himself more restrictively defined his œuvre. He maintained a division between studies done from nature ('études') and pictures ('tableaux'). The more important works he signed and gave specific titles; they tended to be larger than the rest and often spawned variants or copies.

113 *Young Man with a Sickle* (or *Boy cutting Grass with a Sickle*), October 1881, is an early, large (47 × 61 cm), worked-up composition. The drawing combines the mediums of black chalk and watercolour on paper. Local colour is tentatively suggested within a pervasive brown tonality. The watercolour has been used simply as a wash, while the chalk has been worked as outline, parallel and cross-hatched marks for shading. Only a few tense, rippling strokes, standing for dried grass-blades and folds in the shirt fabric, explore a more descriptive gestural language.

The image of agricultural labour, in the centre of the paper, within a generalized landscape, derives from a Millet peasant with a sickle from his ten

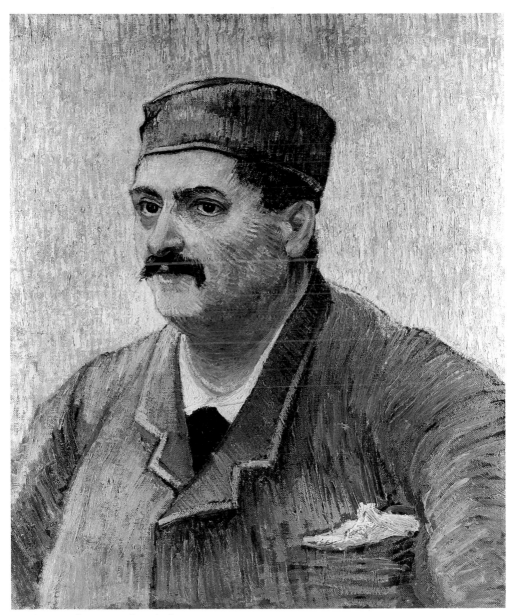

112 *Portrait of a Man with a Skullcap* 1887–88

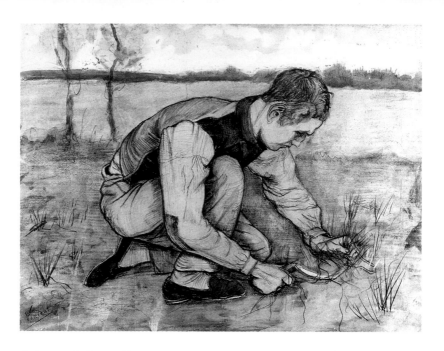

88 *Labours of the Field.* Van Gogh had copied it from Jacques Laveille's reproductions and he reinterpreted the same figure in paint eight years later. Its horizontal format differs from Millet's series. Most of Millet's vertical compositions have upright figures, but even Millet's harvester, bent double, adapted itself to the series' format.

In contrast with Millet, van Gogh depicted a specific agricultural labourer rather than a generalized peasant type. The same young man in waistcoat and shirt appears in several Etten drawings, although in other contexts he is shod with wooden clogs rather than the curious 'carpet slippers' of this drawing. The accumulated details, which individualize the model, attest to van Gogh's study from life, but the overall pose – one of his most ambitiously complex for this period – fails to convince, especially in the anatomically dubious legs. The insistence on linear detail at the expense of form suggests a close point of observation; it may also be a residual effect of his study from Bargue's *Cours*, which featured drawings by Holbein. The nude studies in Bargue's *Exercices* also bound the figure with heavy outline but, instead of modelling forms, their internal drawing proposes a geometrical structure for the body, whereas van Gogh's linear patterns seem to invade their surfaces.

Apart from the blades of grass being cut, the landscape appears to be an afterthought. Other contemporary drawings of crouching and kneeling figures are simply figure studies within a scarcely articulated sheet of paper.

114

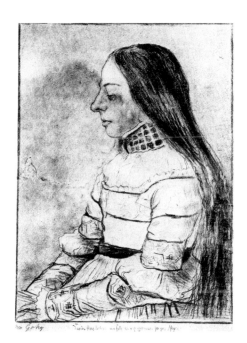

< 113 *Young Man with a Sickle*
(Boy cutting Grass with Sickle)
1881

114 *Daughter of Jacob Meyer (after*
Holbein) 1881

Here, the filled-in environment turns study into composition. The horizon line specifies a point of view – one as low to the ground as the model – even if not a totally consistent one.

The work is signed, the 'V'-like sprout of grass in the lower left echoing the first letter of 'Vincent', confirming it as a finished picture rather than an exercise. For all its shortcomings the drawing's intensity of observation reinforces the imagery. The vantage point of the viewer and the focused enumeration of matter-of-fact details reiterate the figure's close concentration on his task and his minute attention to a few blades of grass (unlike the generalized labour of Millet's precedent). The drawing constructs a kind of metaphor for van Gogh's own contemporary drawing practice.

Despite the prevalence of rural imagery in Hague School painting, van Gogh confronted urban motifs in The Hague. For a drawing like *Gas Tanks* 116
in The Hague, March 1882, he had no precursors in the fine art tradition to follow. Even illustrations offered little help for constructing an imagery of the raw, desolate zone on the edges of urban expansion. The gas tanks were a new subject. On the other hand, an urban scene with a longer precedent, *Pawnshop in The Hague*, March 1882, like *Gas Tanks* a drawing for Uncle 115
Cor, synthesizes preceding Dutch painting and British graphic illustration. The foreground paving supplies a perspective grid for the distribution of stiff figures, not always plausibly placed – the two nearest male figures impossibly

141

overlap. None of the figures inhabits the foremost slice of space. Distanced by this no-man's land, they contribute picturesque incident without comment on the social ramifications of the pawnshop.

In contrast with the centrally recessional space in *Pawnshop*, the foreground in *Gas Tanks* bifurcates into a heavily shaded ditch extending diagonally rightwards from the lower left corner and a much less emphatic furrow running along a wedge-like shadow, which inclines left and upwards from the middle foreground. The visual routes depart from a point very close to the spectator, but the two-point perspective deflects recession away from the obvious focal point on the horizon towards the margins of the picture, thus isolating the distant motif. Minute background figures skirt the empty lot and are themselves fenced off from the precincts of the tanks.

The central field is simply a reclining rectangle, one corner foremost. Obviously derived from van Gogh's perspective study and possibly accentuated through his use of a perspective frame, the format distinguishes itself in the immediacy of the near picture space to the viewer and in its evacuation of the entire middle space. This pictorial juxtaposition of contradictory invitation and alienation, first realized in his Hague drawings of the uncategorized territory at the margins of the city, became a device that van Gogh retained and developed into his final landscape paintings of 1890.

The drawing materials are used much more tonally than in *Young Man with a Sickle*. Many of van Gogh's early Hague drawings are limited to a grey to black value-scale, but *Gas Tanks* makes use of a more extended range from broad chiaroscuro smudges on the ground to hatchings in the tanks. Descriptive striations pick out the slats of the fence, and sketchy lines indicate leafless tree branches. The white paper begins to function as light. Broken only by the birds and a smear of smoke from the chimney stacks it both serves as sky and gives relief to the ground.

Inverting conventional atmospheric softening, the broadest marks sketch the foreground, while the finest graphic detailing describes the background. The attentive, delicately rendered observation competes with the diminution of scale. In the furthest distance, at a figurative if not literal vanishing point, a minute windmill, the most 'picturesque' element, is ironically juxtaposed with the gas tanks, elements of modern industry and energy. The three prominent birds, conventionally depicted as 'V' forms – a device with which van Gogh continued to populate and articulate his skies – have their flight countered in three incoherent, crushed and angular splats at the left foreground.

Van Gogh lived in that uncategorized zone that was not city or country or even suburb. As an artist who saw the world through a range of images, he here attempted to come to terms with the as yet visually unarticulated. This

115 *Pawnshop in The Hague* 1882

116 *Gas Tanks in The Hague* 1882

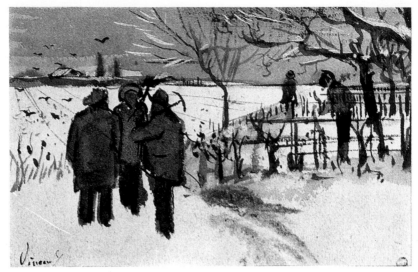

117 *Miners in the Snow* 1882

he tried to locate in the interstices of topography, landscape and graphic confrontation. Invading industry uncomfortably superimposes itself on nature through contradictory and discontinuous visual conventions.

117

22, 118, 119

In his figure drawings of the Hague years van Gogh had constant recourse to models in illustrated magazines. Most commonly he depicted the socially marginalized: old men from the workhouse, working men (labourers, peasants, fishermen) and working-class women worn with fatigue, performing domestic chores and maintaining the family. Single-figure studies predominate. For group studies he frequently relied on Sien and her family as models. Rarely do these drawings show men and women interacting; an imagery of the family only began to emerge in Nuenen, while male and female couples do not appear until his Paris paintings. The expenses of hiring models may have hindered such depictions; moreover, these subjects were distant from the images of alienation and loneliness that dominated the Hague drawings. Single figures fill a gap betwen the categories of portraiture and typology. A verisimilitude of character, profession and emotional state is ensured in the specificity of the models (*this* old man, *this* care-worn woman). Group drawings occasionally represent specifically urban, working-class

107, 120

scenes (a soup kitchen, a lottery office), they sometimes depict labour, but often pairings and small groups of figures construct domestic relationships between or among women and children. A few drawings depict children on their own.

118 *Orphan Man with Walking Stick* 1882

119 *Head of Fisherman* 1883

120 *State Lottery Office* 1882

A drawing usually entitled *Sien's Daughter seated*, January 1883, may in fact depict Sien's sister since the child appears older than five, the age of Sien's daughter then. Unlike many images of poor children, this drawing refuses to sentimentalize or soften the representation of childhood. The little girl sits tensely, glancing up and outwards. The spectator's vantage point is located at adult height; the glance notes this position of authority while the posture resists submission. Spiky hair, shorn probably for hygiene, echoes the outline of a sharp lower profile, stiff folds of clothing, and an angularly broken shape of sleeve and arm.

The strong silhouette clearly defined against its background evinces van Gogh's assimilation of characteristics found in his favourite wood engravings. So does the signature scratched into the black skirt, but the thick strokes of lithographic chalk more insistently stick the tonal surface of the image onto the working surface of the paper than do the various grooves, nicks and striations devised for wood engraving.

Pencil scribbles rapidly indicate the planar turns of the child's sleeve; pencil also gives a lighter value and tonal contrast. The wrist and hand flatten into her lap. So intensively did van Gogh press his medium onto the paper in the darkest areas that the coarsely textured paper ripples and crinkles.

Van Gogh's depictions of children stress gaucheness, awkwardness and ungainliness. This child, with her rigid fist, her self-conscious awareness and the concavities biting into her outline, suggests an urchin pinched by poverty

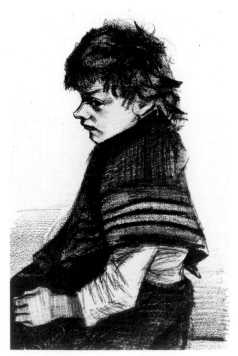

121 *Sien's Daughter seated* 1883

122 *Landscape at Nightfall* 1883

and stripped of the illusions which adults' representations so regularly impose on children.

Van Gogh's move to Nuenen in December 1883 admitted temporary defeat in earning financial independence; it also confirmed his rejection of the city as a site for pictorial representation, which his departure for Drenthe had first proclaimed. Not long after his arrival (probably as soon as the weather permitted) van Gogh made a group of ambitious, large pen and ink landscape compositions. Although he had used pen and ink before, he approached it with a new concentration and delicacy. He departed from the relatively simple, stark black and white drawings of The Hague and built up more complex, atmospheric spaces with broad areas of mesh-like hatching. In turning to an idea of 'the country' he looked back to precedents in seventeenth-century Dutch landscape drawing for precision and detail, for the sepia colouring, and even for the inked borders with which he bounded the field of his image.

147

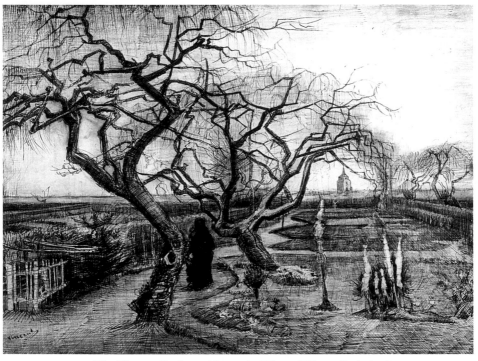

123 *The Vicarage Garden at Nuenen in Winter (Winter Garden)* 1884

The drawings formulate an image of rural community as well as landscape. They depict habitations and cultivated land, the presence of the church and animal husbandry. Two of the most adventurous extensions of van Gogh's visual vocabulary are *The Vicarage Garden at Nuenen in Winter (Winter Garden)* and *Pond in the Vicarage Garden at Nuenen (The Kingfisher)*, both drawn in March 1884. *Winter Garden* proposes a more sophisticated realization of a previously exploited perspective format, that of an off-centre single-point recession, whose impulse into space here is interrupted by crossing paths and vertical interpositions of plants and a human figure. *The Kingfisher's* composition, with strong verticals formed by trees and their watery reflections, fragments and compresses space into pockets contained by an insistent horizontal and vertical surface-pattern, maintained in the infrastructural weave of the pen lines. Van Gogh had not yet, however, embraced the flattened patterning manifested in his late work; white heightening of elements on the near bank brings them forward. Several landscape paintings from Drenthe close the spatial recession through simple

123
124

122

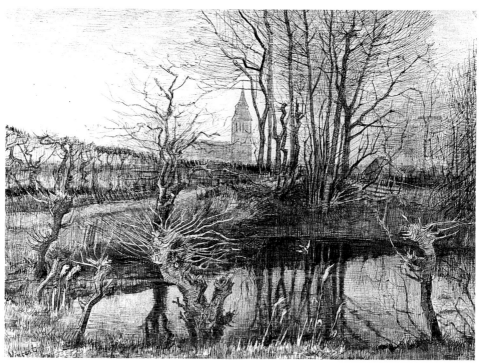

124 *Pond in the Vicarage Garden (The Kingfisher)* 1884

devices such as reflections in water or a bulky mass imposing itself in front of the spectator's low vantage point. In this Nuenen drawing the recession, evoked atmospherically and perspectivally (a diagonal path), is simultaneously thwarted, interrupted and diverted.

The reduction of outline to a selective reinforcement of shapes allows light and form to interpenetrate, suggesting a veil-like softening without sacrificing the precise character of, for example, gnarled tree stumps. There are virtually no cast shadows but light seems to emanate from the picture in contrast to the light-absorbing Hague drawings.

The horizontal nave and vertical spire of the church (the most distant pictorial element) are significantly framed by a rectangular space defined by trees and horizon line. The more geometric architectural forms resonate within the natural ones. While unobtrusively fitting into nature's setting they are also differentiated. Van Gogh's rejection of established religion had led to a major quarrel with his father in December 1881. Although the presence of the church in the landscape may be a conciliatory gesture, its distant position

and its embrace by nature are more likely to be negotiating terms for van Gogh's pantheism (of course, it could simply be a formal device). During the Drenthe sojourn he had read Carlyle's *Sartor Resartus* (1831), and Carlyle saw nature as the 'Time-vesture of God'. In the drawing the church building, a symbol of established religious order, is absorbed into the greater order of nature.

Although van Gogh had received his first oil-painting lessons from Mauve, he painted only sporadically in The Hague. Indeed, while living in The Hague his painting was associated mostly with country scenes or Scheveningen seascapes. His concentration had been directed towards the goal of draughtsmanship. His painting career began with the move to Drenthe in September 1883. Instead of landscapes his early Nuenen paintings depicted a cottage industry threatened by new industrial modes of production. The paintings of weavers at their looms developed from more graphically legible images in which the whole loom and its weaver present an arresting shape agaist a light background, to a closely cramped view of the weaver enmeshed in his loom's mechanism, his face expressionless as if a robot performing a task. Similarly, van Gogh's handling of the paint changed from a relatively inert impasto to a lively surface of painterly textures and highlights.

The visages of the weavers contrast with the more individualized portrayal of peasants later in van Gogh's stay in Nuenen. In the winter and spring of 1885 he worked on a number of head and shoulders portraits, which coalesced in and grew out of *The Potato Eaters*, April 1885. The most ambitious project of the first half of his artistic career, *The Potato Eaters* was worked up in the studio from a series of generic and detailed studies and compositional sketches, and memories of other artistic images. The process derived from academic tradition and was atypical of van Gogh's usual painting methods. For van Gogh *The Potato Eaters* was the culmination of his effort to make himself a painter, and its disheartening reception from friends and dealers contributed to his change of course within the year. Nevertheless, he continued to regard it as one of his best works and returned to the motif in drawings done at Saint-Rémy in 1890.

Models for the motif have been suggested in works by Léon Lhermitte, Charles de Groux and Jozef Israëls. The prevalence of such imagery in French and Dutch nineteenth-century works suggests that no specific source was necessary for van Gogh, but while these other images of peasants gathered for their evening meal reassuringly exude warmth, conviviality and plenty, van Gogh's *Potato Eaters* disquietingly disrupts the romantic peasant idyll.

The implausible perspective dislocates the architectural coherence of the peasant dwelling. The additive, rather than observed, compositional

26

25

125

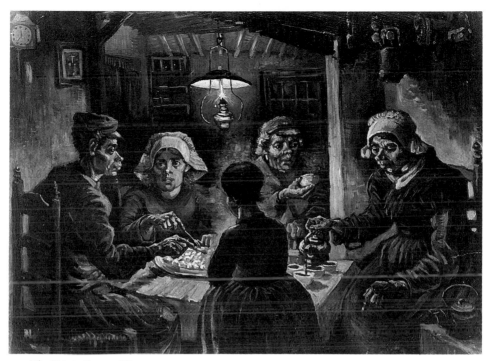

125 *The Potato Eaters* 1885

procedure presents each of the five relatively isolated figures from different viewpoints. The slippage of communicating glances and gestures among the figures leaves them alienated within a gathering linked by an eccentric and unstable geometry. In the uncompromising portrayal of lumpish faces and gnarled hands the peasant visages are likened to the platter of potatoes. Despite van Gogh's much vaunted empathy with 'the peasant' these peasants belong to another realm, and the child's back obdurately turned to the spectator, right in the centre of the picture, forecloses the scene despite the nearness of the subject.

The oil lamp just off-centre above the child casts a burnt orange glow on facial protruberances, makes the potatoes glowing nuggets, and leaves a cool, greenish blue shade beyond its reach. Elsewhere the broken application of orange and green yields earthen colouration. The lamp makes the steam from the potatoes into an atmospheric aura around the child, but otherwise darkness envelops the scene in near opacity.

The unaccommodating ugliness, which van Gogh himself acknowledged, manifested both in the unflinchingly close observation (so close that the

family circle fills the whole space) and dully lurid colour, signals verisimilitude. This in turn counteracts generalizations in the figures' anatomy and spatial discontinuities. The paint, too, constructs a powerful presence; in the course of his studies van Gogh had achieved a plasticity of paint handling that described volume and solidity.

Far from regarding *Potato Eaters* as an exercise in objective description, he tried to represent his own bourgois conception of peasant life: 'I have tried to emphasize that those people, eating their potatoes in the lamplight, have dug the earth with those very hands they put in the dish, and so it speaks of *manual labour*, and how they have honestly earned their food.' (LT370).

Lack of technical facility, even downright clumsiness, constitutes a kind of honesty which fails to match pictorial formulae for the representation of peasants in the nineteenth century. In its failure to add up the work demands a second look. Despite the fact that van Gogh attempted to live like and with his models (and painted this group as if practically on top of them) their otherness – his failure to identify with them – reads through the perplexity of the pictorial contradictions.

In contrast with these Nuenen peasants and those portrayed and drawn at their agricultural labour during the following summer, the city dwellers of Antwerp do not show the alterity imparted by this conscientious ugliness holding itself up as uncompromising objectivity. *Portrait of a Woman in Blue*, now dated to December 1885, displays less certainty of purpose in the modelling, but the clear, fresh skin tones and the more bravura painterliness lend familiarity to the model through their alliance with convention. The new palette of hues and facture was probably encouraged by looking at Rubens through eyes trained by reading about Delacroix. The less penetrating confrontation of more generalized features and the averted head conform to less discomforting codes of portrayal.

Before he left for Antwerp van Gogh painted a more coherent, more personal manifesto of his position in the still-life *Open Bible, Extinguished Candle and Novel*, October 1885. The sharp perspective of the Bible recedes more precipitously than necessary for its spatial placement. By contrast, the novel, a flattened parallelogram whose edges are rather ambiguously defined, does not quite adhere to the plane of the table-top. While the two books lay out opposing diagonal axes, the candlestick and the parallel upright clasp of the Bible establish stable verticals. The lower Bible clasp lies prone on the table, forming a right angle to its partner within the receding picture space.

For no perceptible reason, the right rear of the table lies in shadow. The Bible casts only a weak, ambiguous shadow, while the shadow of the novel is a definite, rather eccentric shape on the table-cloth. Pictorial incident

126 *Portrait of a Woman in Blue*
1886

127 *Open Bible, Extinguished Candle and Novel* 1885

concentrates at the far right where table-cloth folds finger upwards to the novel and its shadow, whose upper corners in turn play against the lower right angle of the Bible. The candlestick and Bible clasps redirect the spatial flow and hold the picture surface against spatial recession.

Apart from the smoothly painted background the oily paint vibrates in a painterly modulation of colour. It retains the freshness of being painted in one go. The touches of colour sing out strikingly against the range of browns, the Bible text illuminated with aqua, salmon, yellow and orange, the yellow novel luminous despite lying mostly in shade. Flicks of a burnished bronze hue highlight the candlestick and Bible clasps. The colouring may seem hesitant in the retrospective light of his later work, but it marks an early achievement in van Gogh's effort to subscribe to a new awareness of colour theory. The painting responds to Theo's verbal reports of Impressionism, which van Gogh attempted to displace with a mastery and extension of Delacroix's colour as understood from his reading.

Still-lifes of books recur in several Paris and Arles paintings. In some, the books are the entire motif; in others they offset, for example, a plaster cast statuette of the female torso. *Open Bible, Extinguished Candle and Novel* emphasizes contrasts in scale, direction, perspective and placement between the two books, one open and the other closed. The language of the Bible, whose chapter title is written in French, sets up more than a visual comparison with the small yellow-bound novel, Emile Zola's *La Joie de vivre*. While his father was still alive, van Gogh's fondness for novels by the French realist and naturalist writers had been a source of contention between the clergyman and his son. The Bible has been identified as belonging to van Gogh's father, but would his not have been in Dutch? While the Bible may invoke personal reference to the Pastor van Gogh, it also alludes to Vincent van Gogh's own previous calling. Zola was not only a favourite author; his novels were specifically Parisian, and a move to Paris was on van Gogh's mind in October 1885. An extinguished candle, of course, had long signified mortality or death. It obviously reads as time snuffed out, against which the novel seems to give off light, but the juxtaposition is not just a contrast of past and present, old and new, for the Bible text alludes to van Gogh's rationalization of his lack of public success; the massive Bible is open at Isaiah LIII, a passage prophesying that the servant of the Lord will be despised and rejected.

The austere still-life items cannot be accorded symbolically simple meanings but fluctuate against each other with multiple possible readings. Knowledge of van Gogh's personal circumstances may give priority to certain readings of the paintings over others but it does not wipe away ambiguity.

128 *Parisian Novels* 1888

After van Gogh's exposure to newer colour practices in Paris in 1886, the clarity and intensity of hues became more pronounced, but the complementary pairing of orange-yellow with aqua-blue tentatively proposed in *Open Bible* remained a favourite colour chord. The chalk and ink drawing *Window at the Restaurant Chez Bataille in Paris*, February/March 1887, simply dispenses 129 with the brown sludge of blended contrasting colours. The application of chalk in dry, separate strokes naturally circumvents the muddying result of the intermingling of two wet paint colours. The spaces between the drawn marks allow the texture of the paper to contribute to the general atmospheric effect. In the window embrasure the radiating lines suggest light entering the interior while also laying down a rudimentary perspective recession. Local colour has completely yielded to an exaggeration of light effects. The blue interior wall, its shadow contrasting with the light outside, contains orange strokes within the web of the more densely drawn dominant hue. Orange pigment in the chair and foreground table allies with the fragment of an orange shutter outside the window and the golden-toned street just lightly articulated in blue.

The simple alternation of colour works as one spatial device to demarcate and play off interior and exterior. Against this convention, linear diagonals reading as perspective clues zig-zag back and forth from the table edge through the window embrasure to the street outside. The rectangular

129 *Window at the Restaurant Chez Bataille in Paris* 1887

window, proportionally consistent with the sheet of paper, holds the wall flat. Although the view of the deep-set window moves the spectator's position to the left, pentimenti indicate that the vantage point was originally centralized; the present ambiguity somewhat loosens the identity of wall and

paper surface, while the plane of the wall interrupts the continuity of the interior and exterior spaces.

Two tiny figures in the street appear to turn away from an encounter. In the interior of the restaurant there are no figures, but the ghostly coat and hat applied to the wall and the empty chair pulled back from the table stand for human presence through obvious absence. Are the coat and chair traces of the same person, possibly the artist?

In some of his earliest drawings van Gogh contrasted interior and exterior spaces by means of the device of a window view. Often, the *contre jour* effect silhouettes a figure inside the closed-off space. The early scenes, linked to a Dutch tradition of interior painting, focus on a room and its inhabitants; this Paris work resonates with metaphysical and psychological tensions. In *Window at the Restaurant Chez Bataille* and a slightly later Paris café scene, *Glass of Absinthe and a Carafe*, spring 1887, the interior is shallower, the wall forming a screen close to the spectator, which permits a partial, discontinuous perception of a world outside.

The drawing gestures appear to be basically a means of laying down colour. Except for some of the pen and ink reinforcements, the marks are largely undescriptive. Striations and hatchings bring about an effect of broken colour, though not rigorously applied. The draughtsmanship appears much more pedestrian than in his Nuenen drawings: the direction of some marks establishes planes but in a rather obvious, heavy-handed manner compared with a contemporary pastel by Toulouse-Lautrec, *Portrait of* 130 *Vincent van Gogh*, early 1887, also set in a café interior. Van Gogh's self-education may in part account for the uneven development of separate aspects of his work, some of which seem to backtrack in skill when he took on board new ideas.

130 Henri de Toulouse-Lautrec *Portrait of Vincent van Gogh* 1887

131 *Hill of Montmartre with a Quarry* 1886

 Van Gogh's early Parisian 'urban landscapes' were located at the edges of urbanization, a territory he had explored in his Hague drawings. *The Hill of*
131 *Montmartre with Quarry*, autumn 1886, places green fields and windmills on the far side of the quarry's trench, the quarry presumably being worked for urban building material. In the spring of 1887 he painted the outer boulevards, and that summer he several times depicted the city from just outside the *barrière* and looked at the increasingly industrial suburb of
134 Asnières from the surrounding fields. *Wheatfield with a Lark*, summer 1887, banishes the smokestacks and other signs of urban encroachment, still visible
133 even in the far distance of an expansive landscape like *Road along the Seine near Asnières*, spring/summer 1887; but the grain, seen from a close, low vantage point, appears as a barrier perhaps deliberately blocking out the signs of a less pastoral existence. The foreground stubble and wheatfield occupy half the picture surface. The bird, barely skimming the grain, is ambiguously located in some deeper space. The motif, incorporating memories of numerous nineteenth-century landscape images (among them Daubigny's and Millet's), remained a significant one in van Gogh's œuvre. In the Paris *Wheatfield* the lark proposes a kind of liberation into nature. He restructured
132 the image in *Crows in the Wheatfields*, July 1890, where splaying paths offer no certain way through or around the wheatfields, and whose raised vantage point renders the birds as static interference over land and sky.

158

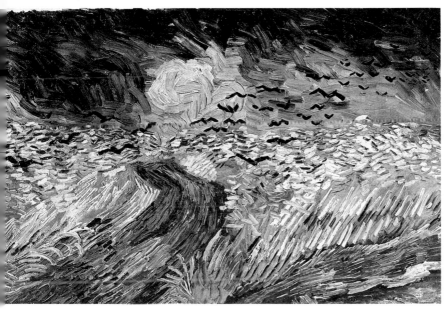

132 *Crows in the Wheatfields* 1890

133 *Road along the Seine near Asnières* 1887

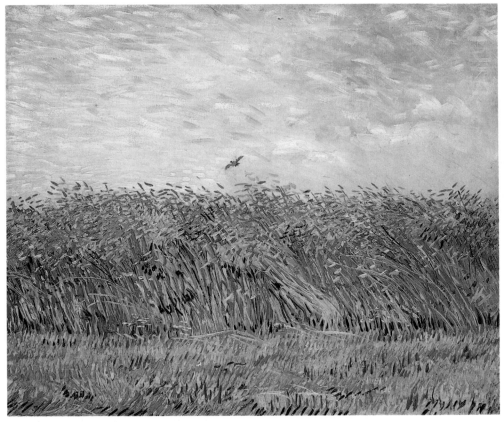

134 *Wheatfield with a Lark* 1887

135 Claude Monet
*The Seine at
Argenteuil* 1873

By the summer of 1887 van Gogh's draughtsmanship had become more articulate, having absorbed Neo-Impressionism and Impressionism into his own graphically descriptive language. Superficially, *Wheatfield with a Lark* 134 appears to have relaxed from the reference to a more rigid Neo-Impressionist facture in *Figures in a Park at Asnières*, spring/summer 1887, into a freely 167 brushed variant of Impressionism. A comparison of *Wheatfield with a Lark* with Monet's *Seine at Argenteuil*, 1873, brings out the greater identification of 135 paint with the material presence of the object in van Gogh's painting. However texturally suggestive is Monet's flecked and dappled touch, the objects seem to dissolve into an atmosphere of marks on the canvas surface. Van Gogh's motif may have encouraged a coincidence of facture and descriptive texture: the paint application is at one with the rough stubble, the breeze-blown wheat and the stippled grains.

The pale beige primed ground of the 1887 *Wheatfield* shows between the brush-strokes near the edges of the canvas, the lightness of the support underpinning the bright hues which are skimmed in horizontal flecks in the sky and more thickly crowded and overpainted below. Although green stalks among the grain, the blue sky and the red poppies intermingling with the stalks are spectrum-like hues, the foreground stubble displays muted lavenders and ochres, colours which are less prominent in Impressionist and Neo-Impressionist palettes but which van Gogh later used frequently in combination as a kind of colour chord.

During the 1887 autumn and winter he continued to expand the possibilities of direct draughtsmanship in colour. The still-life *Lemons, Pears,* 136 *Apples, Grapes and an Orange*, autumn 1887, reads like a dense embroidery of painted threads and knots. This extraordinary painting appears to be nearly monochromatic and thus the texture gives restless vibrancy to the surface and searches out the contours of the seething mass of fruit.

The paint surface dazzles in its range of colours almost entirely made up of yellows from salmon to olive. The pigment seems to emit an intense, colour-bleaching light, as if transmuting light into palpable material. Even the minimal, articulating flecks of blue, turquoise, pink and red seem to have been made honorary yellows for the occasion. In Arles and Saint-Rémy van Gogh sometimes painted suns into his landscape skies. Here, ripened fruit seems to stand for the sun's energy, as later would the similarly monochromatic *Sunflowers*, although their brilliance does not prompt the 1 same sensation of bedazzlement.

A fold of foreground cloth and the overlapping fruit barely indicate spatial recession, but the depicted surface refuses to lie back, and the motif, centred iconically within the frame, seems to adhere to the paint surface, itself a crust of dryish, dragged scumbling which reveals the canvas weave. A frame

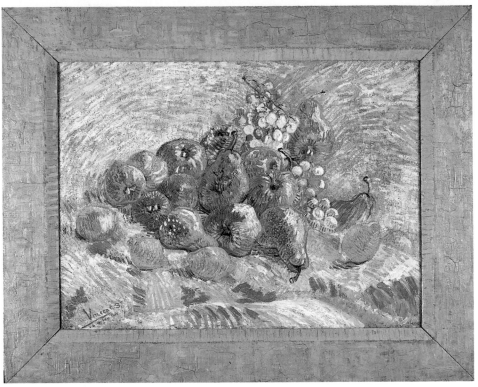

136 *Lemons, Pears, Apples, Grapes and an Orange* 1887

painted in a woven texture maintains the tension between the material presence of the painting and the dissolving illusion of light. The more orangey-yellow of the frame and the greener tone of its bevelled edge heighten the glow of the painting proper while containing its energy. Seurat had earlier introduced painted borders and frames, whose colours intensify the neighbouring hues of the painting within. Van Gogh himself had given complementary borders to his interpretations of Japanese prints in the summer and autumn of 1887 and in the winter painted a fringe-like band along two sides of his portrait *The Italian Woman*. He included a depiction of the still-life with its painted frame among the Japanese prints in the background of one version of *Portrait of Père Tanguy*, winter 1887–88.

84

Besides signing *Lemons, Pears* he dedicated it to Theo. Unfortunately, no document exists to illuminate its meaning in relation to his brother, tempting as it may be to speculate on Theo's support as a source of energy.

162

Not until 1889 in Saint-Rémy did van Gogh again paint such a restless image; rather he exploited his growing vocabulary of painted marks as a more disciplined means of differentiation. Both *Portrait of a Man with a Skullcap*, winter 1887–88, and *Self-Portrait at the Easel*, early 1888, cool the palette with blues and neutralizing admixtures of white. Different textures belong to clearly demarcated objects and surfaces within the painting. In contrast with the textures, lines reinforce the edges of clothing, the contour of the palette or pick out facial features with an incipient cloisonnism.

In Arles later in 1888 van Gogh no longer had to contend with the turbulent Paris art scene: he had rejected the city in search of an ideal world. Despite Arles's urban growth, which he did not totally ignore, he found some of his most felicitous motifs in landscapes featuring agricultural growth, abundance and harvest. No longer subject to the immediate pressures of competitive artistic camps, his paintings more confidently synthesized space, colour and drawing. He was not yet disillusioned with his quest for a mythical 'Japan' and his presentations of nature put forth an image of 'natural' order. *Harvest at La Crau*, June 1888, constructs a favourite panoramic landscape format on a large canvas (size 30: 73 × 92 cm). A foreground diagonal – the fence and path – declines from left to right. A

137 *Harvest at La Crau (Blue Cart)* 1888

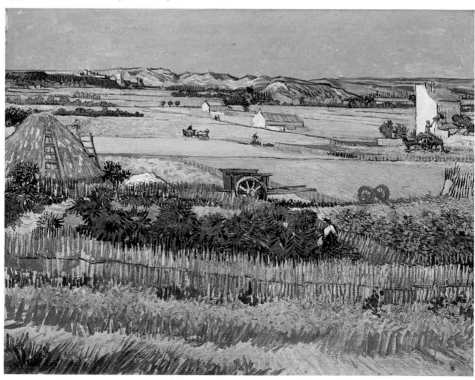

distant high horizon bounds the recession with purplish–blue hills. Between these foreground and background limits the sequential and intersecting boundaries of orchards and fields mark out a vestigial perspective diagram. Although irregular the landscape is securely demarcated. Edging the fields, the buildings and the cart, prussian blue outlines reinforce the separateness of shapes. The blue cart, effectively in the centre of the picture, pins down the scene with its radiating spoked wheel.

While spatial recession is guided through a careful arrangement of defined fields, the horizontal extension is less definitively contained. Elements like the haystack, blue fence and hay barn do stand at the very edge, but the bands of the fields slip between. It is a surveyed landscape laid out for visual possession with finiteness and expansion carefully balanced. Various scattered elements – small figures, the blue cart, a haystack, an orange chassis, farm buildings – serve as visual foci and as signs of a productive relationship between humans and nature.

138 *View of Arles with Irises in the Foreground* (*Field with Irises, Arles in the Background*), May 1888, proposes a simpler version of the formal arrangement of *Harvest at La Crau*, with its coloured wedges fanning back to the town on the horizon. Although this horizon is high, the vantage point is relatively low, offering the foreground irises to close scrutiny against the

138 *View of Arles with Irises in the Foreground* 1888

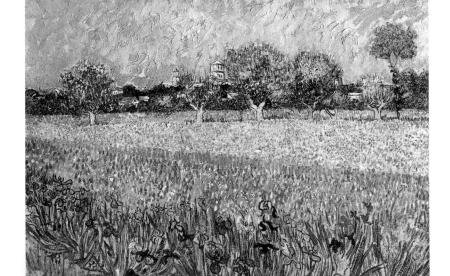

139 *Public Garden Opposite the 'Yellow House'* 1888

yellow-green grain. A drawing, *La Crau seen from Montmajour*, July 1888, 44
distances the spectator to a bird's-eye view, though maintaining the same
format for visually scanning the land. In this drawing the white paper,
standing for the sky, stops recession. The fields themselves diminish in density
into the distance. The flat plains of the Crau reminded van Gogh of Dutch
painting, and he took over some of the topographical language of his
predecessors while developing his own distinct drawing vocabulary. A very
different drawing, *Public Garden Opposite the 'Yellow House'* (*A Park in Arles*), 139
May 1888, displays an even more graphically precise range of descriptive
marks, which bring into being differing foliage forms. The dead branch
above imparts not only a sombre note but reflects the configuration of leafless
branches earlier favoured by van Gogh in many Nuenen landscape drawings.

In the five large drawings of the Crau surveyed from Montmajour, made
instead of paintings as a gesture of economy but none the less with com-
mercial intent (to raise money for Gauguin's visit), the pen marks suggest
physical texture while implying a variety of colour and spatial positioning
dependent on their context. A light pencil underdrawing establishes the
compositional framework, filled in by brown and black ink, the black
apparently drawn last. As with the blue cart, a small incident – here, a tiny
couple added after the path had been drawn – pins down the middle
landscape. Like the Crau drawing, *View of Arles with Irises* is virtually all

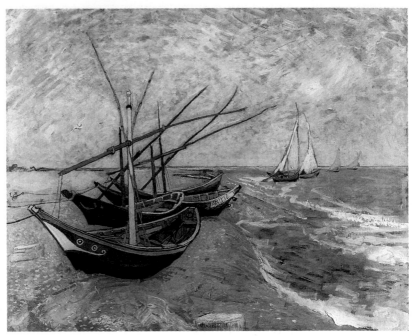

140 *Boats on the Beach at Saintes-Maries-de-la-Mer* 1888

surface texture, whereas *Harvest at La Crau* contrasts textural marks with a
smoother colour patchwork.

 An even more cloisonnist handling of shapes went into the striking
imagery of a seascape resulting from his visit to Saintes-Maries-de-la-Mer,
140 *Boats on the Beach at Saintes-Maries-de-la-Mer*, June 1888. The three beached
boats may allude to local folklore, which annually celebrated the arrival of
three Biblical Marys in A D 45 to convert Provence. The middle boat is named
'amitié' (friendship). The boats flatly painted in spectrum hues allude to
Japanese prints, but the much more painterly sand, sea, and sky flow and eddy
with broken tertiary colours. Such plastic variety and painterly dynamism
were not frequent in van Gogh's later painting but they occur in another
141 Saintes–Maries seascape and in the tauter, more convulsive surface of *Ploughed
Fields*, September 1888.

 In this latter painting, whose diverging diagonal paths recall early
132 landscape formats and anticipate the late *Crows in the Wheatfields*, the
137 foreground hues are pale, earthy beiges and olives. *Harvest at La Crau*
counterpoints a range of mauve and ochre against notes of more definite
green, blue and orange. If many of van Gogh's Arles paintings lack
colouristic subtlety, their bold, frequently saturated colours bring raw

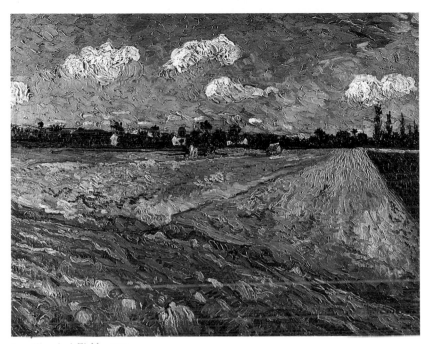

141 *Ploughed Fields* 1888

142 *Peach Blossom in The Crau* 1889

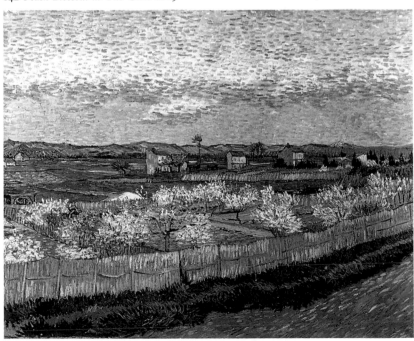

intensity and vibrant contrast to the motifs and parallel van Gogh's emotional response to the light and climate of Arles.

At the end of his stay in Arles van Gogh returned to the site of *Harvest at La Crau* for *Peach Blossom in the Crau*, April 1889, shifting the view to the right of the hay barn. Whether or not he used his perspective frame in making this picture, a comparison of the two compositions effectively poses two possible framings of a continuous panorama. In the later work the road makes a dominant angle upwards and rightwards, its wedge establishing a barrier to visual access. Fence, peach trees and buildings all interrupt the recessional flow to the distant hills. The lowered horizon further compresses recession, while the speckly, textured sky weighs heavily over the landscape. The marks construct the imagery in a mosaic of touches in which the tiny human figures become all but lost. The blue cart, once so dominant, has been marginalized to the left edge. Van Gogh was soon to leave Arles. The southern dream had failed. The landscape, while fresh and scintillating, does not feature a harmonious integration of land and human presence, nor does it invite the kind of surveillance that claims possession as it travels through a landscape.

Peach Blossom in the Crau was one of several canvases that returned to the motif of flowering orchards, a dominant theme of the landscapes executed soon after his arrival in Arles the previous spring. *Orchard in Blossom, Arles in the Background*, April 1889, is quite unlike the stippled and tesserated facture that derives from Impressionism and Neo-Impressionism and renews a different aspect of van Gogh's Paris experience – his confrontation with Japanese prints. Not necessarily referring primarily to the prints but to his earlier pictorial response to them, the flat mauve trees are angularly contoured by a cloisonnist blue outline; the large expanse of green grass is woven in criss-crossing strokes and strewn with scattered orange and yellow dots and lines. The low vantage point sets the flowering tree branches against the sky. In contrast to the warm-toned, spatially inviting orchards of the previous year, this work is cooled by the mauves and greyed blues of the background. The flat foreground space interceding in front of the nearest tree contrives to contradict the spatial recession implied in the diminishing scale of the two principal trees and the diagonal boundary of the background field.

Landscape and portraiture dominated van Gogh's Arles production, causing other kinds of motifs to stand out more singularly. In many landscapes the town of Arles is pushed back by the fields, its urban and industrial presence acknowledged but thrust at an imaginary arm's length; nevertheless, he also painted several views within the town close to his own base – the square where his yellow house stood, the neighbouring café terrace, the railway viaducts beyond – and he portrayed the familiar interiors

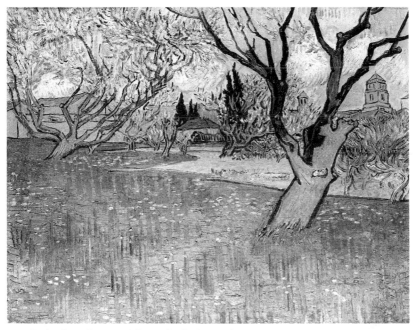

143 *Orchard in Blossom, Arles in the Background* 1889

of his bedroom, his local restaurant, and the night café. The equivalent dimensions and comparable colour of *Vincent's House in Arles, the 'Yellow House'*, September 1888, and *Vincent's Bedroom in Arles*, October 1888, facilitate the visual pairing of the exterior and interior views of van Gogh's abode. While the formats and colouring of *The Night Café*, September 1888, and *Café Terrace at Night*, September 1888, are dissimilar, the motif, the artificial lighting and their proximity in date (to each other and to van Gogh's domestic exterior and interior scenes) suggest an intentional juxtaposition of contrasting spatial experiences and expressive colouration.

 The block on which the 'Yellow House' sits is seen from the corner, the house itself being the nearest building to the spectator. The boundary streets recede at divergent diagonals. To the right the avenue de Montmajour (a main route out of the city) plunges towards the railway viaducts: although we do not see the right-hand side of the street, the sequence of viaducts in the distance implies a precipitous channelling of spatial recession, locating the view-point to the right of centre. To the left the street meanders at a less steeply inclining angle, its flow interrupted by what appear to be earth mounds thrown up by roadworks. The just visible edge of the central island of the place Lamartine (a triangle rather than a square) curves round, and a

144
145
54
55

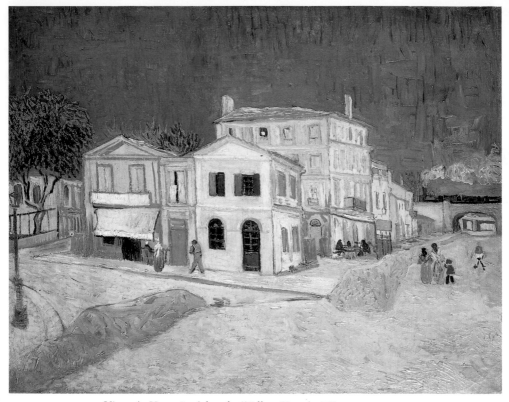

144 *Vincent's House in Arles, the 'Yellow House'* 1888

small side street off the place diverts the recession rightwards to parallel the main road.

The earth mounds complicate the broad foreground space. They are hardly indicated in a watercolour sketch; consequently, the house and neighbouring buildings seem more remote, their scale slightly reduced. In the oil painting the roadworks direct the foreground towards the 'Yellow House', the two mounds interrupted just by the corner. Only a line connects them – perhaps a ditch – supplying a spatial pause rather than an interruption. In a pen sketch of the same scene the earth mound acts as a more continuous diagonal barrier between the viewer's vantage point, displaced further to the left of the picture, and the block of buildings.

Small figures populate the middle distance, walking on the road leading to the viaducts and on the pavement in front of the house and neighbouring food shop. Others sit at an outdoor café. A train on the bridge trails smoke

and its horizontal trajectory, raised above the actual horizon, closes the background, a closure in turn excavated by the space beneath the viaducts. Amidst the attention-diverting details the 'Yellow House' holds its focal position. Though dwarfed by the building behind, its simple cubic form is more sharply delineated, its dark-green-trimmed windows and doors strongly contrasting with the lighter-value yellow. Like the sequence of viaducts, though through different means, they invite penetration.

The 'Yellow House' is the most brilliant yellow in the painting. It sets a kind of yellow essence to which the ochres, oranges and greenish yellows seem to aspire. Even with the accents of green, rust and pink, the lower portion of the painting reads as yellow and as light, against a contrastingly dark cobalt sky. Various paint textures distinguish three main zones in the painting: a mottled and stippled ground, a woven-stroked sky and, in between, relatively slab-like buildings, each with its own sense of substance and significance materially resisting the hallucinatory value inversion of dark sky and light earth.

Space, colour and environmental details specify and position the 'Yellow House'. Around its central place in the composition the rest of the world

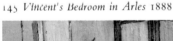

145 *Vincent's Bedroom in Arles* 1888

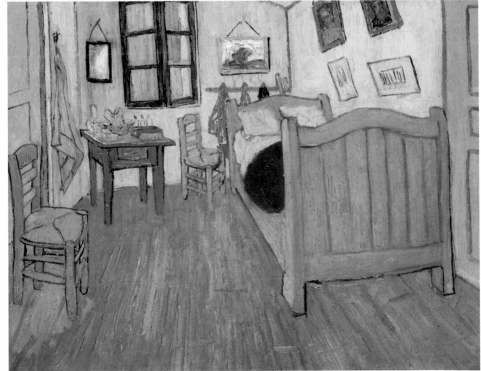

seems to coalesce, revolve and spill away. By contrast, the space of van Gogh's bedroom is defined on its outer perimeter. All the elements of furnishing draw towards the boundaries leaving the centre of the room open, inviting entrance. What may initially seem a distorted perspective was due to the irregular shape of the room, which had one wall longer than its opposite. The massive bed imposes itself against what was an acutely angled corner, stabilizing and slowing down spatial recession.

Van Gogh explained to his brother that the painting was to be suggestive of rest (LT554). This stated intention might be read as a gesture of reassurance to Theo, who had enabled the rental of the house and purchase of furniture. The room builds an image of containment but not of closure. Of all the furnishings only the upper two pictures on the wall to the right are cut by the framing edge. The nearest end of the bed and its counterpart chair to the left are set comfortably back within the foreground, which seems to extend almost to beneath the spectator's vantage point. On the left and right framing edges two doors indicate modes of egress. Indeed one (possibly both) seems to be ajar.

The furniture and its distribution emphasize pairing: two chairs, two pillows, a coupling of paintings and of a painting and a mirror, a hanging towel and hanging clothes on a rack. Chairs and table turn towards the bed as if involved in some inanimate conversation-piece.

Apart from the more tactile long licks of paint laying down the recessional floor, the impasto surface is relatively evenly spread. Its dryness allows the canvas weave to show through in several places. Outlines of prussian blue pick out the edges of furniture and diagramatically draw the architecture of the room. Drawing specifies and compartmentalizes. The contained colour individualizes, places and orders the communication of the very precisely enumerated elements of van Gogh's domestic world. A cool blue, sometimes inclining towards lavender, serves for walls and woodwork. A pinkish mauve lays down the floor, whose tiles (or boards) are edged in green. Beneath the chair to the left there is a rather confusing patch of green, which may be accounted for by the work's damage in transit to Paris. Warmer brown, yellow, yellow-green and red fill in most of the furnishings, which are allied with the yellow and green light coming through the window blinds.

Van Gogh had written that he intended to decorate his bed with an image of domesticity – perhaps a female figure or a child's cradle. The painting itself constructs a domestic ideal, emphasizing security without claustrophobia, filling coolness with warmth, and implying companionship in the duplication and interrelation of furniture. To appropriate a word from the jargon of modern interior decoration, the room has 'personality'.

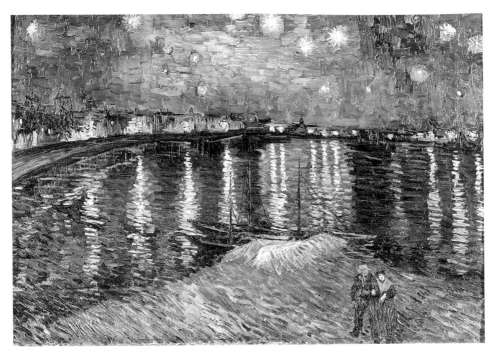

146 *Starry Night over the Rhône* 1888

The two portrait paintings on the upper right wall represent Eugène Boch and the Zouave lieutenant Milliet. Other versions show different sitters. Portraiture took an increasingly significant role in van Gogh's œuvre, individual sitters being made into symbolic types. In Nuenen his heads of peasants were presented as variants on a type, the Brabantine peasant. While more self-portraits than portraits survive from the Paris years, the portraits draw on a wider variety of sitters than he had heretofore depicted: some friends, probably some hired models, a range of social classes. Only in a few such as *The Italian Woman* does the individual seem generalized into a type. Even the self-portraits as a group present markedly variant images. In Arles he began to develop a kind of portraiture in which individuals came to signify an ideal. Portraiture became a field that van Gogh marked out for himself, a territory in which most of his colleagues showed relatively little interest.

Eugène Boch was a Belgian artist introduced to van Gogh by Dodge MacKnight. He became for van Gogh 'the Poet' in 'that picture which I have dreamed of for so long' (LT531). As in the *Café Terrace at Night* and *Starry Night over the Rhône*, September 1888, the portrait of Boch, executed in the same month, prominently displays a star-studded sky. Whereas the presence

26

84

52

55, 146

of night skies could have naturalistic justifications in landscapes, the deep ultramarine, speckled mostly with brush-stabs of pale pink and turquoise, with a radiant star of yellow with pale green rays in the extreme upper left corner, does not literally imply that the portrait was posed at night. The stars serve an evocative purpose in the landscapes, too, contributing to a transcendental quality, but in the portrait they evoke a spiritual state contrasting with the material presence of the figure. Millet offered a precedent for the starry landscape, and there are prototypes in the Dutch and Flemish tradition; but figural prototypes come less readily to mind and perhaps need to be sought in religious motifs.

The portrait was begun more naturalistically but developed towards its expressive symbolism in the course of its execution. Boch is closely scrutinized, his head and shoulders filling most of the compositional area. Asymmetry varies a basically frontal pose, with Boch turning just slightly to the left, his nose more exaggeratedly in profile than the rest of his face. The eyes gaze straight out of the picture but do not focus on the viewer. Short directional brush-strokes modulate the colour from a pale beige forehead through ochre, turquoise and olive green, emphasizing the taut skull-like structure of the head. The pronounced recession of the hairline at the temples, the faun-like pointed ear and the thin, forked beard suggest a Mephistophelean or daemonic quality. The marigold-yellow line round the top of Boch's cranium reads in this context as a vestigial halo. The sky implies infinite distance, yet its impasto asserts a surface akin to the hermetic backgrounds of some icons.

Boch's ochre jacket reinforces the dulled warmth of his face and spells out one term of a complementary pairing with the dark ultramarine sky. The radiant star in the upper left and Boch's face share a yellow and turquoise chord. This star's position marks the source of the artificial illumination, which seems to come from above and behind. Boch's glaringly striped orange and green tie picks up a secondary colour chord also operating in the facial shading.

The portrait compares favourably as a likeness with a photograph of Boch – van Gogh described his appearance as the head of a Flemish gentleman of William the Silent's time (LT506) – but physiognomic exaggeration and deliberately unnaturalistic colours contribute to an otherworldly rather than historicizing appearance. Van Gogh again brought out otherworldly associations in the *Self-portrait*, September 1888, that he sent to Gauguin, which, like the portrait of Boch, he intended to be a study rather than a finished picture. In this instance the exaggerated features impart an oriental look to the face, and by the time he wrote about it to Gauguin he likened the character to that of a Japanese *bonze* (LT544a). Instead of representing a starry

147

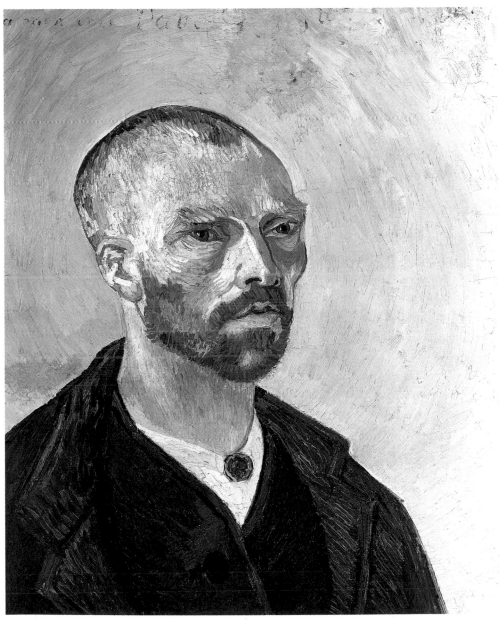

147 *Self-portrait* 1888 (dedicated to Gauguin)

firmament, the pale malachite background has been painted in concentrically curving strokes around van Gogh's head. Darkening slightly towards the edges, the background effectively seems to glow with an aura around the sitter. The pale green 'whites' of his eyes, like Boch's, seem to give off an eery inner illumination, and here the match of hue with that of the background suggests a transparency through the eyes to this spiritual malachite green ether.

Gauguin, too, had been working out a means of painting an evocatively symbolic portrait. During his stay in Arles he portrayed *Van Gogh painting Sunflowers* – van Gogh had invested the motif of sunflowers with symbolic allusions. Van Gogh never portrayed Gauguin, but in November 1888 he began pendant paintings of chairs on the coarse canvas Gauguin had brought to Arles: his own simple rush-bottom chair and Gauguin's more elaborate, upholstered-seated armchair. The pair stand as symbolic evocations of their absent sitters, an image impressed on van Gogh by Fildes's graphic epitaph to Charles Dickens, *The Empty Chair, Gad's Hill – Ninth of June 1870*, a depiction of the author's empty chair. Even more than the other furniture in van Gogh's bedroom, the inanimate chairs acquire an animate presence made individual by the still-life objects on the seats. The pair contrasts lighting,

56

149, 150

148 *Rain* 1889

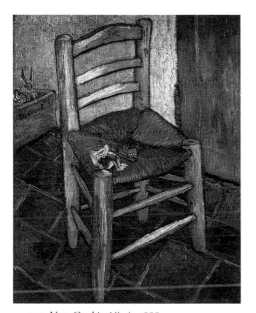
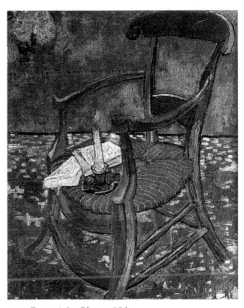

149 *Van Gogh's Chair* 1888 150 *Gauguin's Chair* 1888

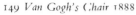

spatial angles, colouration and assertiveness of imagery. The brushwork in Gauguin's chair is bolder – some of the marks on the floor and the frame of the chair threaten to detach themselves. This painting was left unfinished, although van Gogh completed his own in January 1889, after the first crisis, and signed it on the background box of sprouting onions or bulbs.

In Auvers in 1890 van Gogh reaffirmed his interest in symbolic portraiture, but at Saint-Rémy he concentrated on landscape, which he often imbued with symbolic allusion. His confinement restricted the variety of views he had at his disposal, and a repeated motif is the walled field visible from his window. The vantage point frequently looked down from an upper storey, thus emphasizing the angled shape of the boundary wall, but no window bars impose themselves before the view. *Wheatfield with a Reaper*, July 1889 [Rijksmuseum Kröller-Müller], moves the vantage point to ground-level, placing the wall at the horizon line. He repeated the motif between July and September [Rijksmuseum van Gogh] when seasonal factors meant referring to his first picture rather than the actual motif. In the earlier version, the sun hugged the profile of the distant hills, whereas in the later variant it seems to bob against the upper framing edge. A tall tree rising against the sky was the other noteworthy change in the later version's imagery, and appears to have been added as an afterthought on top of the underlying paint layer of sky.

148

151

177

151 *Wheatfield with a Reaper* 1889

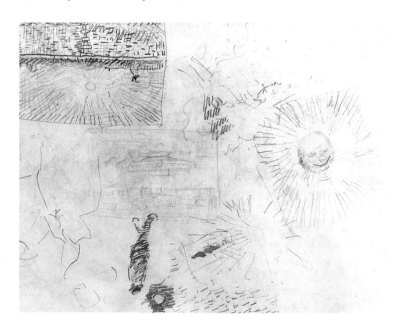

152 *Sheet with Various Sketches* 1888 (detail)

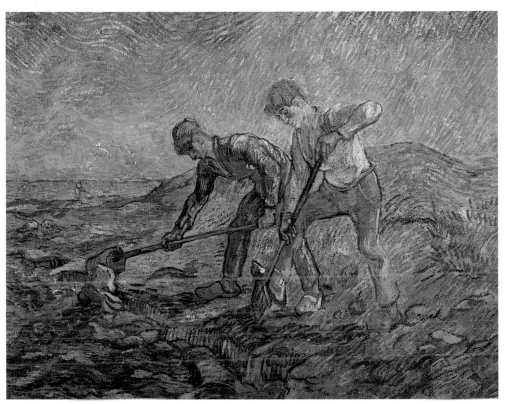

153 *Men digging (after Millet)* 1889

154 Wood engraving after Jean-François Millet's *Men digging*

The later painting divides into three coloured zones, which also have their particular characteristics of facture. The wheatfield occupies the bottom of the picture. On the left side it takes half the vertical dimension. This left-hand area has been partially mown, and choppy strokes indicate the stubble and fallen wheat. The wheat billows upwards in a more golden hue to about two-thirds the height on the right-hand side. The rhythmic eddies and swirls apparent in many Saint-Rémy paintings here serve a descriptive function – wind-blown grass – as well as imparting a vitality of their own to the object painted. Although each brush-stroke is thickly loaded, so much so that each mark is ridged at the edges from the pressure squeezing up the paint, the pale canvas shows between the separate marks. In late autumn van Gogh described such spacing as an atmospheric device and a paint-saving economy.

The brush-strokes on the upper portion of the canvas are closer together but even here the canvas weave appears through the paint. Between the field and sky a mauve wall acts as a boundary, although its horizontal continuity across the canvas is interrupted on the right by the expanding sea of grain. Here the field makes contact with the mounting hills of the far distance. The hills form a modulating blue, green and mauve wedge, which ascends nearly to the upper right corner. Brush-strokes construct inclining slopes and angular rocky projections. Two small houses merge into the landscape, a third makes a note of contrast. A pale green sky painted in broad, stubby strokes seems materially to hold the yellow sun disc in place against the top edge just to the left of centre. The sun as a palpable object began to appear in van Gogh's Arles paintings, and it even became personified: a sketch from the

summer of 1888 depicts the sun as a benevolently smiling face.

Outlines reinforce the edge of the wall and define the profiles of topographical features, but gestural drawing takes over from outline drawing. Each paint stroke is a gestural mark, which accumulates to coalesce in a pictorial surface that is all drawing.

The diagonals of the scythed grain, the alignment of sun and white house, and the sickled shape of the prominent tree all focus attention on the tiny figure of the reaper, a pale green shape towards the rear left of the yellow and ochre field. The odd configuration of the tree plays against the human figure of the reaper and appears to arch and stretch upwards as if drawn towards the sun. The colour of the sun (an agent of growth) and reaper pair against the colours of their respective backgrounds of grain and sky. Almost caricatural with his arms and legs fanning out from his torso, the reaper carries both a scythe and sickle, rather over-determining his identity. Van Gogh specifically identified the figure of the reaper with its traditional personification of death in a description of the painting to Theo (LT604), but death is here locked into a vital matrix.

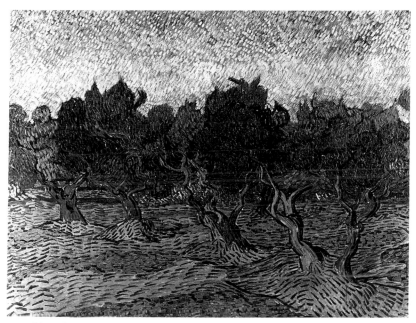

155 *Olive Grove* 1889

While himself constructing symbolically evocative images, van Gogh was appalled by the overtly narrative symbolism in the contemporary work of Bernard and Gauguin. His *Olive Grove*, November/December 1889, was part of a group of olive orchards protesting against his former colleagues' imaginary depictions of 'Christ in the Garden of Olives'. Although painted from observation van Gogh's *Olive Grove* is ordered by stylization. Instead of his more usual application of an entire surface in closely adhering brushstrokes, short dashes of paint dapple an underlying ground colour: the effect is best seen in the patches of earth beneath the olive trees. The approach to colour is quite unlike Neo-Impressionist handling, the marks serving more as a textural effect, yet this overall surface vibration may refer to Neo-Impressionism in opposition to Bernard's and Gauguin's current practice. Van Gogh had used a similar dot effect in his *Memory of the Garden at Etten*, a work closely associated with his attempt to engage with Gauguin's advice.

Van Gogh's palette in *Olive Grove* has dismissed the saturated, searing hues associated with his earlier work in the south. Brown, ochre, olive green and cool blue dominate the painting. Long-cast shadows inform the viewer that the sun is low on the horizon. Indeed, much of his Saint-Rémy work moves away from an apparent exaggeration of natural local colours to a subtler

155

58

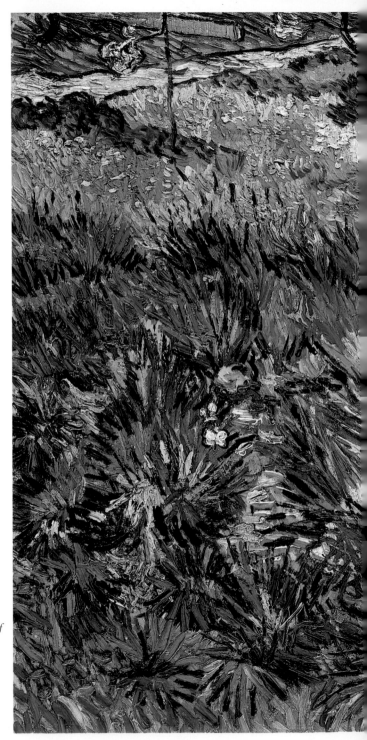

156 *Asylum Garden (Field of Grass with Flowers and Butterflies)* 1890

range and mixture of hues often strongly dependent on earth colours and tertiaries as if light as colour had ceded to light as charged atmospheric illumination. Luminosity as the manifestation of spirit may have been generated by his memories of Dutch seventeenth-century painting, for the north began to become an insistent attraction during the latter months at Saint-Rémy.

Van Gogh's variations on prints after Millet, Delacroix, Doré, Daumier, Rembrandt and Demont-Breton form a significant group of paintings for his shift in colour, for without a coloured motif van Gogh was forced to improvise. In some of the paintings after Millet the colour is plausible as local colour; however, in many, such as *Men digging (after Millet)*, October 1889, the colour combination appears deliberately anti-naturalistic. In *Men digging*, pink striations in the sky and salmon, pink and brown striations for the earth render a charged, hallucinatory environment which evokes a more spiritual vision of the peasant labourers than Millet's numb-looking figures mechanically turning the obdurate soil. Several of van Gogh's variations were done after religious images, which he had found impossible to paint from imagination. Other copies, not specifically of religious motifs, were rephrased into shimmering images of a transcendent natural world. Van Gogh had always read into Millet's work his own spiritual reverence for the natural world and its 'natural' inhabitant the peasant.

Van Gogh's work distances itself from naturalism in more ways than estranging local colour. His earliest drawings show a propensity to depict the motif from a close view-point, one which flattens onto the picture surface a broader visual field than that normally accommodated by a static planar screen. From his Paris years onward, he frequently preferred high horizons in his work and often obscured the exact location of the horizon. Other artists too had shifted it: Gauguin and Bernard had banished the horizon from the picture space in some works of 1888 and among former Impressionists both Monet and Degas slid the horizon upwards, displacing the spectator's gaze from the normal straight-on view. During Gauguin's visit to Arles van Gogh produced paintings that drive the horizon completely off the upper edge. As in Gauguin's work, the ground appears to rise up behind the figures to produce a decorative flattening. Subsequently, in the spring of 1889 he painted landscape images whose 'downward' view is more internally consistent: the depicted field on the canvas is all ground. Two paintings done at the beginning and end of his stay at Saint-Rémy, *Irises*, May 1889, and *Asylum Garden (Field of Grass with Flowers and Butterflies; Long Grass with Butterflies)*, May 1890, present two variants of this downward directed painting. In *Irises* the spectator is sited on top of the flowers, and the space does not recede very far into the distance. The rich blue flowers, and a lone

157 *Landscape with the River Oise* 1890

white one, are individually detailed (one is tempted to say personified) against a writhing mass of blade-like leaves in a cool green. Dark blue outline is used extensively on the right where flowers and leaves seem to compete for surface space. To the left the space is eased by the reddish brown, thickly painted earth in the foreground and a contrasting bed of round yellow flowers with greener foliage behind the irises. The *Asylum Garden* offers a deeper spatial slice. Foreground clumps of grass are not so closely observed but rather offer textured, sprouting strokes radiating from the centre of each clump, while the background generalizes into small dots and strokes. A diagonal path and the bases of vertical tree-trunks are relegated to the upper margin, securing the picture's edge. In both paintings the tension between the surface and the elusive slide of ground away from under the spectator's feet offers a tantalizing identification of the picture surface with a ground to be entered and simultaneously a displacement of the spectator from her or his actual position in front of a vertically hung painting.

158 *Road Menders* 1889

159 *Branches of an Almond Tree in Blossom* 1890

160 *Roots and Tree Trunks* 1890

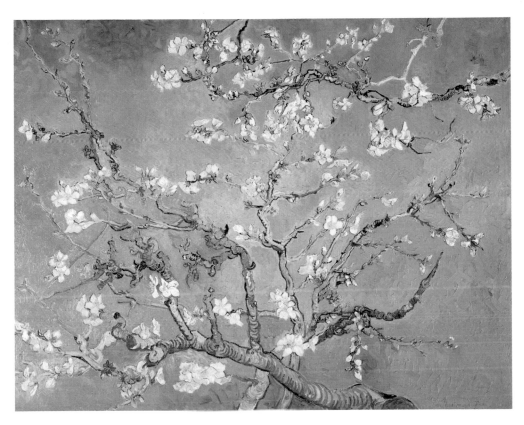

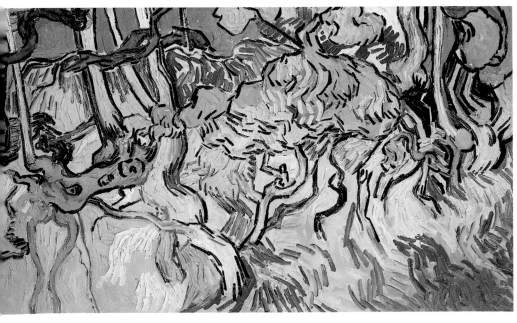

159 *Branches of an Almond Tree in Blossom*, February 1890, looks through from beneath tree branches to a sky whose eggshell-blue lightens in the centre rather than towards a horizon. As a picture it can be nearly as convincing viewed from any side. Like van Gogh's paintings of ground motifs, *Branches of an Almond Tree* resists merely decorative effect through its spatial displacement of the spectator. One of van Gogh's last canvases, the

160 horizontal, double-square *Roots and Tree Trunks*, July 1890, is even more disorientating. Here the predominant ochre and brown between the blue tree-trunks, roots and green foliage suggest that one is looking down onto bare earth (alternatively that this is a steep hillside), yet indications of scale are

157 totally baffling. By contrast, a drawing, *Landscape with the River Oise*, June/July 1890, looks straight ahead but dissolves the horizon into a stack of oscillating horizontal bands, each one emphatically a textured, outlined shape with its own spatial assertiveness. In both *Roots and Tree Trunks* and *Landscape* ambiguity seems to be intended.

The late horizontal paintings have been related to a format favoured in Puvis de Chavannes's decorations, but van Gogh's facture and space are alien to the classicizing order of Puvis's works. The spirit (though not the form) of ambiguity is closer to the work of Cézanne, an artist usually contrasted with van Gogh. The emotional tension is totally different from Cézanne's as is the

163 pictorial formulation of ambiguity. Dr Gachet owned several works by Cézanne, three of which impressed van Gogh sufficiently to earn a mention in his first letter from Auvers to Theo (LT635): *Geraniums and Coreopsis in a Small Delft Vase*, *Bouquet in a Small Delft Vase* and *Dr Gachet's House*, all of 1873.

Roots and Tree Trunks finally shuts out the viewer with its tangle of roots and branches. The broadly laid in paint, no longer proposing a descriptive or evocative texture, sticks to the surface. Repeatedly, in the late paintings the

161 viewer is excluded from the picture. Paths lead nowhere or seem to switch back, while thick, weightily coloured paint resists visual penetration. These late works construct an alienating discontinuity between the viewer and the motif, rather than an image of consolation.

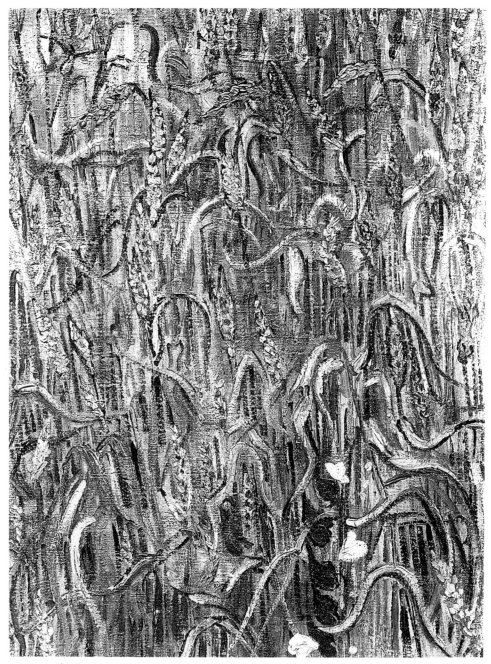

161 *Ears of Wheat* 1890

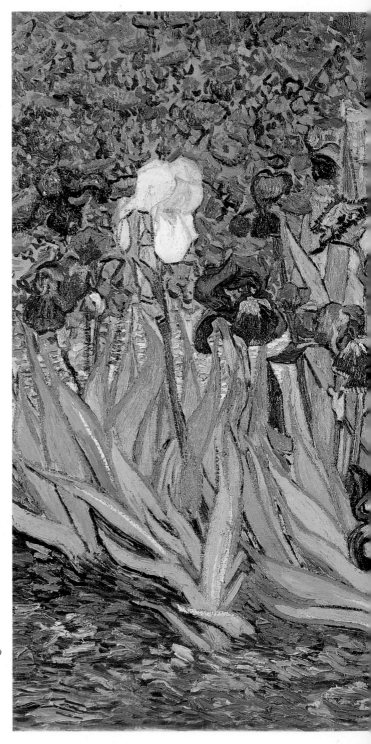

162 *Irises* 1889

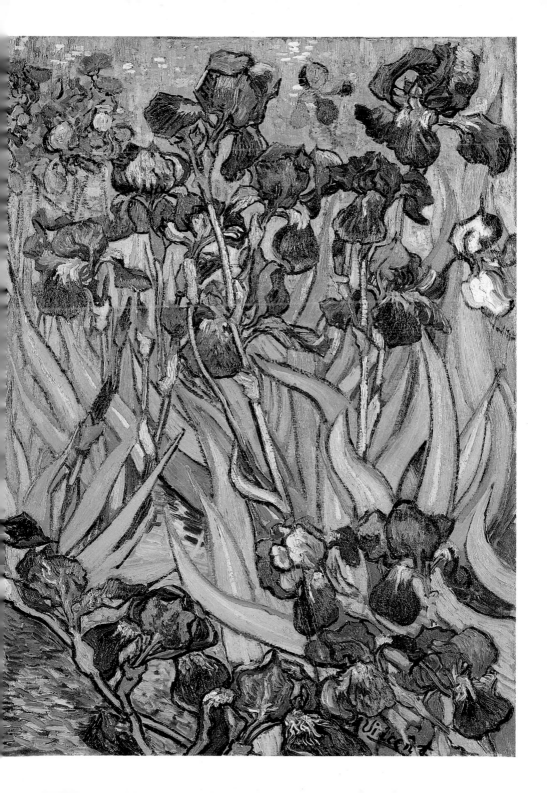

163 *Doctor Paul Gachet* 1890

Siting van Gogh

Contradiction rather than resolution is the theme of this final chapter. The myths referred to in Chapter I – those of genius, madness, inspiration and individuality conflict with our knowledge of van Gogh's conscious strategies, his persistent study and work, his articulation of his purpose, and his cultural awareness. The intention here, however, has not been to replace one set of myths by a revised, and equally mythical, image of the artist, although it is almost inevitable that a monograph, by its focus on the work of a single artist, will reinforce and perpetuate certain myths of artistic individuality. Such a study often assumes a relatively unproblematic relationship between works of art and their painter.

Compounding these unavoidable contradictions, built into cultural ideologies since the formation of modernism in the second half of the nineteenth century, are the contradictions within van Gogh's painting practice. These emerge both in his facture and his representations. Concerning facture, the quality of his work is extraordinarily uneven, an unevenness that cannot be tied simply to technical mastery nor to bouts of illness. As for his representations, tensions occur between his stated aims and some of the images (his paintings of consolation were not always read as such), and within the images themselves (when keen observation encounters convention).

Van Gogh's moves – his changes of residence, his reorientations of his enterprise, his shifts of style – might be linked to these contradictions. Moving on became a way of avoiding conflict. Two crucial moves, from The Hague to Drenthe and from Paris to Arles, were escapes from the city, from the insecurity of change and the social conflicts that change produced, to the vision of a natural ideal, and in each case when the ideal proved to be an illusion he again departed for a venue projected as an opposite of the place of his disillusion: from nature (Nuenen) to culture (Antwerp and Paris), from 'the south' (Arles and Saint-Rémy) to 'the north' (Auvers). It might even be argued that the closure of space in his late work was a kind of formal strategy to exclude contradiction or illusion, as if not allowing room for contradiction.

The rest of this chapter will simply look at several significant areas of conflict and contradiction in the study of van Gogh and his work, both

bringing together issues raised in previous chapters and introducing questions that may beg further investigation. In the area of mythologies it will juxtapose the longest enduring of the van Gogh myths, that of the *isolé*, with his activity in several art worlds. The chapter will attend to van Gogh's negotiation of selected representations between, on the one hand, representational conventions absorbed from his reading and viewing and, on the other hand, direct observation of the motif. Finally, it will question the standard characterizations of van Gogh's art as unique and radical.

Aurier's characterization of van Gogh as an *isolé*, set apart from the ordinary through his artistic inspiration, has been translated into a more widespread myth of his isolation through public misunderstanding, his own unsociable behaviour and consequent friendlessness. Very little of van Gogh's work sold during his life, yet he was deeply knowledgable about the Dutch and French art markets. While he knew what was saleable, he expressed ambivalence over the kind of spectator and patron he envisaged for his art. Some letters accuse Theo of not exerting himself enough to help create a market, but others prescribe a small, appreciative public. His contempt for the bourgeois art-buyer, inherited from Romantic Bohemianism, was reinforced by his role in the formation of the Parisian avant-garde during the later 1880s.

Even after van Gogh had supplanted graphic illustration with painting, he continued to regard illustration as a viable means of earning a living; nevertheless, his aspiration to produce an imagery for mass consumption eventually gave way to his commitment to easel painting – a unique, possessible object. His later duplications of certain of his own paintings in oil and other media were addressed principally to specific individuals. Like his letters, they spoke only to selected friends and relatives as part of an artistic dialogue phrased in an exclusive language.

In his changing conception of the audience to whom he directed his art van Gogh differed from his immediate artistic predecessors. Manet had continued to participate in the Salon exhibitions despite problems with the jury and critical and public reception. Although the Impressionists turned their backs on the Salon in 1874, they showed at venues that were likely to attract a certain range of middle-class viewer: Nadar's photographic studio in the boulevard des Capucines, Durand-Ruel's gallery in the rue Le Peletier, a house on the newly built avenue de l'Opéra. The Indépendants, while opposing the selectivity of the Salon jury, wooed a socially defined sector of the art establishment by inviting the president of the French republic to attend their opening (although he failed to appear).

Van Gogh's exhibition strategies display an unpredictable ambivalence about his relation to a public. The exhibition he organized at the Du Chalet

restaurant may have been partly directed towards an audience not normally considered as patrons of art, but, given van Gogh's knowledge of art markets, it is doubtful whether he ever visualized the restaurant's customers as potential buyers. The Du Chalet exhibition was as much an endeavour to draw together an artistic community as a commercial venture. When van Gogh later exhibited with the Indépendants and Les XX he expressed diffidence and doubt over his participation.

Even during long periods away from centres of art, van Gogh sought contact with other artists. It has even been suggested that van Gogh's late interpretations of other artists' work during his isolation at Saint-Rémy were conceived as a kind of substitute collaboration. Moreover, in Paris he became instrumental in actually bringing together groups of artists both through organizing the Du Chalet exhibition and in motivating the discussions that took place at Theo's and his apartment. These discussions took up practical concerns as well as affording artistic stimulation. In an article published in *La Plume*, 1 September 1891, Bernard referred to 'gigantic exhibitions, philanthropic communities of artists, founding of colonies in the south of France; moreover, a progresive invasion of the public domain in order to re-educate the masses to the love of art which they knew in the past.' Theo's position was essential to the economic viability of these plans, at least initially: he had the institutional contacts among art dealers, who were assuming a growing role as mediators between living artists and the public during the later nineteenth century. After receiving his legacy in 1888 he, himself, had greater means to offer contracts and to buy paintings. Without Theo Vincent van Gogh's schemes would have been inconceivable. Yet Theo's profession was antipathetic to his brother's ideal of an art untainted by commercial constraints. Theo's dual position as a facilitator of ideals and as a representative of processes detested by Vincent gave rise to an ambivalence often expressed in his letters.

The 'Yellow House' in Arles belonged to van Gogh's project to establish an artistic community which, although it did not survive beyond Gauguin's visit, had been envisaged as a centre for artists in the south. Actual, idealized and even religious models (among them the Barbizon group and the Pre-Raphaelite Brotherhood) inspired van Gogh's plans for an artistic community. Social encouragement of independent enterprise made such associations a feature in nineteenth-century art, at the same time encouraging the withdrawal of artists from an integral role in a wider community.

From his early experience as a dealer in The Netherlands to his final years as an artist in France, the art worlds of which van Gogh had knowledge and those through and within which he moved were various in their public and their productions. They covered national diversities and several generations

of artists. As an artist himself van Gogh engaged selectively with the art institutions of his time, as he positioned and repositioned his enterprise. Although he sought to intervene in the reformation of art world practices, he lacked a radical programme of cultural transformation. His several retreats from the turmoil of urban life and from the fray of artistic controversy were not simply personal gestures of withdrawal and isolation. They participated in the historical and economic processes that were effecting a separation of cultural spheres from meaningful social integration at that time.

Van Gogh was a voracious reader of the printed word and of pictures – and of words about pictures. Although he insisted on working from the motif, these readings structured his perceptions and his own representations. He described the world in terms of pictures he had seen, and he visualized images from descriptive passages in the works of his favourite novelists: Dickens, Eliot, Daudet, the Goncourt Brothers, Maupassant and Zola. His approach to human relationships and his conception of 'the Natural' depended on 127 Michelet and Carlyle. *Open Bible, Extinguished Candle and Novel*, 1885, and 128 numerous later still-lifes acknowledge the importance of literature, the titles of the depicted books often contributing to a painting's meaning. Such paintings suggest an analogy between reading a picture and reading a written text.

There are few images by van Gogh which do not refer to visual traditions whether fine art or graphic. His human subjects often represent types that could be distinguished from his own class, gender and age, as if otherness more easily allowed a visual objectification of the subject portrayed.

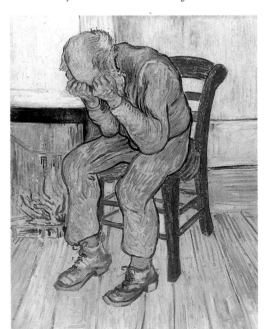

164 *The Threshold of Eternity* 1890 (after the drawing *Old Man with his Head in his Hands* 1882)

165 *Sien with Cigar sitting on the Floor near a Stove* 1882

Although he donned the trappings of the working class in The Hague and the peasantry in Nuenen, he retained the values of his own sector of the middle class. His images are distancing in spite of his supposed sympathy with the lower classes. In The Hague his scrutiny was fixed in hard, linear depictions, which partake of the appearance of verisimilitude realized in the graphic illustrations he avidly collected, but which show few traces of their sentiment or cosmetic improvement. For the most part, van Gogh's struggle simply to render an image distances these figures from empathy. Moreover, they turn away or, if facing the viewer, they nearly always refuse eye contact. Only the conversion of an individual into an emblem of painful emotion undermines the toughness of his focus, as in *Sorrow* or *Old Man with his Head in his Hands*, 1882.

118, 119

164

The women in the Hague drawings are not beautified. Frequently, they pose with a resigned weariness: a slumped posture, head hanging forward or propped by a hand. While not idealized they do not fundamentally challenge conventional images of womanhood. When active they perform domestic tasks (sewing, preparing food, child-care).

22

A few images, however, manage to escape stereotypes. *Sien with Cigar sitting on the Floor near a Stove*, April–May 1882, struggles to produce meaning without the precedent of a ready vocabulary. It is an observation which embodies mixed feelings, uncertainty and ambivalence, but it appears as a momentary hiatus in van Gogh's construction of a 'natural', domestic representation of woman. Although van Gogh offended the morality of his family and friends by openly living with the working-class woman Sien, he

165

parted from her in disillusionment over her failure to conform to his thoroughly middle-class project of saving the 'fallen woman', which may have been inspired by Michelet's writings.

26 After the earlier Nuenen weaver paintings in the spring and summer of 1884, which acknowledged social misfortune though they proposed no alternative, van Gogh turned to less problematic agricultural labourers. Painting peasants was a more clearly defined and more conservative enterprise than illustrating the urban working class or more rural artisan; it represented the peasant's condition and labour as natural and eternal. In the Nuenen peasants van Gogh adapted the model of Millet and Breton, through the ideas of Carlyle, and reworked his precedents as he also had in his depictions of the urban poor. The images frequently seem to be thrust under the viewer's nose, and the confrontation results in a merciless recording of features and physiques. Although van Gogh claimed the peasant to be more

25, 28, 29 beautiful than the city dweller, these peasants are represented as lumpish. Unlike Millet's peasants, dehumanized by their work, van Gogh's Nuenen peasants are simply alien beings opaque to the viewer's understanding in spite of their proximity and their steady gazes. He wrote from Nuenen, 'I often think how the peasants form a world apart, in many respects so much better than the civilized world. Not in every respect, for what do they know about art and many other things?' (LT404).

Van Gogh rarely portrayed the people who were closest to him. There are no images of Theo, of van Rappard, or of Gauguin or Bernard. Portraits of his mother and other relatives were done from photographs rather than sittings. Only a few of the sitters were from van Gogh's own class: Reid, Boch, Dr Gachet and his daughter. Among the Paris works, an unidentified woman in *Lady sitting by a Cradle*, March 1887, appears to be a bourgeoise, and a few unidentified men are dressed in the garb of the socially comfortable. The most sympathetic depictions of sitters were the first portrait of Tanguy and *Woman at a Table in the Café du Tambourin* (probably Segatori). Near the end of his Paris stay his portraits moved towards a new

51, 52, 84 kind of distancing. The emblematic poses of the later Tanguy portraits, set against a background of Japanese prints, and of *The Italian Woman*, pasted against a flatly woven background, continued in the Arles portraits of the Roulin family, the Zouave lieutenant Milliet, the artist Boch, the peasant

49 Patience Escalier and the girl he referred to as La Mousmé (after a character in Pierre Loti's novel *Madame Chrysanthème*). These works are more like icons than portraits of individuals.

If van Gogh retreated from the direct, awkward confrontation of human images, which sometimes allowed glimpses of social instability, to more conventional constructions, so too his images of the environment around

him withdrew from topographies lacking social definition and traditions of depiction (although they were described in some of his favourite novels) to more categorizable locations such as cityscape and landscape. Both in The Hague and in Paris he confronted urban outskirts that were neither city nor 116 country, nor even suburbs, and the effort involved in constructing a legible image produced some of his strongest early work.

The Hague images jar with the Dutch landscape models, which van Gogh adopted as means of spatial organization, but his later scenes of the Drenthe 122 and Brabant countryside reside more comfortably within conventions. In Paris van Gogh represented views from his window over the city and the 34 vistas of boulevards lined with buildings, which had early Impressionist prototypes. His more countrified Montmartre scenes had precedents in Dutch seventeenth-century landscape painting and the later work of the French landscapist Georges Michel. In less derivative Montmartre paintings, 38, 39, 131 pleasure sites and shop-lined streets displace the small, tilled plots. Views at the *barrière* looking back towards the city take as their motif the boundary 166 marked by the fortifying walls. Moving further afield to the environs of

166 *La Barrière with Horse-drawn Tram* 1887

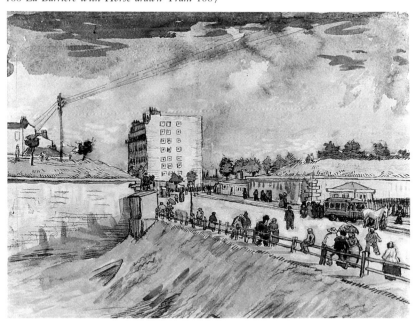

167 *Figures in a Park at Asnières* 1887

Asnières, van Gogh reworked Impressionist representations of such sites as non-city, proffering views of village streets, inns, and riverside walks with the occasional intrusion of factory chimneys and trains. There are works from Asnières, as from The Hague and Arles, that position urban presence behind foreground fields as if trying to push back the ever present industrial opponent of the country.

133
167

Although the move to Arles was a retreat from Paris, as Drenthe and Nuenen had been from The Hague, Arles was unlike the rural Drenthe and Brabant. Van Gogh's views of Arles, taken as a group, struggle to come to terms with this possibly unexpected situation; he had formed an unrealistic expectation of Arles based on hearsay, literature and imagination. Although he frequently painted the fields and countryside beyond Arles, he also pictured the city from within. These urban paintings usually feature motifs of passage through or out of the city: roads, bridges, canals, rivers. In a series of public garden images – a bit of nature partitioned off within the city – van Gogh depicted spatial enclosure and density of growth rather than the openness of rural nature.

105, 144

53

After his breakdown he hardly confronted an urban setting again. At first, trips to Arles from the hospital proved too stressful, and later his institutionalization secluded him from any contact with urban motifs; his first visit to the small town of Saint-Rémy left him with a feeling of faintness. Saint-Rémy did supply him with one image, that of road menders on the town street. He depicted the streets and houses of the village of Auvers as a rural hamlet and portrayed both church and town hall in isolation. Although derived from observation, the Saint-Rémy and Auvers countrysides taken together appear more as a symbolization of nature than a representation of specific places.

158

77

63, 68, 155
157

Van Gogh's project became increasingly conservative as he met conflicts that emerged from his manner of working. His dependency on observed motifs confronted him with experiences that refused to conform to his vocabulary based on past images. He witnessed the social instability brought about by industrialization and urbanization. The avoidance of these conflicts of the modern world by retreat into 'Nature' proved to be an illusion. The discomfort is registered both in strength and awkwardness. Sometimes awkwardness delivers the strength of a work, but at other times it simply appears incoherent. Frequently, the awkward pictures that succeed are those in which observation prevails, perhaps, as in some Hague drawings, some weaver paintings, and some images of urban outskirts, because there were no coventions on which he could rely: he had to look. The easier pictures, those that seem less problematic, like the early Nuenen landscapes and the Arles works done before Gauguin's visit, were done at a moment when vision and expectation harmonized. They are not as challenging, but they are splendid illusions. The works of his last year and a half tend to avoid conflict, both through the restriction of their representations and in the more limited role given to direct visual transcription.

The choice to move from The Hague to a peasant environment allowed van Gogh to identify more closely with Millet and artists he admired of the 'generation of 1848' (as he described them). These artists were his touchstones for a serious and ambitious painting for the 1880s, which would be educational for its urban public. But his way of painting failed to produce works that could be read or had the appeal of Millet's. Further attempts to come to terms with a modern, urban world in Antwerp and Paris left him overwhelmed, both by the life he adopted and by the conflicting artistic strategies for confronting and avoiding modernity, which he encountered among his colleagues.

In identifying Arles with Japan he sought an impossible ideal; he did not identify Arles (like Brabant) with the enterprise of painting peasant subjects. Initially, he chose to observe a variety of motifs which, although they can be

grouped into categories such as landscape, townscape, and portraiture, seem to disperse over a range of experience. Without an immediate grounding in a specific imagery, such as peasant painting, he moved towards the representation of a symbolic order whose qualities were transcendental and whose values were socially conservative. The transition was not immediate or smooth, since observation remained a necessary reference whatever symbolic expression was invested in it.

The motifs of his final eighteen months are more restricted, becoming less specific observations and more vehicles of evocation. In this, he had an affinity to the enterprise of Gauguin and the Symbolists even if he disagreed with their methods.

Van Gogh wrote about his desire to produce a symbolic painting at the time of his portrait of Boch as 'the poet'. In such symbolic portraits the sitters lose specificity and are rendered eternal embodiments of ideas. At the extreme, Madame Roulin became *La Berceuse* (the cradle rocker), considered as a central element of a proposed triptych (flanked by two versions of his series of *Sunflowers*), a modern altarpiece to a maternal ideal. The discomfiture registered in van Gogh's close scrutiny of other beings in his Hague and Brabant works, which projects the awkwardness of the encounter onto his subjects, was transformed into his desire to produce a painting of consolation in his late work.

In personal terms, painting thus filled the place once satisfied by religion. The painting he wanted to produce would also evoke the eternal as had religious painting in the past. In so doing, as he wrote to Theo, it would offer comfort and consolation and express hope in the face of 'delusive realism' (LT531, September 1888).

With the manifestation of his illness he became more preoccupied with art as consolation. In such painting, as in illness, lay a defence against the contradictions of reality. A consolatory painting could construct a depiction that expressed (as if a quality of itself) an ideal (hope, beauty, tenderness) projected onto the motif. Describing to Gauguin 'the heart-broken expression of our time' (LT643, June 1890) in the portrait of Dr Gachet, and to Theo and Jo the late paintings of wheatfields that 'try to express sadness and extreme loneliness' (LT649, July 1890), his faith in this enterprise seemed to waver, but he also wrote of the same wheatfields as evoking 'the health and restorative forces that I see in the country'. These late paintings, in which recessional space seems to be cancelled out, foreclosing the viewer's imaginary penetration, stand as visual embodiments of such contradictory projections.

Van Gogh belonged to the artistic generation that negotiated its way out of a naturalist pictorial construction. Instead of aspiring to render an image

168

132

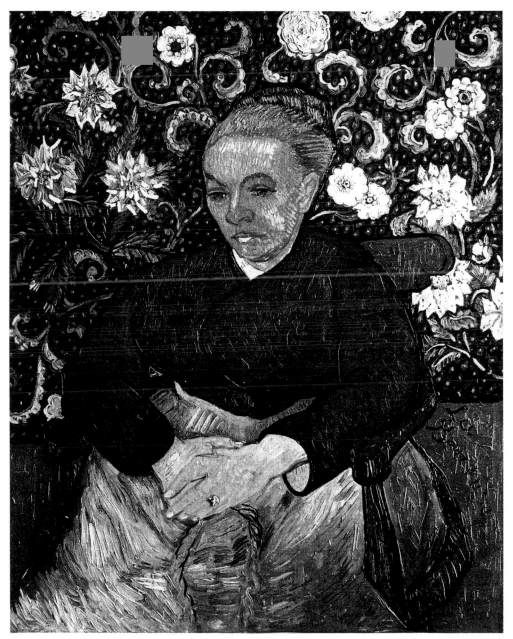

168 *La Berceuse* 1888–90

simply of 'what they saw', the artists of the 1880s in Paris began to attend to the means of producing that image: this process concentrated on the formal aspects of the art, which subsequently would be seen as part of the project of modernism. Yet van Gogh had enthused over the novels of Zola, an exponent of naturalism who acknowledged the importance of seeing nature through an individual temperament. Zola's model may have encouraged him to retain an allegiance to nature even when urged by Gauguin to paint from memory.

In contrast with Gauguin's and Bernard's more neutral surfaces, van Gogh's paintings assert their handwriting. Indeed, his struggle to acquire the means of representation may have made his awareness of facture more pronounced. From his first efforts he had favoured a painterly surface, but his reading of pointillism and Impressionism encouraged the development of a graphic means of painting that brought together draughtsmanship and paint. His experience in Paris both of contemporary painting and Japanese prints was revelatory for his handling of colour, though he did not fully exploit colour's exaggerative potential until he consolidated these ideas in Arles.

In Arles within a short time he did realize a radically individual style, one which stands uniquely for 'van Gogh' (and which thereby tempts forgeries). It seems fittingly ironic, given the value accorded his uniqueness, that in some cases he produced multiple copies of his paintings, the very emblems of uniqueness.

Bernard proclaimed: 'van Gogh's work is more personal than that of anyone else.' The works assert themselves vibrantly as registrations of a personality in paint, which perhaps contributes to the great popularity of van Gogh's later paintings with a general public. Conversely, the projection of the artist's personality on the motif may have made these works uncomfortable for many modernists who were concerned primarily with formal issues.

To the attention of critics who singled him out from his colleagues van Gogh responded with mixed pleasure and dismay. Some psychological explanations have pointed to a fear of success, but his letters to Isaäcson and Aurier seem more concerned that the work be understood and re-presented through a syntax of his own artistic references, implying a fear that it might not be adequately understood without this framework.

Van Gogh's projection of a narrow, sensitive and informed audience for his work relates to his own experience of art. He wanted to make the kind of art that moved him. He tried to make Theo's tastes like his own; he was thrilled when van Rappard shared his love for illustrations; he tried to reconvert Bernard from his imaginary compositions. Repeatedly in the letters there is a tone of didacticism, of explanation as if to proselytize. The phrase 'I have tried to express' echoes through the letters.

Van Gogh's individuality has sustained and expanded with his myth. His personal style ensured his identity and unlikeness to other artists. It is almost that his work looks more radically different the more the imagery avoids a confrontation with modernity (or modern subjects): this too perhaps contributes to these works' popularity now. The course of his art might be charted from the modernity of imagery in his Hague works to the modernism of the attention to pictorial features in the Arles ones.

Despite the lack of public acclaim during van Gogh's life, his art negotiates with the policy expressed by the French director of fine arts, Gustave Laroumet, who in 1888 advocated no single favoured artistic course but rather competition, plurality and individuality. Van Gogh began his practical art studies by copying Bargue's course, itself a product of government art policies of the Second Empire concerned with reforming aesthetic education in the trade schools. In a sense, van Gogh the artist was produced from the values of the late nineteenth-century art policies, a conclusion which seems to contradict the very myths of genius which have accorded value to his art; but these myths, too, have been manufactured out of those nineteenth-century ideals of the uniqueness of individual talent. What secures his work for serious critical attention are its deeper strengths – its awkwardness, its tensions, and its contradictions. These are produced not just from personal vision or artistic forces but from negotiation through particular circumstances in response to particular conditions which cannot be generalized.

Select Bibliography

BIBLIOGRAPHIES

Brooks, Charles Mattoon, Jr., *Vincent van Gogh: A Bibliography*, New York, 1942. Schiff, Richard, 'Art History and the Nineteenth Century: Realism and Resistance', *Art Bulletin*, LXX, 1, March 1988, 25–48. Pages 29 to 31 summarize recent approaches to van Gogh.

CATALOGUES RAISONNÉS

Faille, J. B. de la, *The Works of Vincent van Gogh*, Amsterdam and London, 1970 (4 vols, Paris and Brussels, 1928, revised Paris, 1939). Hulsker, Jan, *The Complete van Gogh: Paintings, Drawings, Sketches*, New York, 1977.

CATALOGUES

Amsterdam, *Rijksmuseum Vincent van Gogh*, ed. Evert van Uitert, 1987. Amsterdam, Rijksmuseum Vincent van Gogh, *Japanese Prints collected by Vincent van Gogh*, eds Willem van Gulik and Fred Orton, 1978. New York, Metropolitan Museum of Art, *Van Gogh in Arles*, ed. Ronald Pickvance, 1984; *Van Gogh in Saint-Rémy and Auvers*, ed. Ronald Pickvance, 1986. Paris, Musée d'Orsay, *Van Gogh à Paris*, eds Françoise Cachin and Bogomila Welsh-Ovcharov, 1988. 's-Hertogenbosch, Noordbrabants Museum, *Van Gogh in Brabant*, ed. Evert van Uitert, Zwolle, 1987. University of Nottingham and Arts Council of Great Britain, *English Influences on van Gogh*, ed. Ronald Pickvance, 1974.

CORRESPONDENCE

Gogh, Vincent van, *The Complete Letters of Vincent van Gogh*, 3 vols, London and New York, 1958. The order of the letters has been revised by Hulsker and Pickvance. Gauguin, Paul, ed. Douglas Cooper, *Paul Gauguin: 45 Lettres à Vincent, Theo et Jo van Gogh: Collection Rijksmuseum Vincent van Gogh*, Amsterdam, 's-Gravenhage and Lausanne, 1983. Hulsker, Jan, 'What Theo really thought of Vincent', *Vincent*, III, 2, 1974, 2–28; 'Vincent's letters to Anton Kerssemakers', *Vincent*, II, 2, winter 1973, 16–24; (ed.) 'Critical days in the hospital at Arles', *Vincent*, I, 1, autumn 1970, 20–31.

CRITICISM

Aurier, G.-Albert, 'Les Isolés: Vincent van Gogh', originally published in *Le Mercure de France*, Jan. 1890, reprinted and trans. by Pickvance, *Van Gogh at Saint-Rémy and Auvers*, pp. 310–15. Matthews, Patricia, 'Aurier and Van Gogh: Criticism and Response', *Art Bulletin*, LXVIII, 1, March 1986, 94–104. Stein, Susan Alyson, ed., *Van Gogh: A Retrospective*, New York, 1986. Welsh-Ovcharov, Bogomila, *Van Gogh in Perspective*, Englewood Cliffs, New Jersey, 1974. Zemel, Carol M., *The Formation of a Legend: Van Gogh Criticism, 1890–1920*, Ann Arbor, Michigan, 1980.

MONOGRAPHS AND BIOGRAPHICAL STUDIES

Pollock, Griselda, and Fred Orton, *Vincent van Gogh: Artist of his Time*, Oxford, 1978. Tralbaut, Marc Edo, *Vincent van Gogh*, London 1969.

CONTEXTUAL AND SPECIALIZED STUDIES:

Art Gallery of Ontario, Toronto, and Rijksmuseum Vincent van Gogh, Amsterdam, *Vincent van Gogh and the Birth of Cloisonnism*, ed. Bogomila Welsh-Ovcharov, Amsterdam and Toronto, 1981. Chetham, Charles, *The Role of Vincent van Gogh's Copies in the Development of His Art*, New York and London, 1976. Derkert, Carlo, 'Theory and Practice in van Gogh's Dutch Painting', *Konsthistorisk Tidskrift*, special number: Swedish van Gogh Studies, XV, 3–4, Dec. 1946, 97–120. Green, Nicholas, 'Art History and the Construction of Individuality', *Oxford Art Journal*, 6, 2, 1983, 80–82; an expanded book review of Zemel, *The Formation of a Legend*. House, John, 'In Detail: Van Gogh's *The Poet's Garden, Arles*', *Portfolio*, Sept.-Oct. 1980, 28–33. Hulsker, Jan, 'van Gogh's threatened life in St. Rémy and Auvers', *Vincent*, II, 1, autumn 1972, 21–39; (ed.) 'Vincent's stay in the hospitals at Arles and St-Rémy', *Vincent*, I, 2, spring 1971, 24–44; 'van Gogh's ecstatic years in Arles', *Vincent*, I, 4, summer 1972, 2–17; 'van Gogh's years of rebellion in Nuenen', *Vincent*, I, 3, autumn 1971, 15–28; 'van Gogh's dramatic years in The Hague', *Vincent*, I, 2, spring 1971, 6–21. Johnson, Ron, 'Vincent van Gogh and the Vernacular: The Poet's Garden', *Arts Magazine*, 53, 6, Feb. 1979, 98–104; 'Vincent van Gogh and the Vernacular: His Southern Accent', *Arts Magazine*, 52, 10, June 1978, 131–35. Millard, Charles W., 'A Chronology for Van Gogh's Drawings of 1888', *Master Drawings*, XII, 2, summer 1974, 156–65. Murray, Ann, ' "Strange and Subtle Perspective . . .". Van Gogh, the Hague School and the Dutch Landscape Tradition', *Art History*, 3, 4, Dec. 1980, 410–24. Nordenfalk, Carl, 'Van Gogh and Literature', *Journal of the Warburg and Courtauld Institutes*, 10, 1947, 132–47. Outhwaite, David, *Van Gogh at Auvers-sur-Oise*, M.A. thesis, London University, 1969. Pollock, Griselda, 'Artists, Mythologies and Media: Genius, Madness and Art History', *Screen*, 21, 3, 1980, 57–96 (I should like to acknowledge my indebtedness to the stimulation of Pollock's numerous books and articles); 'Stark Encounters: Modern Life and Urban Work in Van Gogh's Drawings of the Hague 1881–3', *Art History*, 6, 3, Sept. 1983, 330–58; 'Van Gogh, Rembrandt and the British Museum', *Burlington Magazine*, Nov. 1974; *Vincent van Gogh and Dutch Art: a Study of the development of van Gogh's notion of modern art with special references to the critical and artistic revival of seventeenth century Dutch art in Holland and France in the nineteenth century*, Ph.D. thesis, London University, 1980; *Vincent van Gogh in zijn Hollandse jaren*, Amsterdam, van Gogh Museum, 1980 (contains English synopsis); 'Van Gogh and the Poor Slaves: Images of Rural Labour as Modern Art', *Art History*, 13, 3, Sept. 1988, 408–32. Rewald, John, 'Theo van Gogh, Goupil, and the Impressionists', *Gazette des Beaux-Arts*, LXXXI, 1973, 1–64, 65–108. Roskill, Mark, 'Van Gogh's exchanges of work with Emile Bernard in 1888', *Oud Holland*, LXXXVI, 1971, 142–79; 'Van Gogh's

"Blue Cart" and His Creative Process', *Oud Holland*, LXXXI, 1966, 3–19; *Van Gogh, Gauguin and the Impressionist Circle*, London, 1970. Sand, Judy, 'Favoured Fictions: Women and Books in the Art of Van Gogh', *Art History*, 11, 2, June 1988, 255–67. Schapiro, Meyer, 'On a Painting of van Gogh', *Modern Art: 19th and 20th Centuries*, London, 1978 (1st publ. 1952). Soth, Lauren, 'Van Gogh's Agony', *Art Bulletin*, LXVIII, 2, June 1986, 301–13. Sotheby's, New York, *Vincent van Gogh: Irises* (sale catalogue) New York, 1987. Uitert, Evert van, 'Vincent van Gogh and Paul Gauguin: A Creative Competition', *Simiolus*, 9, 3, 1977, 149–68; 'Vincent van Gogh in anticipation of Paul Gauguin', *Simiolus*, 10, 3–4, 1978–79, 182–99; 'Vincent van Gogh and Paul Gauguin in Competition: Vincent's Original Contribution', *Simiolus*, 11, 2, 1980, 81–106; 'Van Gogh's Concept of his Œuvre', *Simiolus*, 12, 4, 1981–82, 223–44. Walker, John A., *Van Gogh Studies: Five Critical Essays*, London, 1981. Wylie, Anne Stiles, 'Coping with a dizzying world', *Vincent*, III, 1, 1974, 8–

18; 'An Investigation of the Vocabulary of Line in Vincent van Gogh's Expression of Space', *Oud Holland*, LXXXV, 4, 210–35. Zemel, Carol, 'Sorrowing Women, Rescuing Men: van Gogh's Images of Women and Family', *Art History*, X, 3, Sept. 1987, 351–68; 'The Spook in the Machine: Van Gogh's Pictures of Weavers in Brabant', *Art Bulletin*, LXVI, 1, March 1985, 123–37.

OTHER SOURCES:

Boime, Albert, 'The Teaching of Fine Arts and the Avant-garde in France during the Second Half of the Nineteenth Century', *Arts Magazine*, 60, 4, Dec. 1985, 46–57. Green, Nicholas, 'All the Flowers of the Field: the State, Liberalism and Art in France under the early Third Republic', *Oxford Art Journal*, 10, 1, 1987, 71–84. London, Royal Academy; Paris, Grand Palais; The Hague, Haags Gemeentemuseum, *The Hague School: Dutch Masters of the 19th Century*, eds. Leeuw, Ronald de; John Sillevis and Charles Dumas, 1983.

List of Illustrations

All works are by Vincent van Gogh unless stated otherwise. Measurements are given in centimetres and inches, height before width. The letter F followed by a number refers to the catalogue by J. B. de la Faille, *The Works of Vincent van Gogh*, 1970.

24 *Hand Studies* 1885. F1153r. Black chalk 21 × 34.5 (8¼ × 13⅝). Vincent van Gogh Foundation/National Museum Vincent van Gogh, Amsterdam

25 *Head of a Peasant Woman with a White Cap, facing right* 1885. F1182. Black chalk 40 × 33 (15¾ × 13). Vincent van Gogh Foundation/National Museum Vincent van Gogh, Amsterdam

26 *Weaver facing front* 1884. F27. Oil on canvas on panel 48 × 61 (18⅞ × 24). Museum Boymans-van Beuningen, Rotterdam

27 *Old Church Tower* 1885. F84. Oil on canvas 63 × 79 (24¾ × 31⅛). Vincent van Gogh Foundation/National Museum Vincent van Gogh, Amsterdam

28 *Peasant Woman stooping* 1885 F1269. Black chalk 52.5 × 43.5 (20⅝ × 17⅛). Kröller-Müller State Museum, Otterlo

29 *Peasant turfing* 1885. F1310. Black chalk 44 × 28 (17⅜ × 11). Vincent van Gogh Foundation/National Museum Vincent van Gogh, Amsterdam

30 *Birds' Nests* 1885. F111. Oil on canvas 38.5 × 46.5 (15⅛ × 18¼). Vincent van Gogh Foundation/National Museum Vincent van Gogh, Amsterdam

31 *Women dancing* 1885. F1350b. Black and coloured chalk 9.3 × 16.4 (3⅝ × 6½). Vincent van Gogh Foundation/National Museum Vincent van Gogh, Amsterdam

32 *Skull with Burning Cigarette* 1885. F212. Oil on canvas 32.5 × 24 (12¾ × 9½). Vincent van Gogh Foundation/National Museum Vincent van Gogh, Amsterdam

33 *Houses in Antwerp in the Snow* 1885. F260. Oil on canvas 44 × 33.5 (17¼ × 13¼). Vincent van Gogh Foundation/National Museum Vincent van Gogh, Amsterdam

34 *View from Vincent's Room in rue Lepic* 1887. F341. Oil on canvas 46 × 38 (18⅛ × 15). Vincent van Gogh Foundation/National Museum Vincent van Gogh, Amsterdam

35 *Studies of a seated Nude Girl and Plaster Statuettes* 1886. F1366r. Black chalk 47.5 × 61.5 (18¾ × 24¼). Vincent van Gogh Foundation/National Museum Vincent van Gogh, Amsterdam

36 *Studies of Plaster Statuettes* 1886 (detail of verso of 35). F1366v. Black chalk and charcoal 47.5 × 61.5 (18¾ × 24¼). Vincent van Gogh Foundation/National Museum Vincent van Gogh, Amsterdam

37 Adolphe Monticelli *Vase with Flowers* c. 1875. Oil on canvas 51 × 39 (20 × 15¾). Vincent Van Gogh Foundation/National Museum Vincent van Gogh, Amsterdam

38 *Suburb of Paris seen from a Height* 1887. F1410. Watercolour, heightened with white 39.5 × 53.5 (15½ × 21). Vincent van Gogh Foundation/National Museum Vincent van Gogh, Amsterdam

39 *Montmartre near the Upper Mill* 1886. F272. Oil on canvas on masonite 44 × 33.5 (17⅜ × 13¼). Art Institute of Chicago, Helen Birch Bartlett Memorial Foundation

40 *Nude Woman on a Bed* 1887. F330. Oil on canvas 59.5 × 73 (23⅜ × 28¾, oval). The Barnes Foundation, Merion, Pennsylvania

41 Photograph of the Yellow House at Arles. Vincent van Gogh Foundation/National Museum Vincent van Gogh, Amsterdam

42 *Sower with setting Sun* 1888. F422. Oil on canvas 64 × 80.5 (25¼ × 31¾). Kröller-Müller State Museum, Otterlo

43 *Peasants working in a Field* 1888. F1090. Reed pen, ink 26 × 34.5 (10¼ × 13½) Vincent van Gogh Foundation/National Museum Vincent van Gogh, Amsterdam

44 *La Crau seen from Montmajour* 1888. F1420. Black chalk, pen, reed pen, brown and black ink 49 × 61 (19¼ × 24). Vincent van Gogh Foundation/National Museum Vincent van Gogh, Amsterdam

45 Emile Bernard *Self-portrait 'à son copaing Vincent'* 1888. Oil on canvas 46.5 × 55.5 (18¼ × 21⅞). Vincent van Gogh Foundation/National Museum Vincent van Gogh, Amsterdam

46 Paul Gauguin *Les Misérables (Self-portrait with Portrait of Bernard)* 1888. Oil on canvas 45 × 55 (17¾ × 21⅝). Vincent van Gogh Foundation/National Museum Vincent van Gogh, Amsterdam

47 *Postman Roulin* 1888. F432. Oil on canvas 81 × 65 (31⅞ × 25⅝). Museum of Fine Arts, Boston. Robert Treat Paine II Bequest

48 *Pink Peach Trees (Souvenir de Mauve)* 1888. F394. Oil on canvas 73 × 59.5 (28¾ × 23½). Kröller-Müller State Museum, Otterlo

49 *La Mousmé* 1888. F431. Oil on canvas 74 × 60 (29⅛ × 23⅝). National Gallery of Art, Washington DC, Chester Dale Collection

50 *Lieutenant Milliet* 1888. F473. Oil on canvas 60 × 49 (23⅝ × 19¼). Kröller-Müller State Museum, Otterlo

51 *Old Provençal Peasant (Patience Escalier)* 1888. F444. Oil on canvas 69 × 56 (27⅛ × 22). Private Collection

52 *Eugène Boch (The Poet)* 1888. F462. Oil on canvas 60 × 45 (23⅝ × 17¾). Musée d'Orsay, Paris. Photo Réunion des Musées Nationaux

53 *Park at Arles* 1888. F479. Oil on canvas 73 × 92 (28¾ × 36¼). Private Collection (?)

54 *The Night Café* 1888. F463. Oil on canvas 70 × 89 (27½ × 35). Yale University Art Gallery. Bequest of Stephen Carlton Clark

55 *Café Terrace at Night (place du Forum)* 1888. F467. Oil on canvas 81 × 65.5 (31⅞ × 25¾). Kröller-Müller State Museum, Otterlo

56 Paul Gauguin *Van Gogh painting Sunflowers* 1888. Oil on canvas 73 × 92 (28¾ × 36¼). Vincent van Gogh Foundation/National Museum Vincent van Gogh, Amsterdam

57 Paul Gauguin *Garden at Arles* 1888. Oil on canvas 73 × 91.5 (28¾ × 36). Art Institute of Chicago. Mr and Mrs Lewis L. Coburn Memorial Collection

58 *Memory of the Garden at Etten* 1888. F496. Oil on canvas 73.5 × 92.5 (28⅞ × 36⅜). Hermitage, Leningrad

59 *Plate with Onions, Annuaire de la Santé and Other Objects* 1889. F604. Oil on canvas 50 × 64 (19¾ × 25¼). Kröller-Müller State Museum, Otterlo

60 *Window of Studio at St Paul's Hospital* 1889. F1528. Black chalk, gouache 61.5 × 47 (24¼ × 18½). Vincent van Gogh Foundation/National Museum Vincent van Gogh, Amsterdam

61 *Dormitory in Hospital* 1889. F646. Oil on canvas 74 × 92 (29⅛ × 36¼). Oskar Reinhart Collection, Winterthur

62 *The Red Vineyard* 1888. F495. Oil on canvas 75 × 93 (29½ × 36⅝). Pushkin Museum, Moscow

63 *Starry Night* 1889. F612. Oil on canvas 73 × 92 (28¾ × 36¼). Museum of Modern Art, New York. Acquired through the Lillie P. Bliss Bequest

64 *Undergrowth* 1889. F746. Oil on canvas 74 × 92 (29⅛ × 36¼). Vincent van Gogh Foundation/National Museum Vincent van Gogh, Amsterdam

65 *Cornfield with Cypresses* 1889. F615. Oil on canvas 72.5 × 91.5 (28½ × 36). National Gallery, London.

66 *L'Arlesienne* 1888. F488. Oil on canvas 90 × 72 (35½ × 28¾). Metropolitan Museum of Art, New York. Samuel A. Lewisohn Bequest

67 *Pine Woods* 1889. F652. Oil on canvas 92 × 73 (36¼ × 28¾). Kröller-Müller State Museum, Otterlo

68 *Road with Cypresses and Star* 1890. F683. Oil on canvas 92 × 73 (36¼ × 28¾). Kröller-Müller State Museum, Otterlo

69 *Entrance to a Quarry* 1889. F744. Oil on canvas 60 × 72.5 (23⅝ × 28½). Vincent van Gogh Foundation/National Museum Vincent van Gough, Amsterdam

70 *Self-portrait* 1889. F627. Oil on canvas 65 × 54 (25⅝ × 21¼). Musée d'Orsay, Paris. Photo Réunion des Musées Nationaux (also cover illustration)

71 *Cottages with Thatched Roofs at Auvers-sur-Oise* 1890. F792. Oil on canvas 72 × 91 (28⅜ × 35⅞). Musée d'Orsay, Paris. Photo Réunion des Musées Nationaux

72 *Landscape in the Rain* 1890. F811. Oil on canvas 50 × 100 (19⅝ × 39⅜). National Museum of Wales, Cardiff

73 *Sower in the Rain* 1890. F1550. Pencil and chalk 23.5 × 31.5 (9¼ × 12⅜). Folkwang Museum, Essen

74 *Interior of a Farm with Figures by a Fire* 1890. F1608r. Black chalk 23.5 × 32 (9¼ × 12⅝). Vincent van Gogh Foundation/National Museum Vincent van Gogh, Amsterdam

75 *Daubigny's Garden* 1890. F777. Oil on canvas 56 × 101.5 (22 × 40). Offentliche Kunstsammlung Basel

76 *Marguerite Gachet at the Piano* 1890. F772. Oil on canvas 102 × 50 (40⅛ × 19⅝). Offentliche Kunstsammlung Basel

77 *Church at Auvers-sur-Oise* 1890. Oil on canvas 94 × 74 (37 × 29⅛). Musée d'Orsay, Paris. Photo Réunion des Musées Nationaux

78 *Undergrowth with Two Figures* 1890. F773. Oil on canvas 50 × 100 (19⅝ × 39⅜). Cincinnati Museum, Cincinnati

79 *Two Pear Trees with Château* 1890. F770. Oil on canvas 50 × 100 (19⅝ × 39⅜). Vincent van Gogh Foundation/National Museum Vincent van Gogh, Amsterdam

80 Photograph of Theo van Gogh. Vincent van Gogh Foundation/National Museum Vincent van Gogh, Amsterdam

81 *Japonaiserie: the Courtesan after Keisai Eisen* 1887. F373. Oil on canvas 105 × 61 (41⅜ × 24). Vincent van Gogh Foundation/National Museum Vincent van Gogh, Amsterdam

82 Luke Fildes *Houseless and Hungry* 1869. Engraving 31.6 × 40.3 (12½ × 15⅞). Vincent van Gogh Foundation/National Museum Vincent van Gogh, Amsterdam

83 Hubert von Herkomer *Sunday at the Chelsea Hospital* 1871. Engraving 34 × 26.2 (13½ × 10¼). Vincent van Gogh Foundation/National Museum Vincent van Gogh, Amsterdam

84 *The Italian Woman* 1887–88. F381. Oil on canvas 81 × 60 (31⅞ × 23⅝). Musée d'Orsay, Paris. Photo Réunion des Musées Nationaux

85 *Portrait of Père Tanguy* 1887–88. F363. Oil on canvas 92 × 75 (36¼ × 29½). Musée Rodin. Photo Bruno Jarret

86 Pierre Puvis de Chavannes *Inter Artes et Naturam* 1888–90 (central panel). Wall painting 295 × 830 (116 × 327). Musée des Beaux-Arts, Rouen

87 *The Sower (after Millet)* 1881. F830. Pen and wash, heightened with green and white 48 × 36.5 (18⅞ × 14⅜). Vincent van Gogh Foundation/National Museum Vincent van Gogh, Amsterdam

88 Print after Jean-François Millet's *Labours of the Field*. Vincent van Gogh Foundation/National Museum Vincent van Gogh, Amsterdam

89 Jean-François Millet *The Sower* 1850. Oil on canvas 101 × 82.5 (39¾ × 32½). Museum of Fine Arts, Boston. Shaw Collection

90 Emile Bernard *Breton Women and Children* 1888. Oil on canvas 74 × 92 (29 × 36¼). Private Collection

91 *Breton Women (after Bernard)* 1888–89. F1422. Watercolour 47.5 × 62 (18¾ × 24⅜). Civica Galleria d'Arte Moderna di Milano

92 *Night: the Watch (after Millet)* 1889. F647. Oil on canvas 72.5 × 92 (28½ × 36¼). Vincent van Gogh Foundation/National Museum Vincent van Gogh, Amsterdam

93 *The Sower* 1888. F451. Oil on canvas 32 × 40 (12⅝ × 15¾). Vincent van Gogh Foundation/National Museum Vincent van Gogh, Amsterdam

94 Paul Gauguin *Vision after the Sermon* 1888. 73 × 92 (28¾ × 36¼). National Galleries of Scotland, Edinburgh

95 *L'Arlésienne (after Gauguin)* 1890. F542. Oil on canvas 65 × 54 (25⅝ × 21¼). Museu de Arte de São Paulo, Brazil. Photo Luiz Hossaka

96 Paul Gauguin *L'Arlésienne: Mme Ginoux* 1888. Charcoal 56 × 48.4 (22 × 19). Fine Arts Museum, San Francisco, Achenbach Foundation for the Graphic Arts

97 Paul Signac *Railway Junction at Bois-Colombes* 1886. Oil on canvas 33 × 47 (13 × 18½). Leeds City Art Gallery

98 *Road at Loosduinen near The Hague* 1882. F1089. Black chalk and pen, heightened with white 26 × 35.5 (10¼ × 14). Vincent van Gogh Foundation/National Museum Vincent van Gogh, Amsterdam

99 *Vases with Asters and Phlox* 1886. F234. Oil on canvas 61 × 46 (24 × 18⅛). Vincent van Gogh Foundation/National Museum Vincent Van Gogh, Amsterdam

100 Eugène Delacroix *Pietà* (print by Célestin Nanteuil). Vincent van Gogh Foundation/National Museum Vincent van Gogh, Amsterdam

101 *Pietà after Delacroix* 1889. F630. Oil on canvas 73 × 60.5 (28¾ × 23¾). Vincent van Gogh Foundation/National Museum Vincent van Gogh, Amsterdam

102 Rembrandt *The Raising of Lazarus*. Etching. Metropolitan Museum of Art, New York. Gift of Henry Walters

103 *The Raising of Lazarus (after Rembrandt)* 1890. F677. Oil on canvas 48.5 × 63 (19⅛ × 24¾). Vincent van Gogh Foundation/National Museum Vincent van Gogh, Amsterdam

104 Louis Anquetin *The Mower at Noon: Summer* 1887. Oil on cardboard 69.2 × 52.7 (27¼ × 20¾). Private Collection

105 *Arles, View from the Wheatfields* 1888. F545. Oil on canvas 73 × 54 (28¾ × 21¼). Musée Rodin, Paris. Photo Giraudon
106 *Still-life with Coffee-pot* 1888. F410. Oil on canvas 65 × 81 (25⅝ × 31⅞). Private Collection
107 *Public Soup Kitchen* 1883. F1020a. Black chalk 57 × 44.5 (22½ × 17½). Vincent van Gogh Foundation/National Museum Vincent van Gogh, Amsterdam
108 'Le Japon', cover of *Paris illustré* May 1866. Vincent van Gogh Foundation/National Museum Vincent van Gogh, Amsterdam
109 Van Gogh's tracing of the *Paris illustré* cover, 1887. Vincent van Gogh Foundation/National Museum Vincent van Gogh, Amsterdam
110 *Self-portrait with Bandaged Ear* 1889. F527. Oil on canvas 60 × 49 (23⅝ × 19¼). Courtauld Institute Galleries, London (Courtauld Collection)
111 *Vase with Violet Irises against a Yellow Background* 1890. F678. Oil on canvas 92 × 73.5 (36¼ × 29). Vincent van Gogh Foundation/National Museum Vincent van Gogh, Amsterdam
112 *Portrait of a Man with a Skullcap* 1887–88. F289. Oil on canvas 65.5 × 54 (25¾ × 21¼). Vincent van Gogh Foundation/National Museum Vincent van Gogh, Amsterdam
113 *Young Man with a Sickle (Boy cutting Grass with Sickle)* 1881. F851. Black chalk and watercolour 47 × 61 (18½ × 24). Kröller-Müller State Museum, Otterlo
114 *Daughter of Jacob Meyer (after Holbein)* 1881. F847. Charcoal and pencil 43 × 30.5 (16⅞ × 12). Private Collection
115 *Pawnshop in The Hague* 1882. Black chalk 23.5 × 33 (9¼ × 13). Vincent van Gogh Foundation/National Museum Vincent van Gogh, Amsterdam
116 *Gas Tanks in The Hague* 1882. F924. Chalk and pencil 24 × 33.5 (9½ × 13⅛). Vincent van Gogh Foundation/National Museum Vincent van Gogh, Amsterdam
117 *Miners in the Snow* 1882. F1202. Watercolour 7 × 11 (2¾ × 4⅜). Vincent van Gogh Foundation/National Museum Vincent van Gogh, Amsterdam
118 *Orphan Man with Walking Stick* 1882. F962. Pencil 50 × 30.5 (19⅞ × 12). Vincent van Gogh Foundation/National Museum Vincent van Gogh, Amsterdam
119 *Head of Fisherman* 1883. F1014. Pencil, black lithographic chalk, ink, heightened with black and white 50.5 × 31.5 (19⅞ × 12⅜). Vincent van Gogh Foundation/National Museum Vincent van Gogh, Amsterdam
120 *State Lottery Office* 1882. F970. Watercolour 38 × 57 (15 × 22½). Vincent van Gogh Foundation/National Museum Vincent van Gogh, Amsterdam
121 *Sien's Daughter seated* 1883. F1008. Pencil, black lithographic chalk 50.5 × 31 (19⅞ × 12¼). Vincent van Gogh Foundation/National Museum Vincent van Gogh, Amsterdam
122 *Landscape at Nightfall* 1883. F1099. Watercolour 40 × 53 (15⅜ × 20⅞). Vincent van Gogh Foundation/National Museum Vincent van Gogh, Amsterdam
123 *The Vicarage Garden at Nuenen in Winter (Winter Garden)* 1884. F1128. Pencil and pen 39 × 53 (15⅜ × 20⅞). Vincent van Gogh Foundation/National Museum Vincent van Gogh, Amsterdam

124 *Pond in the Vicarage Garden (The Kingfisher)* 1884. F1135. Pen, heightened with white 39 × 53 (15⅜ × 20⅞). Vincent van Gogh Foundation/National Museum Vincent van Gogh, Amsterdam
125 *The Potato Eaters* 1885. F82. Oil on canvas 82 × 114 (32¼ × 44⅞). Vincent van Gogh Foundation/National Museum Vincent van Gogh, Amsterdam
126 *Portrait of a Woman in Blue* 1886. F207a. Oil on canvas 46 × 38 (18⅛ × 15). Vincent van Gogh Foundation/National Museum Vincent van Gogh, Amsterdam
127 *Open Bible, Extinguished Candle and Novel* 1885. F117. Oil on canvas 65 × 78 (25⅝ × 30¾). Vincent van Gogh Foundation/National Museum Vincent van Gogh, Amsterdam
128 *Parisian Novels* 1888. F358. Oil on canvas 53 × 72.5 (20⅞ × 28½). Vincent van Gogh Foundation/National Museum Vincent van Gogh, Amsterdam
129 *Window at the Restaurant Chez Bataille in Paris* 1887. F1392. Pen and blue chalk, pink, yellow and white crayon 54 × 40 (21¼ × 15¾). Vincent van Gogh Foundation/National Museum Vincent van Gogh, Amsterdam
130 Henri de Toulouse-Lautrec *Portrait of Vincent van Gogh* 1887. Pastel 53 × 44 (21¼ × 17¾). Vincent van Gogh Foundation/National Museum Vincent van Gogh, Amsterdam
131 *Hill of Montmartre with a Quarry* 1886. F230. Oil on canvas 56 × 62 (22 × 24⅜). Vincent van Gogh Foundation/National Museum Vincent van Gogh, Amsterdam
132 *Crows in the Wheatfields* 1890. F779. Oil on canvas 50.5 × 100.5 (19⅞ × 39½). Vincent van Gogh Foundation/National Museum Vincent van Gogh, Amsterdam
133 *Road along the Seine near Asnières* 1887. F299. Oil on canvas 49 × 66 (19¼ × 26). Vincent van Gogh Foundation/National Museum Vincent van Gogh, Amsterdam
134 *Wheatfield with a Lark* 1887. F310. Oil on canvas 54 × 64.5 (21¼ × 25¾). Vincent van Gogh Foundation/National Museum Vincent van Gogh, Amsterdam
135 Claude Monet *The Seine at Argenteuil* 1873. Oil on canvas 56 × 75 (22 × 29½). Courtauld Institute Galleries, London (Courtauld Collection)
136 *Lemons, Pears, Apples, Grapes and an Orange* 1887. F383. Oil on canvas 49 × 65 (19¼ × 25⅝). Vincent van Gogh Foundation/National Museum Vincent van Gogh, Amsterdam
137 *Harvest at La Crau (Blue Cart)* 1888. F412. Oil on canvas 72.5 × 92 (28½ × 36¼). Vincent van Gogh Foundation/National Museum Vincent van Gogh, Amsterdam
138 *View of Arles with Irises in the Foreground* 1888. F409. Oil on canvas 54 × 65 (21¼ × 25⅝). Vincent van Gogh Foundation/National Museum Vincent van Gogh, Amsterdam
139 *Public Garden Opposite the 'Yellow House'* 1888. F1421. Pencil, reed pen and brown ink 25.5 × 34.5 (10 × 13⅝). Vincent van Gogh Foundation/National Museum Vincent van Gogh, Amsterdam
140 *Boats on the Beach at Saintes-Maries-de-la-Mer* 1888. F413. Oil on canvas 64.5 × 81 (25⅝ × 31⅞). Vincent van Gogh Foundation/National Museum Vincent van Gogh, Amsterdam
141 *Ploughed Fields* 1888. F574. Oil on canvas 72.5 × 92 (28½ × 36¼). Vincent van Gogh Foundation/National Museum Vincent van Gogh, Amsterdam
142 *Peach Blossom in The Crau* 1889. F514. Oil on canvas

65.5 × 81.5 ($25\frac{3}{4}$ × $32\frac{1}{8}$). Courtauld Institute Galleries, London (Courtauld Collection)

143 *Orchard in Blossom, Arles in the Background* 1889. F515. Oil on canvas 50.5 × 65 ($19\frac{7}{8}$ × $25\frac{5}{8}$). Vincent van Gogh Foundation/National Museum Vincent van Gogh, Amsterdam

144 *Vincent's House in Arles, the 'Yellow House'* 1888. F464. Oil on canvas 76 × 94 ($29\frac{7}{8}$ × 37). Vincent van Gogh Foundation/National Museum Vincent van Gogh, Amsterdam

145 *Vincent's Bedroom in Arles* 1888. F482. Oil on canvas 72 × 90 ($28\frac{3}{8}$ × $35\frac{1}{2}$). Vincent van Gogh Foundation/National Museum Vincent van Gogh, Amsterdam

146 *Starry Night over the Rhône* 1888. F474. Oil on canvas 72.5 × 92 ($28\frac{1}{2}$ × $36\frac{1}{4}$). Musée d'Orsay, Paris. Photo Réunion des Musées Nationaux

147 *Self-portrait* 1888 (dedicated to Gauguin). F476. Oil on canvas 62 × 52 ($24\frac{3}{8}$ × $20\frac{1}{2}$). Fogg Art Museum. Collection of Maurice Wertheim

148 *Rain* 1889. F650. Oil on canvas 73.5 × 92.5 (29 × $36\frac{3}{8}$). Philadelphia Museum of Art. The Henry P. McIlhenny Collection in memory of Frances P. McIlhenny

149 *Van Gogh's Chair* 1888. F498. Oil on canvas 93 × 73.5 ($36\frac{5}{8}$ × $28\frac{7}{8}$). National Gallery, London

150 *Gauguin's Chair* 1888. F499. Oil on canvas 90.5 × 72 ($35\frac{5}{8}$ × $28\frac{3}{8}$). Vincent van Gogh Foundation/National Museum Vincent van Gogh, Amsterdam

151 *Wheatfield with a Reaper* 1889. F618. Oil on canvas 74 × 92 ($29\frac{1}{8}$ × $36\frac{1}{4}$). Vincent van Gogh Foundation/National Museum Vincent van Gogh, Amsterdam

152 *Sheet with Various Sketches* 1888 (detail). F1375. Pencil 23 × 29 (9 × $11\frac{3}{8}$). Vincent van Gogh Foundation/National Museum Vincent van Gogh, Amsterdam

153 *Men digging (after Millet)* 1889. F648. Oil on canvas 72 × 92 ($28\frac{3}{8}$ × $36\frac{1}{4}$). Stedelijk Museum Collection, Amsterdam

154 Wood engraving after Jean-François Millet's *Men digging*. Vincent van Gogh Foundation/National Museum Vincent van Gogh, Amsterdam

155 *Olive Grove* 1889. F707. Oil on canvas 73 × 92.5 ($28\frac{3}{4}$ × $36\frac{3}{8}$). Vincent van Gogh Foundation/National Museum Vincent van Gogh, Amsterdam

156 *Asylum Garden (Field of Grass with Flowers and Butterflies)* 1890. F672. Oil on canvas 64.5 × 81 ($25\frac{3}{8}$ × $31\frac{7}{8}$). National Gallery, London

157 *Landscape with the River Oise* 1890. F1627. Pencil and black chalk 23.5 × 30.5 ($9\frac{1}{4}$ × 12). Vincent van Gogh Foundation/National Museum Vincent van Gogh, Amsterdam

158 *Road Menders* 1889. F658. Oil on canvas 73.5 × 92.5 (29 × $36\frac{3}{4}$). Phillips Collection, Washington DC

159 *Branches of an Almond Tree in Blossom* 1890. F671. Oil on canvas 73 × 92 ($28\frac{3}{4}$ × $36\frac{1}{4}$). Vincent van Gogh Foundation/ National Museum Vincent van Gogh, Amsterdam

160 *Roots and Tree Trunks* 1890. F816. Oil on canvas 50.5 × 100.5 ($19\frac{7}{8}$ × 39). Vincent van Gogh Foundation/ National Museum Vincent van Gogh, Amsterdam

161 *Ears of Wheat* 1890. F767. Oil on canvas 64.5 × 47 ($25\frac{3}{8}$ × $18\frac{1}{2}$). Vincent van Gogh Foundation/National Museum Vincent van Gogh, Amsterdam

162 *Irises* 1889. F608. Oil on canvas 73 × 93 ($28\frac{3}{4}$ × $36\frac{5}{8}$). Private Collection

163 *Doctor Paul Gachet* 1890. F754. Oil on canvas 68 × 57 ($26\frac{3}{4}$ × $22\frac{1}{2}$). Musée d'Orsay, Paris. Photo Réunion des Musées Nationaux

164 *The Threshold of Eternity* 1890 (after the drawing *Old Man with his Head in his Hands* 1882). F702. Oil on canvas 81 × 65 ($31\frac{7}{8}$ × $25\frac{5}{8}$). Kröller-Müller State Museum, Otterlo

165 *Sien with Cigar sitting on the Floor near a Stove* 1882. F898. Pencil, black chalk, pen and brush, sepia, heightened with white 45.5 × 56 ($17\frac{7}{8}$ × 22). Kröller-Müller State Museum, Otterlo

166 *La Barrière with Horse-drawn Tram* 1887. F1401. Watercolour, pen and pencil 24 × 31.5 ($9\frac{1}{2}$ × $12\frac{3}{8}$). Vincent van Gogh Foundation/National Museum Vincent van Gogh, Amsterdam

167 *Figures in a Park at Asnières* 1887. F314. Oil on canvas 75.5 × 113 ($29\frac{3}{4}$ × $44\frac{1}{2}$). Vincent van Gogh Foundation/ National Museum Vincent van Gogh, Amsterdam

168 *La Berceuse* 1888–90. F504. Oil on canvas 92 × 73 ($36\frac{1}{4}$ × $28\frac{3}{4}$). Kröller-Müller State Museum, Otterlo

Index